TIME

GREAT
PLACES
OF
HISTORY

TIME

MANAGING EDITOR Richard Stengel
DESIGN DIRECTOR D.W. Pine
DIRECTOR OF PHOTOGRAPHY Kira Pollack

Great Places of History
Civilization's 100 Most Important Sites: An Illustrated Journey

EDITOR Kelly Knauer
DESIGNER D.W. Pine
PHOTO EDITOR Patricia Cadley
RESEARCHER Tresa McBee
COPY EDITOR Bruce Christopher Carr
EDITORIAL PRODUCTION Lionel P. Vargas

TIME HOME ENTERTAINMENT
PUBLISHER Richard Fraiman
GENERAL MANAGER Steven Sandonato
EXECUTIVE DIRECTOR, MARKETING SERVICES Carol Pittard
EXECUTIVE DIRECTOR, RETAIL AND SPECIAL SALES Tom Mifsud
EXECUTIVE DIRECTOR, NEW PRODUCT DEVELOPMENT Peter Harper
DIRECTOR, BOOKAZINE DEVELOPMENT AND MARKETING Laura Adam
PUBLISHING DIRECTOR Joy Butts
ASSISTANT GENERAL COUNSEL Helen Wan
BOOK PRODUCTION MANAGER Suzanne Janso
DESIGN AND PREPRESS MANAGER Anne-Michelle Gallero
BRAND MANAGER Michela Wilde
ASSOCIATE PREPRESS MANAGER Alex Voznesenskiy

SPECIAL THANKS TO:
Christine Austin, Jeremy Biloon, Glenn Buonocore, Malati Chavali, Jim Childs, Susan Chodakiewicz, Rose Cirrincione, Jacqueline Fitzgerald, Christine Font, Lauren Hall, Carrie Hertan, Malena Jones, Mona Li, Robert Marasco, Kimberly Marshall, Amy Migliaccio, Nina Mistry, Dave Rozzelle, Ilene Schreider, Adriana Tierno, Jonathan White, Vanessa Wu, TIME Imaging

Published by TIME Books, an imprint of Time Home Entertainment Inc.
135 West 50th Street • New York, NY 10020

ISBN 10: 1-60320-196-3
ISBN 13: 978-1-60320-196-4
Library of Congress Number: 2011930923

We welcome your comments and suggestions about TIME Books. Please write to us at:
TIME Books, Attention: Book Editors, P.O. Box 11016, Des Moines, IA 50336-1016

If you would like to order any of our hardcover Collector's Edition books, please call us at 1-800-327-6388, Monday through Friday, 7 a.m. to 8 p.m., or Saturday, 7 a.m. to 6 p.m., Central Time.

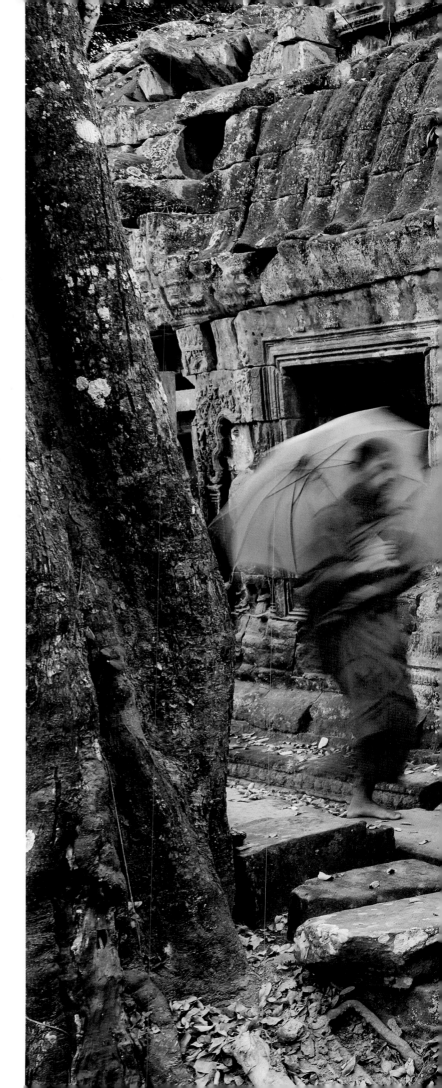

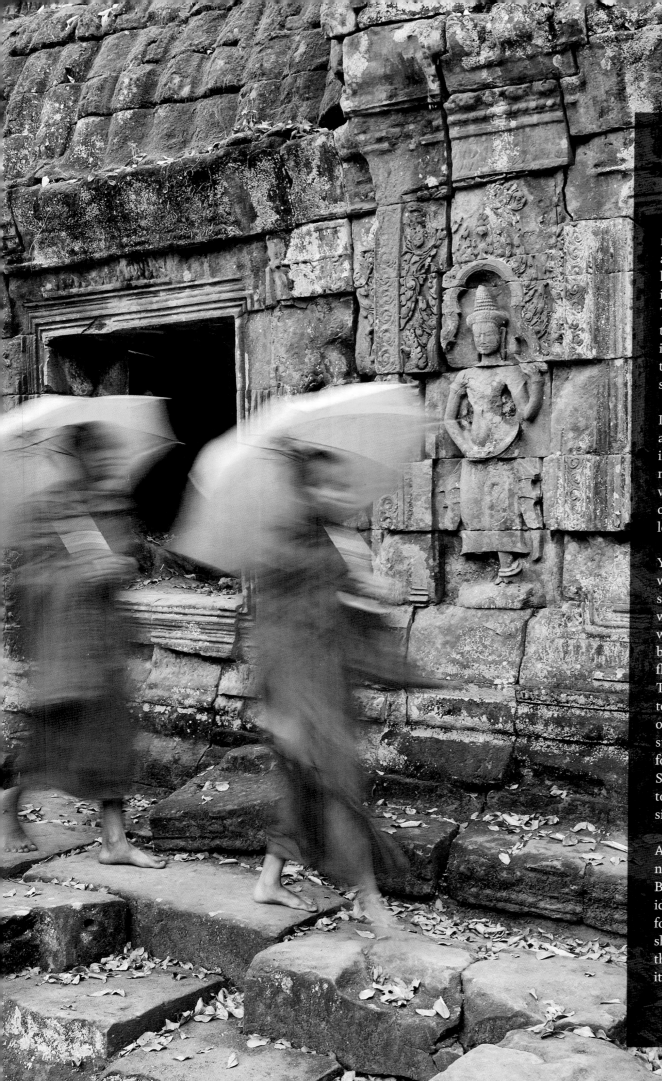

On History's Front Lines

EACH YEAR THE EDITORS OF *TIME* SELECT a Person of the Year—the individual who has done the most in the past 12 months to influence world events, for better or worse. The choice inevitably sparks debate, and that's the idea. After all, TIME's mission is to help readers engage with the news, to care passionately about the events that shape history and our lives.

In this book TIME surveys history through a different lens. Rather than focusing on individual people who have influenced the news, we've looked at the specific places where the news was made. The result is a list of Great Places: 100 of the most influential locations in the course of civilization.

You've heard of a whodunit; this book is a wheredunit, a GPS approach to the human saga. It aims to orient readers to the places where discoveries were made and revolutions were born, where cultures clashed and crucial battles were fought, where radical ideas took flight and great artists worked their magic. The entries span centuries and continents to include ancient temples and futuristic opera houses, skyscrapers and polar research stations. Many of our choices can also be found on UNESCO's list of World Heritage Sites, an admirable United Nations effort to celebrate, protect and preserve the most significant locations in human history.

As with TIME's Person of the Year selection, no one is going to agree with all our choices. But if we start a few arguments, spark a few ideas and inspire readers to care about the forces that shape our cultural heritage—if, in short, these pages move you—that seems like the sort of orienteering that both TIME and its readers enjoy.

—THE EDITORS

GREAT PLACES OF HISTORY

CONTENTS

GREENLAND

NORTH AMERICA

SOUTH AMERICA

Atlantic Ocean

Pacific Ocean

EUROPE

ASIA

AFRICA

AUSTRALIA

Indian Ocean

INNOVATION

76 Segovia Aqueduct *(pg. 118)*
77 Reims Cathedral *(pg. 119)*
78 Château de Chenonceau *(pg. 120)*
79 Imperial Vienna *(pg. 122)*
80 Grand Place *(pg. 123)*
81 Jefferson's Virginia *(pg. 124)*
82 Mountain Railways of India *(pg. 126)*
83 Iron Bridge *(pg. 127)*
84 Skyscrapers of Chicago *(pg. 128)*
85 Panama Canal *(pg. 130)*
86 Brooklyn Bridge *(pg. 131)*
87 Hoover Dam *(pg. 132)*
88 Bauhaus School *(pg. 133)*
89 City of Arts and Sciences *(pg. 134)*
90 CCTV Headquarters *(pg. 136)*
91 Burj Khalifa *(pg. 137)*

ARTS

92 Renaissance Florence *(pg. 140)*
93 Mozart's Salzburg *(pg. 142)*
94 Shakespeare's Globe *(pg. 144)*
95 Dickens' London *(pg. 145)*
96 The Strausses' Vienna *(pg. 146)*
97 Wagner's Bayreuth *(pg. 148)*
98 Yasnaya Polyana *(pg. 149)*
99 Monet's Garden *(pg. 150)*
100 Burning Man *(pg. 152)*

CHAPTER ONE
WHERE CULTURES TOOK SHAPE

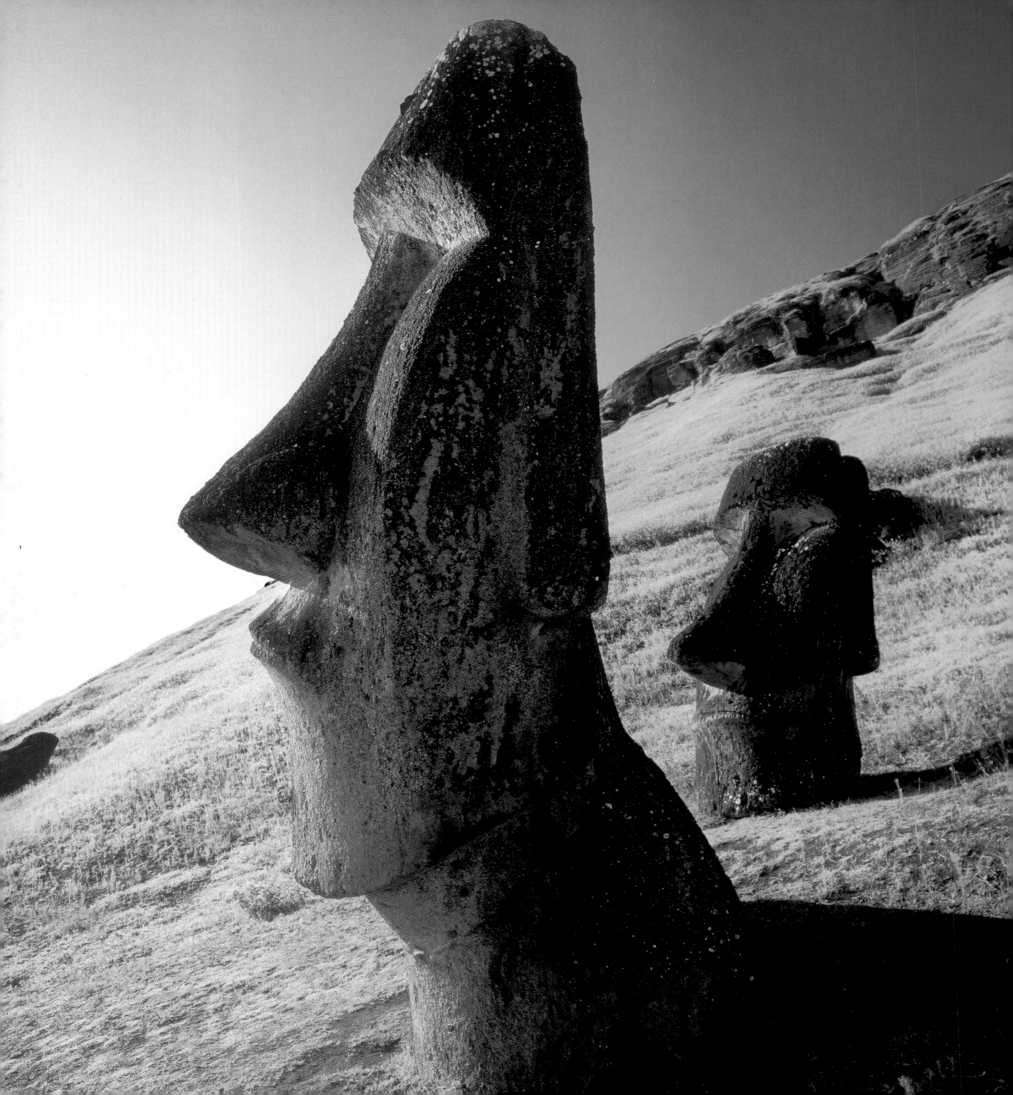

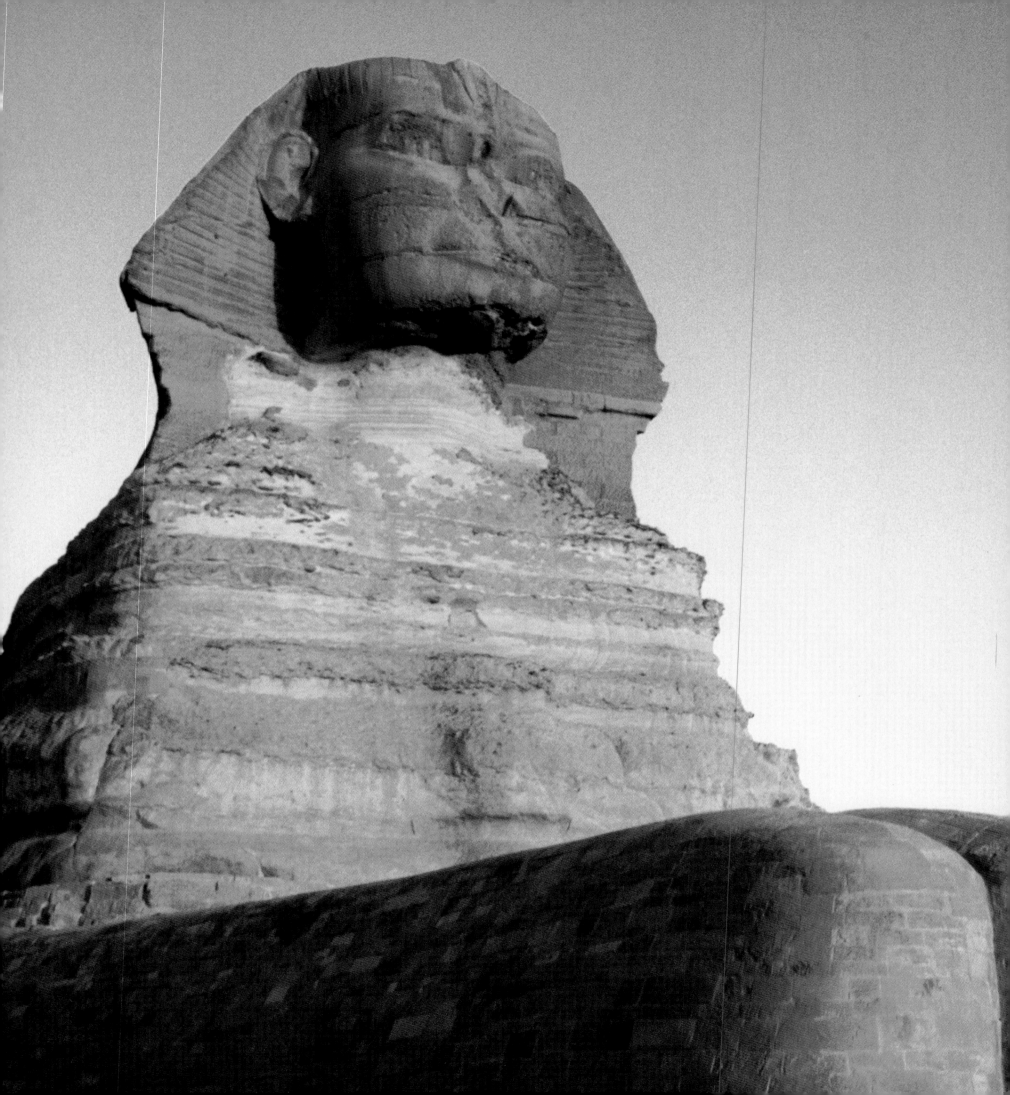

1.
Pyramid of Khufu and The Sphinx

These great structures were built to make their creators immortal. Mission accomplished—so far

THE GREAT PYRAMID OF KHUFU AND ITS mysterious neighbor, the Sphinx, have made Giza in Egypt one of the planet's greatest sightseeing magnets, not just for centuries but for millenniums. Created over a 20-year period ending in 2550 B.C. as memorials for Pharaoh Khufu of Egypt's 4th dynasty, they were 2,200 years old when Alexander the Great stopped by to pay his respects. Three hundred years later, the Cleopatra-besotted Roman general Mark Antony dropped in. A general who envied Alexander, Napoleon Bonaparte, brought a French army and a flock of scientists and academics to the site in 1798 A.D., although the story that French soldiers blew off the Sphinx's nose with cannonballs during target practice is apocryphal. On a hasty visit in 2009, U.S. President Barack Obama eyed the pyramid and uttered the same words spoken by generations of visitors: "This thing is huge." Later, he claimed to have found a relative depicted in one of the hieroglyphics inside a tomb. "That looks like me," he argued, "look at those ears."

If still huge, the pyramid has lost a bit of its luster: when built, its more than 2 million limestone blocks were covered in a layer of gleaming white limestone that must have presented a blinding spectacle in the harsh desert sunlight. Modern engineers marvel at the mathematical regularity of the monolith, a testament to the advanced science of this ancient civilization. The pyramid's neighbor, the Sphinx, seems content to bask in the sun: like all felines, it is inscrutable. Small wonder its name is a synonym for life's enigmas.

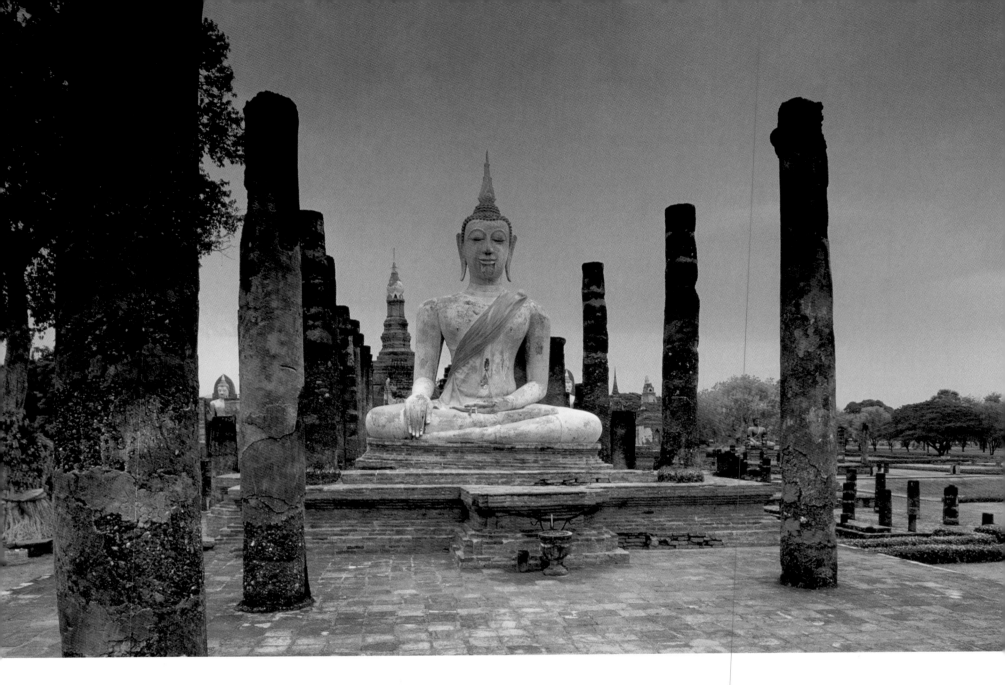

2.
Ayutthaya

Siam's onetime capital is a
repository of the arts and
crafts of the Thai people

THE GREAT ROYAL CITY OF AYUTTHAYA ROSE,
prospered and fell over more than four centu-
ries, lasting roughly from A.D. 1350 to 1767. In
those days, when Thailand was still known as
Siam, Westerners knew very little about the
people and cultures of Southeast Asia, and
only in recent decades has today's historical
park begun to enjoy the respect it deserves as a
magnificent preserve of Thai culture.

Ayutthaya at its height was a sprawling city,
the full extent of which visitors today can only
imagine, for Siam endured consant clashes
with neighboring Burma, ending in the con-
quest and pillage of the complex in 1767. Yet a
host of treasures remain, such as the Buddha
statue above, created in A.D. 1345. And thanks
to its relative obscurity, Ayutthaya is an oasis

of calm amid modern Thailand's bustle and
clamor. After a visit in 2009, TIME's John
Krich declared, "Wat Mahatat [a section of the
complex], with a stone head emerging from
gnarled bodhi (or fig tree) roots, is as good as
historical rummaging gets. And the reclining
Buddha, speckled with fresh squares of gold
leaf, seems hundreds of miles from the nearest
mall or massage parlor ... Its sculptures and
chedis [conical towers] ooze grandeur, not rot."

Siam's ancient capital was a city of some
1 million people in the mid-17th century, when
London's population was half that. But we
must not confuse it with a European city:
in one of the Burmese invasions, Siam's King
fatally wounded Burma's Crown Prince—in a
duel fought on elephant-back.

3.
Confucius Temple

The social philosopher's home
is a beacon of Chinese wisdom

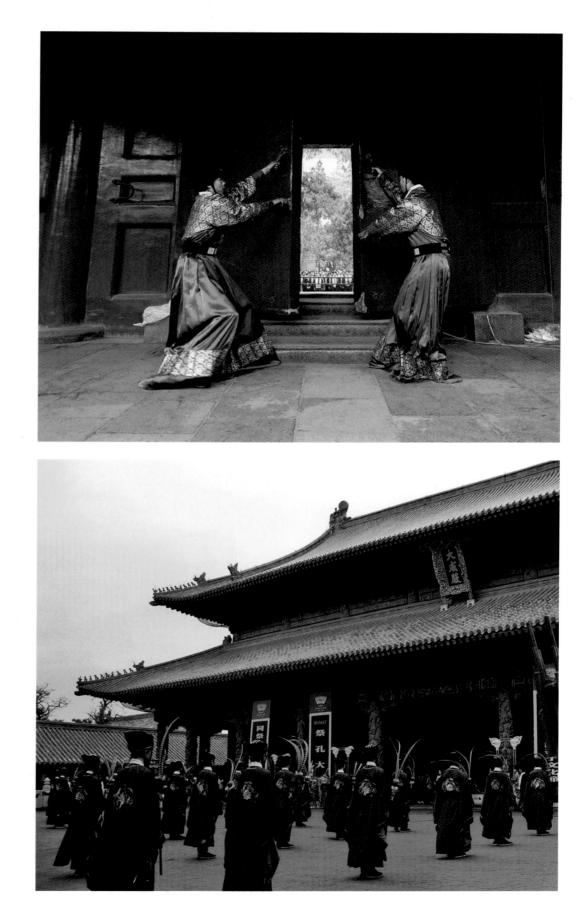

HE MADE NO CLAIMS TO BEING A RELIGIOUS
teacher, but the minor court official Kong
Zi, known in the West as Confucius, left an
indelible stamp on China; his teachings have
survived wars, dynasties and revolutions
unchanged, still points in China's turning
culture. Confucius is not worshipped in
China, but he is venerated, and legend holds
that within two years of his death, around 479
B.C., his home in Qufu, in today's Shandong
province, had been converted into a shrine.

The temple in which Confucius lived
survived for more than 11 centuries, we are
told, before it was cleared to make way for an
updated version in the early 7th century A.D.
The compound was significantly enhanced
many times in the centuries that followed, and
by the time admiring Chinese had finished
paying homage to Confucius, the pilgrimage
complex here was the second largest in China.
Containing some 460 rooms arranged around
a series of nine courtyards, it is exceeded in
size only by the Forbidden City in Beijing.

The teachings of Confucius stress contem-
plation; individual responsibility for ethical
behavior; the Golden Rule; and deep respect
for family, society and traditional folkways.
Confucianism's respect for the individual, the
family and the past made it the natural enemy
of the Chinese communist regime, and in 1966
Red Guards ransacked the Confucius Temple
and destroyed many of its treasures. Today
it has been restored—and while Beijing's
Tiananmen Square is still dominated by a
giant portrait of Mao Zedong, history's
pendulum seems to be swinging back toward
the nation's greatest helmsman, Confucius.

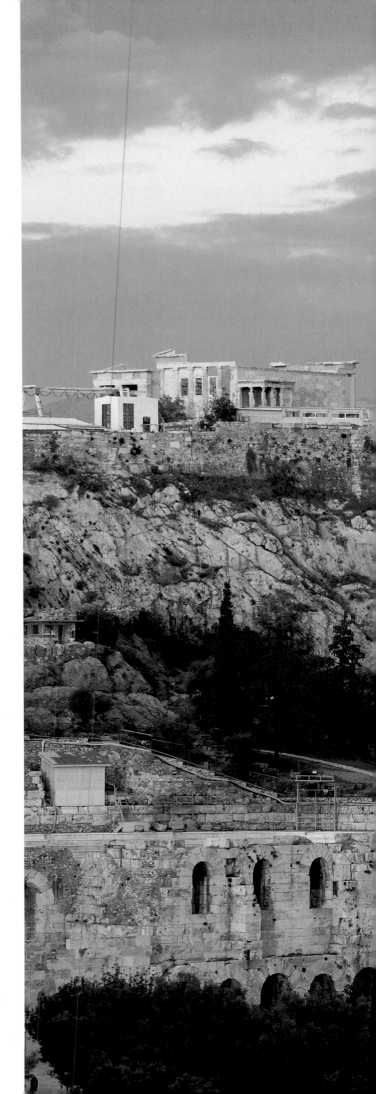

4.
The Acropolis

The great complex in Athens still issues a
challenge to succeeding cultures: Top this!

IT MAY NOT BE THE "CITY ON A HILL" THAT
Christ spoke of in his Sermon on the Mount,
but in Greek the word *acropolis* means "high
city." And this great complex, which rises
some 230 ft. (70 m) above the city of Athens
that sprawls around it, is lofty in ways that
can't be conveyed in altimeter readings: it
embodies the soaring spirit of the great
civilization that built it. As its builders hoped,
it has provided powerful uplift for the aspira-
tions of cultures that followed, from Rome to
Constantinople to London to Washington.

Surrounded by a high wall, the hilltop
complex served as a fortress and palace site
in Mycenaean Greece, circa 1300-1100 B.C.
In the centuries that followed, more buildings
were erected, but every building on the
Acropolis was destroyed when the Persians
conquered Athens in 480 B.C, including a
first, unfinished version of the Parthenon, the
great temple associated with the site.

The destruction proved beneficial, clearing
the site for the shining moment that followed.
Pericles, who presided over the Golden Age of
Athens, led the huge building project that cov-
ered the site with the great structures that still
dazzle us today: the Parthenon (boasting the
frieze of gods above); the Propylaea, a splendid
entryway; and a bevy of temples, including
the famed Erechtheum, whose balcony with
columns in the form of caryatids still stands.

The Parthenon and other buildings on the
site were repaired and used by admiring Ro-
mans and were converted to Greek Orthodox
churches by the rulers of Byzantium. But the
buildings were used for military purposes by
Ottoman Turks, and during a siege of Athens
by the Venetians in 1687, the Parthenon, then
being used as a gunpowder magazine, was hit
by a shell and exploded, doing major damage
to the structure. Yet even in its fallen state, the
Acropolis still speaks of higher things.

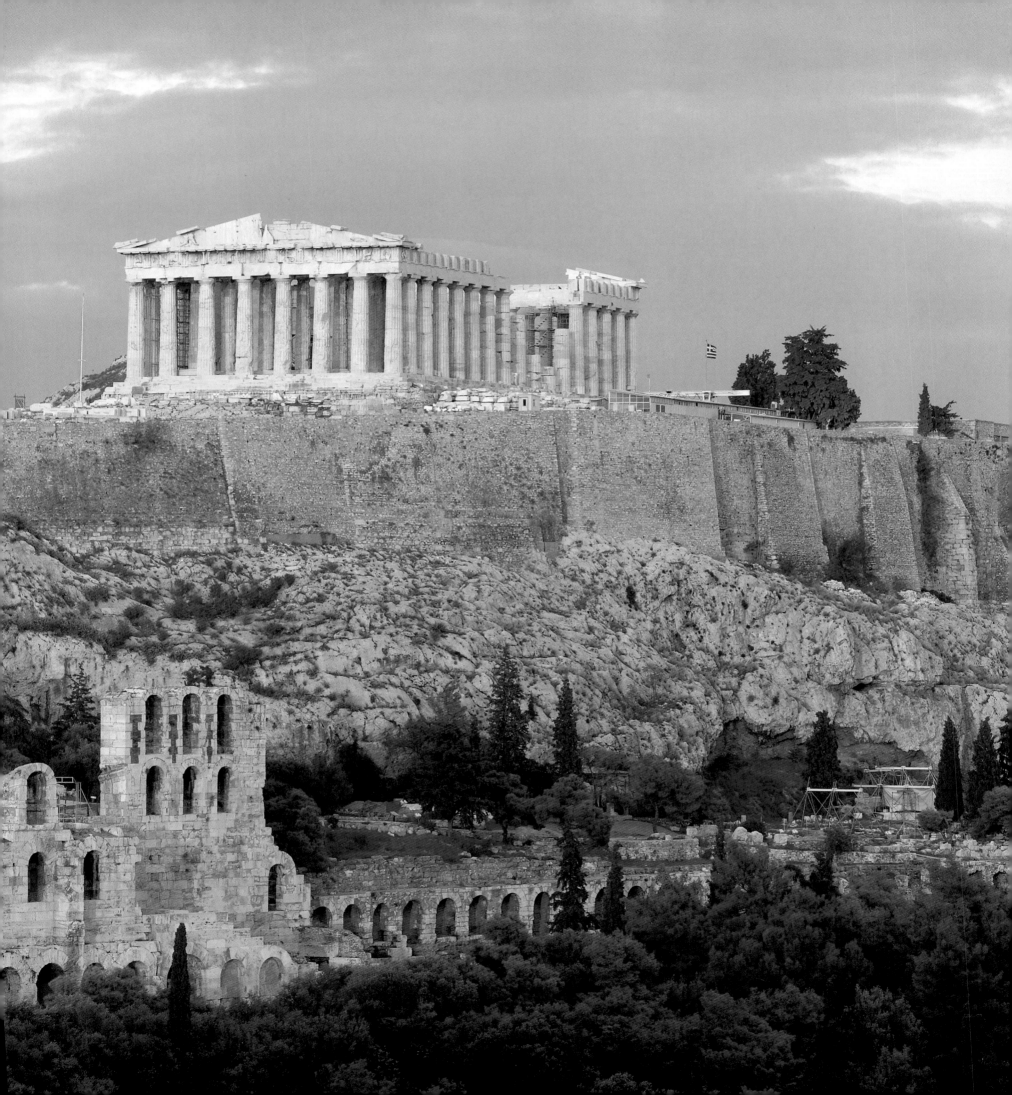

5.
Machu Picchu

Even sans virgins and priests,
the ancient Incan city is a dazzler

PERCHED ON A LOFTY PINNACLE IN THE
Peruvian Andes, with its terraced levels seeming
to spill the arts and knowledge of a mysterious
ancient culture into the valleys below, Machu
Picchu is the archetype of the lost cities sought
by Victorian explorers. This Incan settlement
was unknown to outsiders until Yale University
professor Hiram Bingham, guided by locals,
visited the site in 1911. As TIME's Andrea Dorf-
man reported in 2003, "[Bingham] was convinced
that the remote Peruvian outpost dotted with
temples was a sacred city … where virgins sought
sanctuary and priests worshipped the sun god."
The general public, understandably moved by the
ancient city's extreme beauty and exotic remote-
ness, bought into Bingham's theories.

Now a re-evaluation is in progress, according
to Dorfman. Machu Picchu, it turns out, may have
been nothing more than a summer retreat for the
Emperor Pachacuti and his royal court, sort of a
15th century Camp David. "It was just a country
palace," Yale anthropologist Richard Burger told
TIME. In 2010, Yale agreed to return thousands of
artifacts of Incan life that Bingham took back to
the U.S. When the first of them were returned,
on March 30, 2011, Peru's President, Alan García,
declared, "They are treasures, even though they
are not made of gold or precious stones, because
they represent the dignity and pride of Peru."

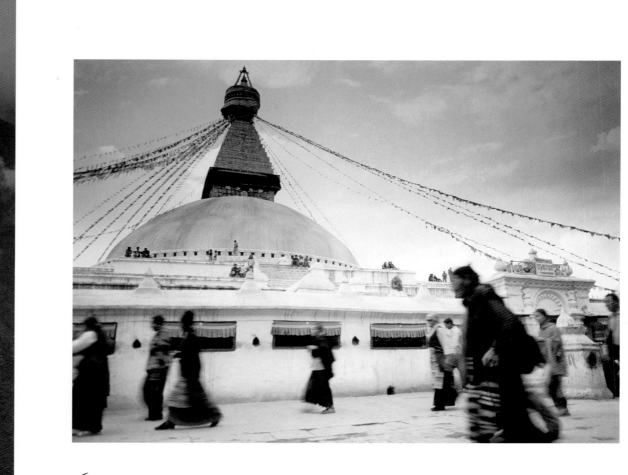

6.
Kathmandu Valley

This ancient trade route in the lower reaches of the Himalayas is the fountainhead of Nepalese culture

NEPAL'S PRIMARY, FERTILE VALLEY IS SO RICH in historic treasures that UNESCO named the entire area along the banks of the Bagmati River a World Heritage Site in 1979. It includes scores of ancient buildings, many of them mound-shaped stupas, shrines that contain sacred relics. Matters of the spirit are central to Nepalese culture, where Buddhists and Hindus have long lived in harmony. The Boudhanath Stupa, shown above, is one of the grandest shrines: located 7 miles (11 km) from the center of the city of Kathmandu, its circular dome towers over the landscape with long strings of prayer flags radiating from it, as it has since it was built in the 4th century A.D.

The Boudhanath Stupa lies on the old trade route between Tibet and Nepal. For long centuries, these small, land-locked Asian kingdoms on the southern ranges of the Himalayas were worlds unto themselves. But in recent years they have found themselves increasingly pressured by their neighbor to the east, China.

From 2001-08, a bitter civil war raged in Nepal between Maoist rebels and the government, leaving some 13,000 people dead. Finally, in 2008, King Gyanendra abdicated, and a coalition government led by the Maoists took over. "The mighty Himalayas may have once been a natural border between the Middle Kingdom and Nepal," TIME's Deepak Adhikari reported in 2011. "As China looks west, that's no longer true."

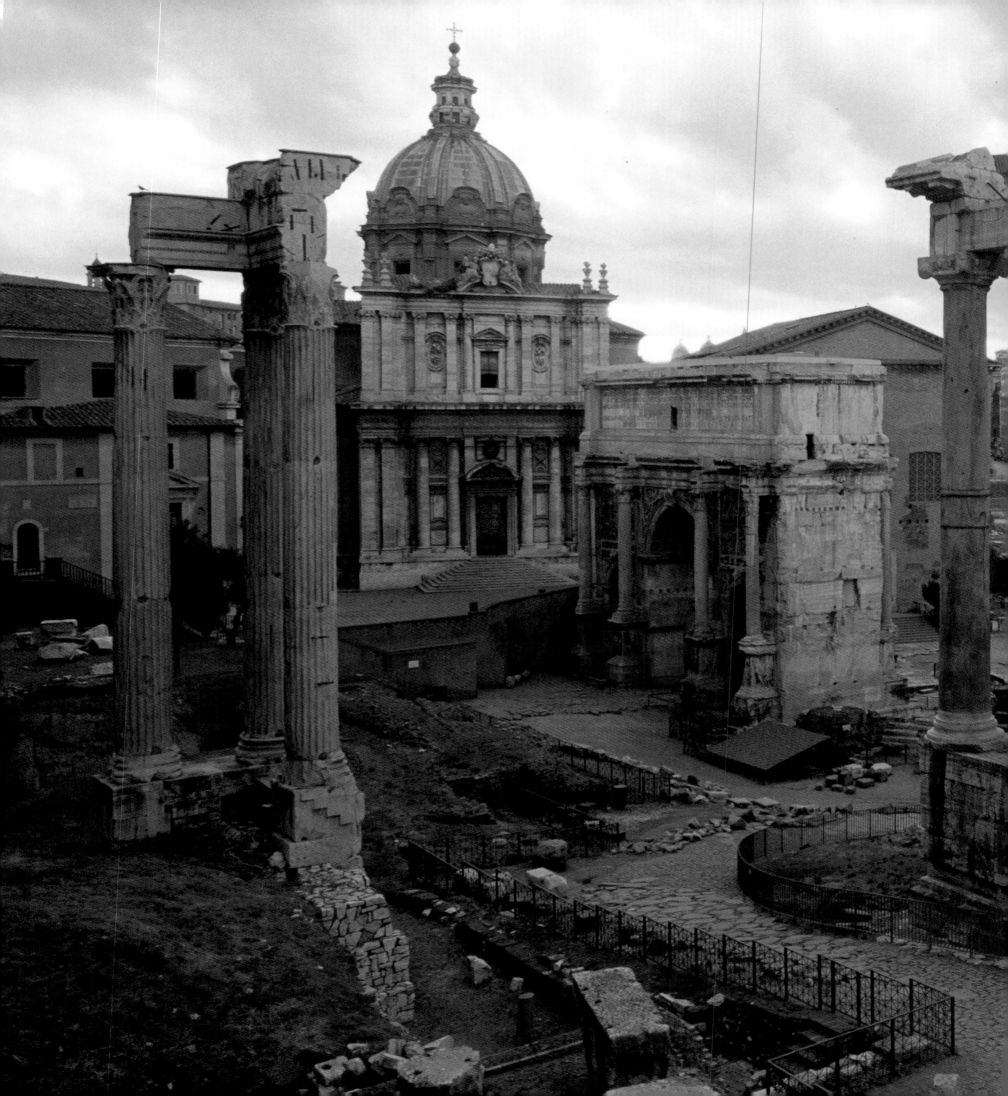

7.
Imperial Rome

The great ruins that endure remind us that Italy's great city was always intended to be eternal

SOME CULTURES ARE BORN GREAT, SOME CULTURES ACHIEVE GREATness—and some cultures grab greatness by the throat and shake it. Count the Romans among the last group: Was there ever a society so enamored of monuments and memorials, pillars and pediments, triumphal arches and fancy friezes? "I found Rome a city of brick and left it a city of marble," declared Augustus Caesar. He was stretching the facts a bit, but his boast raised the bar for every aspirant to imperial glory who followed, as magnificent bathhouses, temples, hippodromes and circuses arose, each bearing its sponsor's name.

But who can complain about the result? Rome is a city befitting the capital of a great empire. All roads led to it—because the Romans built them, with engineering skill so refined that many of them are still in use today. Like the ruins of the Forum shown above, the city is a chockablock profusion of splendor, rendered harmonious by the rigorous mathematics of Roman architects and builders. This historic Forum, of course, was eventually trumped by a larger, more up-to-date gathering place whose naming rights have yet to expire: Trajan's Forum.

Time and nature have conspired to make the city's ruins conform to modern notions of purity and clarity, yet the stark white columns and temples we so admire today, scholars assure us, were painted in gaudy hues of purple and gold when they were first erected. The Eternal City speaks to many aspects of human nature, but seldom in pianissimo.

8.
Easter Island

The stone figures created by
Rapa Nui sculptors still have
the power to move us. But what
power moved them long ago?

SWOOPING, SUBLIMELY MINIMAL AND
highly geometric, the great carved stone
heads, or Moai, of Easter Island in the
Pacific might have been created by the modern
Romanian sculptor Constantin Brancusi. But
if their slippery planes and distorted propor-
tions evoke 20th century art, these sculptures
are far older: scientists believe they were
created between A.D. 1200 and 1600. The
Moai at right are partially buried in the hill-
side; most of the figures, when fully excavated,
include squat bodies that are far out of propor-
tion to the exaggerated size of the heads.

The Moai were created by the Rapa Nui,
the Polynesian colonizers of this most easterly
of the Pacific Islands, possession of which is
claimed by Chile. They are believed to repre-
sent tribal ancestors, and most of them were
hewn from tuff, compressed volcanic ash. In
1979, scientists who had observed pieces of
white coral buried at the feet of the statues
realized that most of them originally had
eyeballs of coral in their deep-set eye sockets.
As of 2011, 887 Moai have been located, and
some of them are immense: the largest erect
figure is 33 ft. (10 m) high and weighs 82 tons.

The size of the Moai begs a question that
scientists still have not resolved: How were
they moved into position? Though today's
Easter Island is treeless, researchers have
concluded that the island was forested until
around A.D. 1200, suggesting that some
combination of log sledges, rollers or poles
was probably employed to place these hefty
monoliths in their eternal stations.

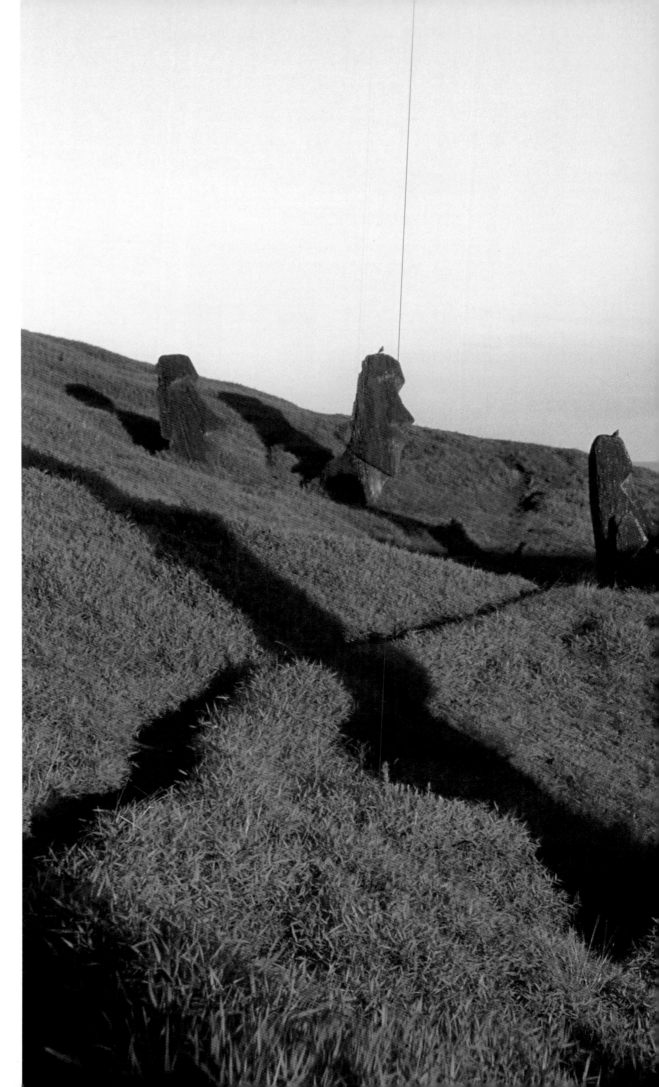

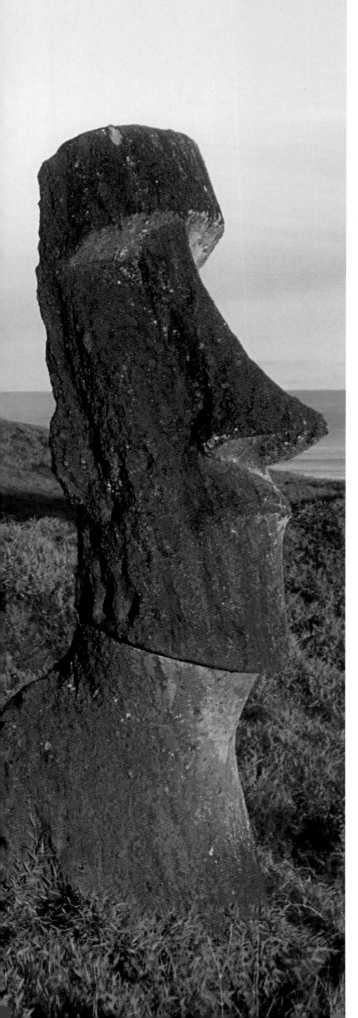

9.
Nazca Lines

These gigantic images, hewn
into the Peruvian desert,
have a story to tell—someday

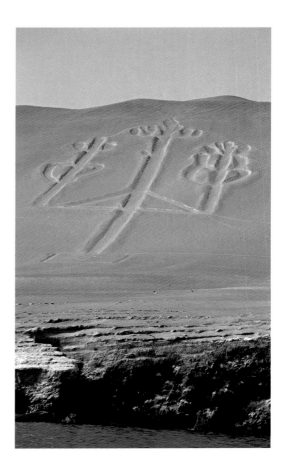

PRESERVED OVER THE COURSE OF CENTURIES by the arid climate of the high Peruvian desert some 248 miles (400 km) south of Lima, the Nazca Lines remain one of the great unsolved mysteries of science. These huge figures were not built: they were "carved" into the surface of the desert by workers who removed red-toned pebbles that covered whiter ground beneath them. Scientists believe they were created between A.D. 400 and 650 by members of the now extinct Nazca culture. The figures show men, monkeys, hummingbirds, lizards and other beasts. They are fanciful and intriguing, but it is their size that distinguishes them: they are shallow, only 4 to 12 in. (10 to 30 cm) deep, but they are sprawling. The largest of them are as much as 660 ft. (200 m) across—which means that they cannot be perceived in their entirety from ground level. Indeed, they were unknown to modern science until they were seen from airplanes in the first decades of the 20th century.

And that brings us to the mystery of these geoglyphs, or earth writings, as scientists call them: If they are too large to have been fully appreciated by those who built them, for whose eyes were they intended? Were the figures messages to gods who might observe them from above? Do they chart the position of stars, much like the constellations of the ancient zodiac? Did the Nazca, as one scientist has argued, possess the means to build hot-air balloons, which would have provided a bird's-eye view during their construction? All these explanations, and more, have been promulgated, and whoever solves the mystery of the lines will earn a place in scientific history.

10.
Ronda

For aficionados of the bullfight, this is the source: the first bullring in Spain

THE FRENCH LITERARY THEORIST AND SOCIAL CRITIC ROLAND Barthes described bullfighting, along with the outdoor wrestling of Greek Olympians, as "great solar spectacles" notable for "the drenching and vertical quality of the flood of light." In both of these open-air events, he said, "a light without shadow generates an emotion without reserve." Bullfighting is one of the unique, enduring pillars of Hispanic culture, and for its followers, no bullring has quite the aura of this smallish arena in the historic city of Ronda, which is perched upon a picturesque canyon in Spain's southern province of Málaga.

The Plaza de Toros de Ronda was completed in 1785, and its two circular galleries can hold 1,250 spectators. Two multigenerational families are associated with it: the Romero and Ordóñez clans. The greatest matador of the 18th century, Pedro Romero, boasted that he had slain 5,600 bulls in the course of his career, but he is more revered for being the first bullfighter to approach his labors as an art form, in addition to being a proof of bravery. Outside the bullring stands a statue of Cayetano Ordóñez, one of the great 20th century masters, who was the model for the character of Pedro Romero in Ernest Hemingway's *The Sun Also Rises*. "Bullfighting," said Hemingway, "is the only art in which the artist is in danger of death and in which the degree of brilliance in the performance is left to the fighter's honor."

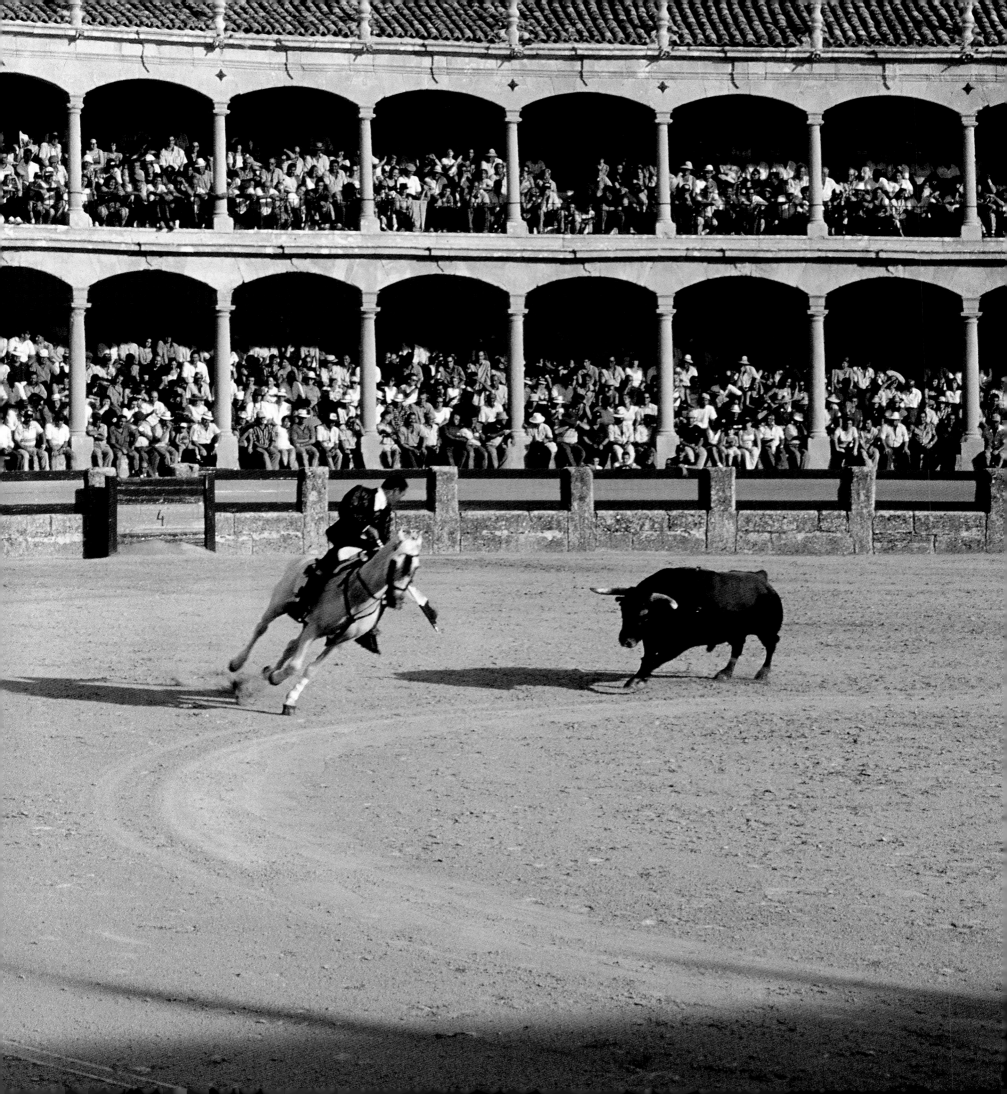

11.
Roskilde

The Viking Ship Museum pays
homage to a seafaring people

EVER SINCE THEY MADE THEIR DRAMATIC
debut on Europe's stage by invading and
pillaging Britain's sacred island of Lindisfarne
in A.D. 793, Scandinavia's Vikings have been
portrayed as little more than Hell's Angels
with oars. But this great culture was far more
civilized—and proved far more of a civilizing
influence—than many people suspect. Yes, the
Vikings were raiders, but they were also trad-
ers whose economic network stretched from
today's Iraq to the Canadian Arctic. They
were democrats who founded the world's
oldest surviving parliament. They were master
metalworkers who fashioned exquisite jewelry
from silver, gold and bronze. And in their
spare time, they discovered America.

The Vikings' success was based on their
mastery of shipbuilding, and the best place to
admire their skills is the Viking Ship Museum
in Roskilde, Denmark, where the remains of
five vessels that were deliberately sunk to
protect the town's harbor around A.D. 1070
were raised and restored beginning in
1962. The modern reproduction of a Viking
ship shown at right was modeled on those
raised at Roskilde.

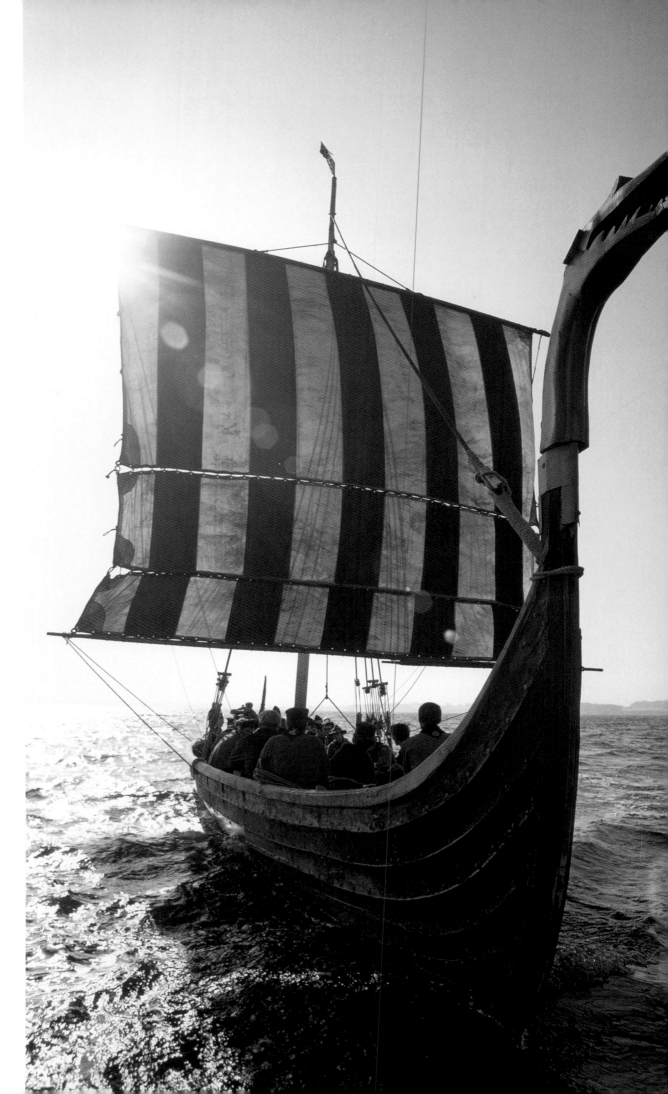

12.
Historic Damascus

Syria's great crossroads city has seen empires come and go—and strives to preserve their heritage

GREAT CITIES ARE PALIMPSESTS, WHERE THE past is constantly being erased to make way for the future. That's an essential process, of course, but it comes at a high price, as it can erode humanity's cultural heritage. To prevent the loss of enduring hallmarks of civilization, the United Nations Educational, Scientific and Cultural Organization, UNESCO, launched the World Heritage Site program in 1972. The program set out to preserve and protect great cultural treasures and was later expanded to include endangered natural sites.

Damascus, Syria's capital and second largest city, is precisely the sort of living antique that UNESCO seeks to preserve; its ancient Old City was named a World Heritage Site in 1979. Damascus is one of the oldest continuously inhabited cities in the world; carbon dating studies on artifacts found there date to the 7th millennium B.C. Conquered by Alexander the Great and the Roman general Pompey, the city later became Byzantium's greatest holding in the Middle East, until it fell to a Muslim army in A.D. 635.

Damascus flowered as the capital of Islam's Umayyad Caliphate. The Umayyad Mosque, completed in A.D. 715, still stands, as do the walls and seven gateways that surrounded the Old City. The Chapel of St. Paul, a modern structure, includes portions of the old city gate through which Christianity's great Apostle made a celebrated escape, and reminds us that this city is so ancient that even Islam, dating to the 7th century A.D., is a newcomer.

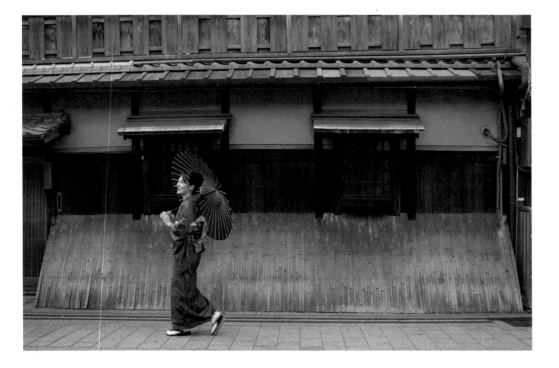

13.
Historic Kyoto

Japan's ancient capital is home to the nation's most characteristic—and artfully curated—cultural treasures

ANYONE WHO HAS VISITED JAPAN CAN TELL you: if you want to see the nation's future, plunge yourself directly into the teeming, neon-lit cacophony of downtown Tokyo. But if you want to visit the past and savor the older, quieter, deeper strains of Japanese culture, hop aboard the bullet train for a fast trip to Kyoto, where you can finally slow down and enjoy the pleasures of a city that served for more than 1,000 years as the nation's capital. Here a visitor will find the stage-managed serenity, the peaceful gardens and pavilions, the quiet, carefully choreographed rituals that are the grace notes of Japanese culture.

But don't expect to see all that Kyoto has to offer on a single visit: there are more than 1,500 temples and 400 shrines to be seen, including no fewer than 17 UNESCO World Heritage sites. There is Rengeo-in, a venerable temple whose main hall, Sanjusangendo, is one-third longer than a football field and

holds 1,001 golden statues of the Buddhist god Kannon. The original hall burned down in 1249, but the Japanese revere their nation's past, and an exact replica was completed in 1266. There is Ryoan-ji, the most celebrated of the dry rock gardens that are associated with Zen meditation: it has changed little since it was first laid out in the late 15th century.

Rokuon-ji is a beautiful complex of villas that served as a shogun's palace; its main villa was converted into a Zen temple in 1420. It is the site of the graceful, three-story Golden Pavilion, Kinkku-ji, whose walls are covered with gold leaf. This building, the only relic of the original compound, survived World War II intact, only to go up in flames in 1950 in an accidental fire started by a young monk. Like Sanjusangendo some seven centuries earlier, it was rebuilt to the exact specifications of the original within five years. In Kyoto, it seems, even time can be choreographed.

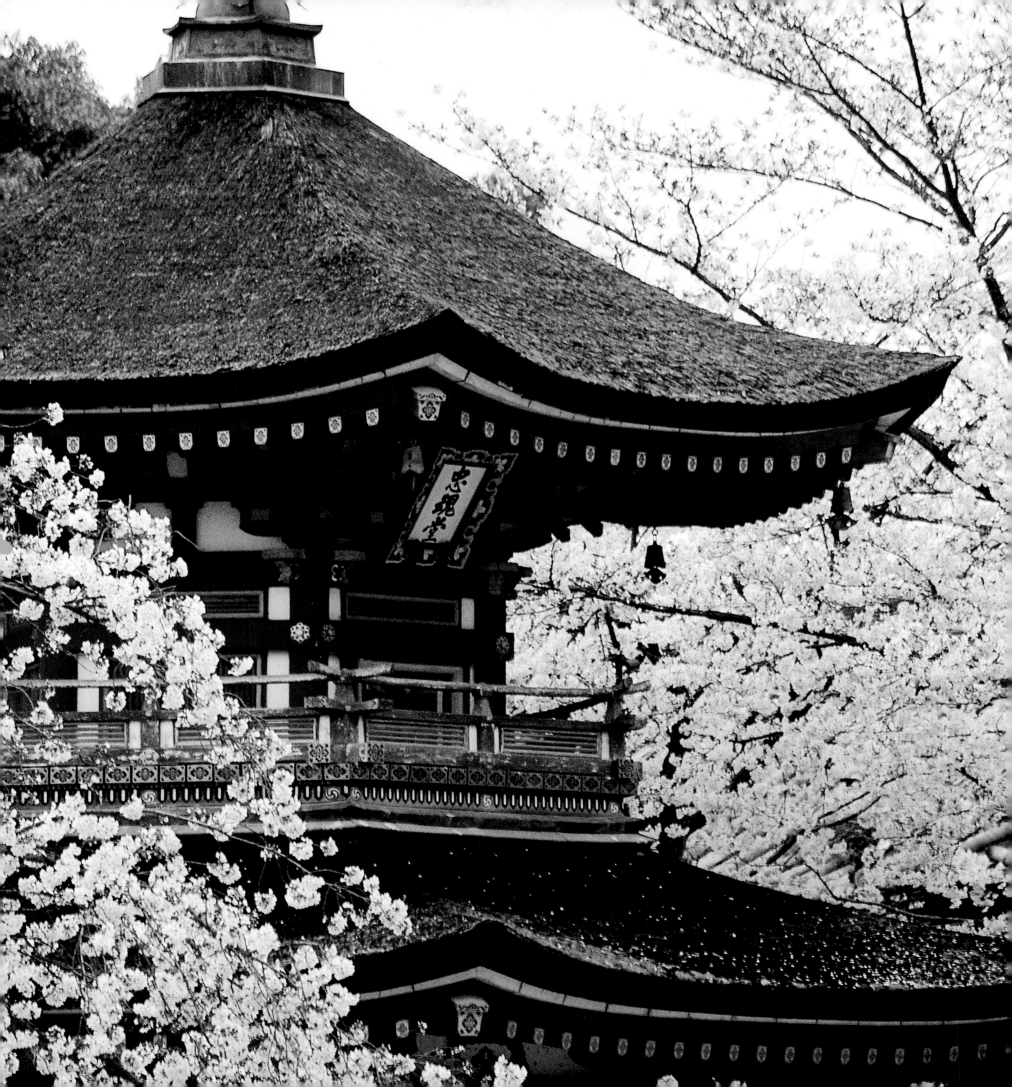

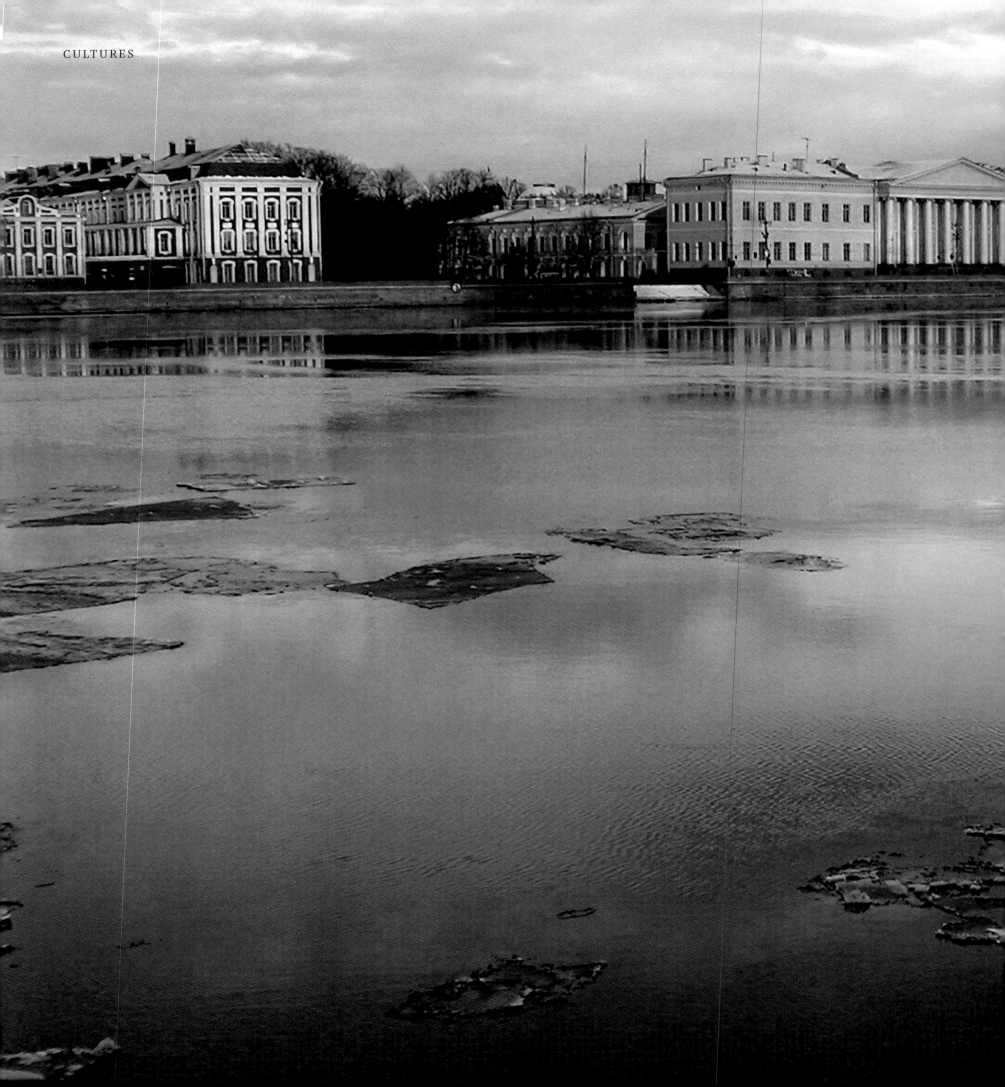

14.
St. Petersburg

An expression of one man's vision, Russia's
bespoke former capital is Peter's burg again

ANTECEDENT OF WASHINGTON AND BRASILIA, ST. PETERBURG IS ONE
of the foremost examples of a great nation's capital city created from
scratch. Like the capitals of the U.S. and Brazil, it was designed to
impress, to embody national ideals and to stand as a monument to the
ambitions of its founder. It is the memorial, in stone and brick, of the
vision and energy of a single man, Czar Peter I (the Great). Born in
1672, Peter was a larger-than-life figure who also happened to be large
in life: he stood 6 ft. 8 in. (200 cm) tall. And Peter nursed an outsized
vision for his vast Eurasian nation, which he believed was inward-look-
ing, hidebound and stagnant: he aspired to turn its gaze westward and
join the wealthy nations of western Europe that embraced progress.

CHAPTER TWO
SACRED SPACES

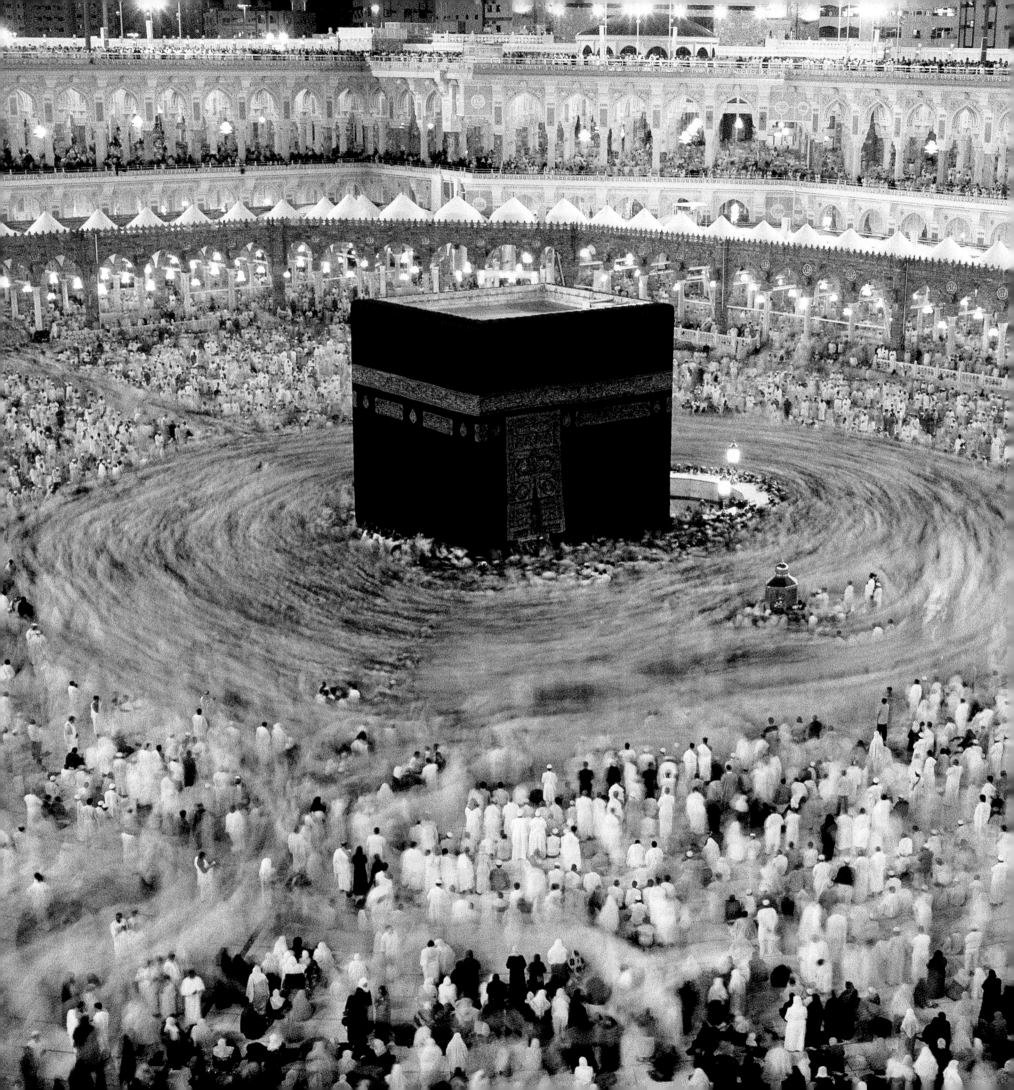

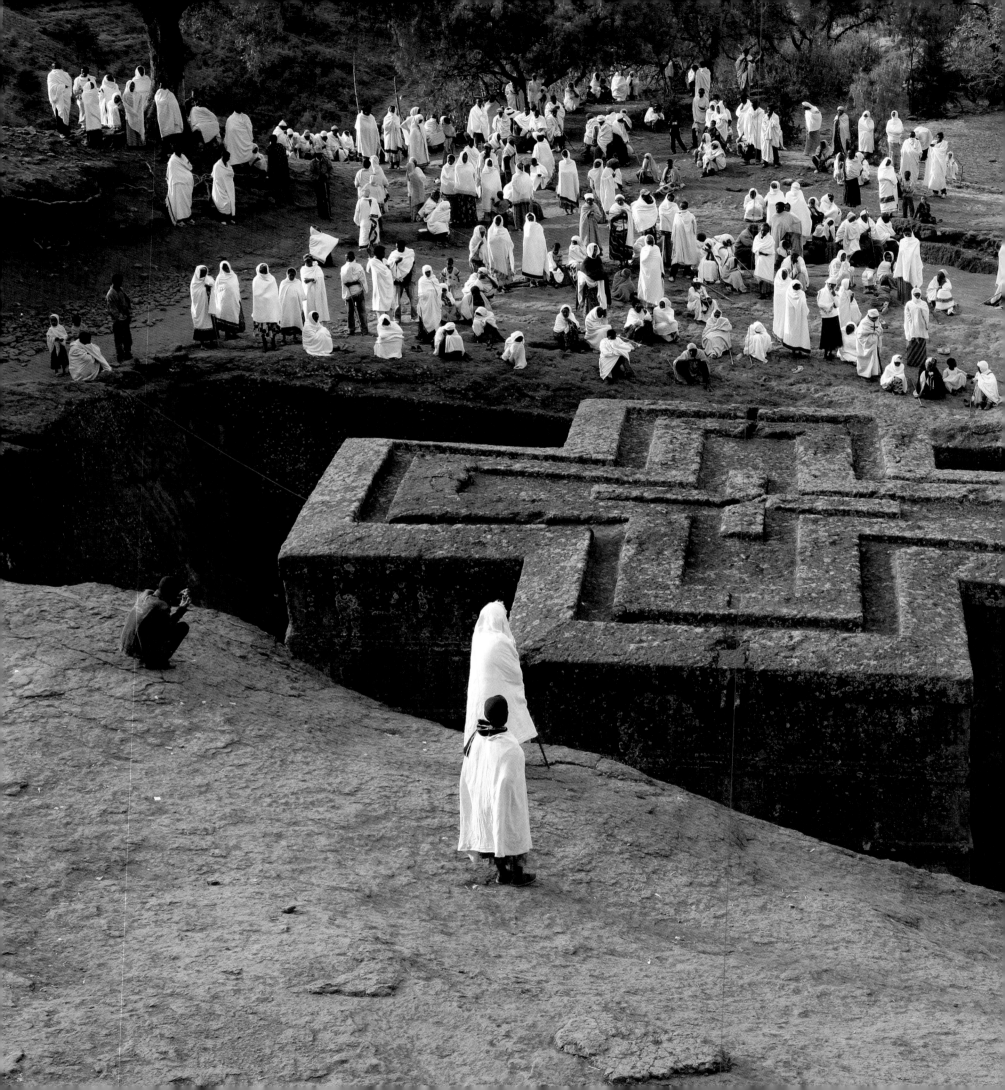

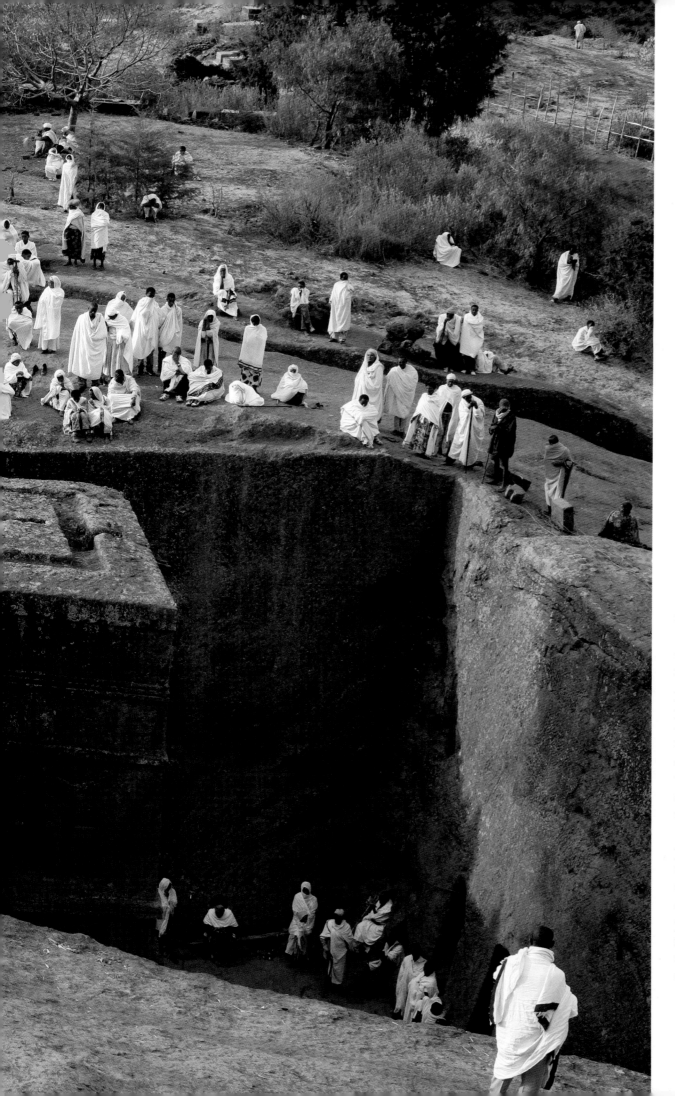

15.
Lalibela

Here an Ethiopian King carved a name for himself as one of religion's greatest builders

THE 11 CHRISTIAN CHURCHES BUILT BY Ethiopia's King Lalibela in the early 13th century are among the world's most unusual sacred sites: seven of them are built aboveground in the mouths of caves, whereas four them, including the Church of St. George, at left, are nestled into the ground. These four structures were not so much built as hewn, created by removing volcanic rock to make spaces for worship. For some viewers, they may recall the sculptures of Michelangelo, who said he sought to reveal forms he saw hidden within marble. Seen from above, as in the view at left, the church is level with the ground; in fact, it stands almost 100 ft. (30 m) tall, while each of its transepts is 82 ft. (25 m) long.

The survival of these churches—like the survival of Christianity itself in Ethiopia—is the result of complex factors. Ethiopia, or Abyssinia, as it was known for much of history, lies on highlands in East Africa that have helped the nation resist invading armies, including those of the Muslims who swept across northern Africa in the centuries after the Prophet Muhammad's death, while the dry, temperate climate of the region has kept the churches from deteriorating.

Six of every 10 Ethiopians, some 46 million people, are Christians. The vast majority of them are adherents of the Orthodox faith. Christianity came to Ethiopia in the 4th century after Christ, although its specific propagators are not known. Because of the nation's relative isolation from historical trends, the forms and practices of ancient Christianity are still alive in Ethiopia today.

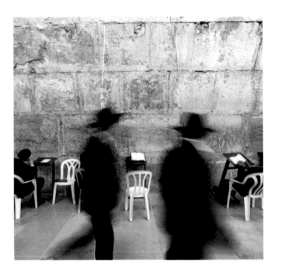

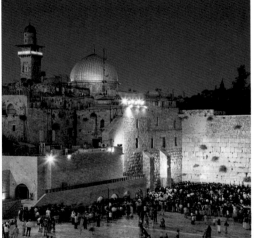

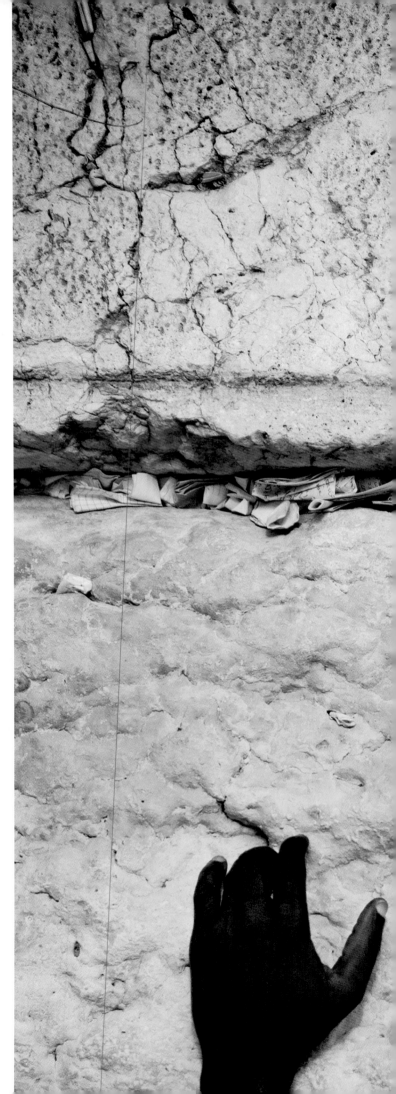

16.
Temple Mount

One of the planet's most hallowed sites,
it is sacred to three great religions

JERUSALEM'S TEMPLE MOUNT IS SANCTIFIED
by three faiths and is a continuing flash point
for political strife. It is also a time machine,
one of those rare places on the planet where
one can reach out and touch the past. Tens of
thousands of pilgrims do so each year, plac-
ing their missives to God between the ancient
stones of the Western Wall, right, a remnant
of Judaism's Second Temple, which was
destroyed by Roman legions in A.D. 70. It had
replaced the First Temple, built by King Solo-
mon, destroyed by Babylonians in 587 B.C.

The site is deeply sacred to Muslims, who
refer to it as the Noble Sanctuary. Like the
Jews, Muslims honor King Solomon, whom
they call Sulayman, as a prophet. The golden-
capped Dome of the Rock, one of the three
holiest sites in Islam, crowns the Mount; it
was begun around 687 A.D. Nearby is al-Aqsa
Mosque, where the Prophet Muhammad is
believed to have visited Jerusalem during

his Night Journey and from which he later
ascended to heaven. Both Jews and Christians
believe Temple Mount is the location where
the patriarch Abraham prepared to sacrifice
his son Isaac at the Lord's command.

After the Romans destroyed the Second
Temple, they erected a temple devoted to
Jupiter on this site; it, in turn, was destroyed
by the Roman Emperor Constantine, a convert
to Christianity. Always a pawn of empire,
Temple Mount fell to Muslim warriors in A.D.
638, six years after Muhammad's death. In
the divisive First Crusade, it was seized
by Christian crusaders in 1099 A.D., then
recaptured by Islam's great warrior Saladin
in A.D. 1187. Today, sovereignty over the site
is claimed by both Israelis and Palestinians.
This time machine is also a mirror, it seems:
soaring with divine aspiration yet stimulating
the thirst for power and control, it reflects all
the contradictory urges of the human heart.

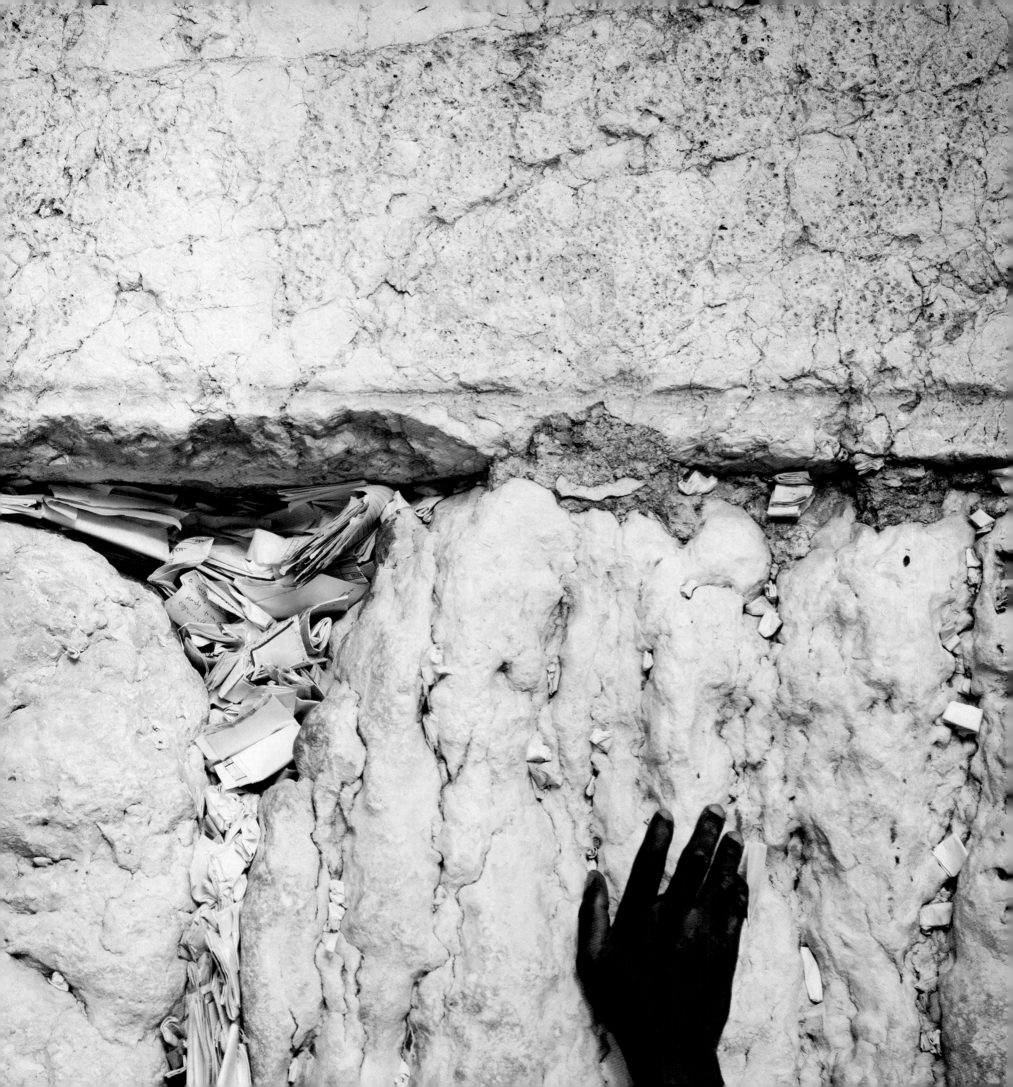

17.
Mecca

The eponym of pilgrimage sites remains the center of the world's largest annual sacred journey

THE CITY OF MECCA IN SAUDI ARABIA HAS always been the spiritual center of the Islamic faith: the world's 1.3 billion Muslims orient themselves to the site during prayers. In the final months of the year, Islam's holiest city becomes even more vital, as an estimated 2.5 million pilgrims make their once-in-a-lifetime journey to the site. This pilgrimage, the Hajj, is one of the five pillars of Islam by which every practicing Muslim must abide. It takes place annually between the eighth and 12th days of Dhu-al-Hijjah, the final month of the lunar Islamic calendar.

The Hajj consists of a five-day excursion to Mecca and three nearby holy sites. The ultimate rite of passage during the Hajj is the counter-clockwise circling, seven times, of the Kaaba, an immense black cube located in the center of the Masjid al-Haram mosque in Mecca. It marks the spot where Ibrahim (Abraham) built a shrine to mark a spring created by the Angel Gabriel to nourish his son Ishmael. In A.D. 630, the Prophet Muhammad led a group of Muslims to it in the first official Hajj, destroying the idols placed within by polytheistic worshipers and rededicating the shrine in the name of Allah.

Saudi Arabia's government has spent millions to expand and improve the holy site, yet even so, overcrowding has led to the deaths of thousands over the years, most notably a 1990 incident in which 1,426 people were crushed inside a tunnel passageway.

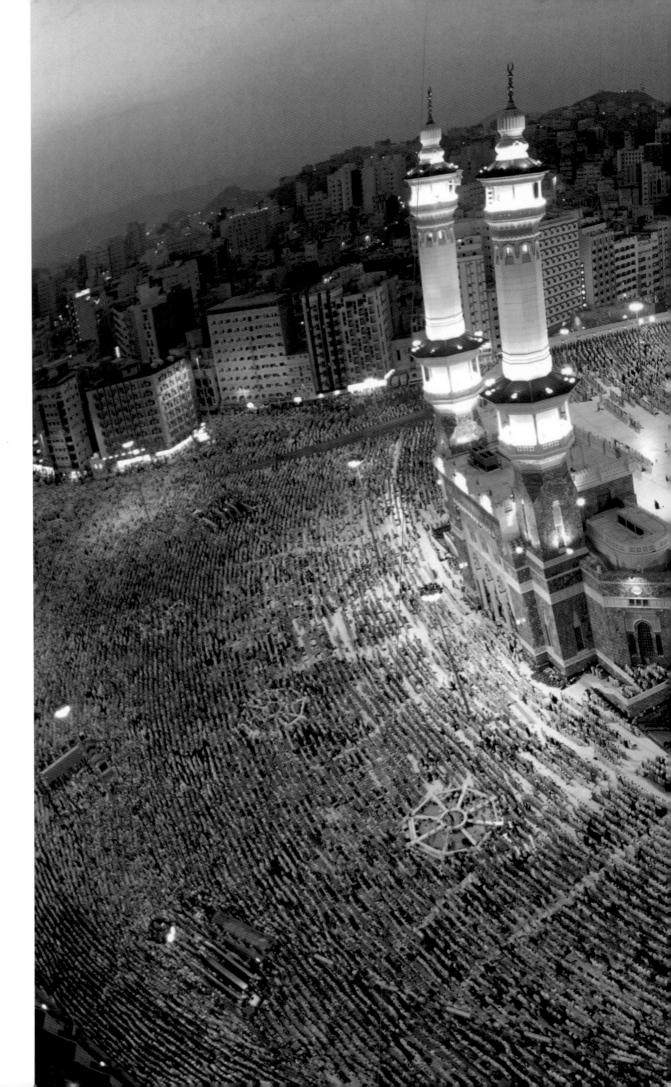

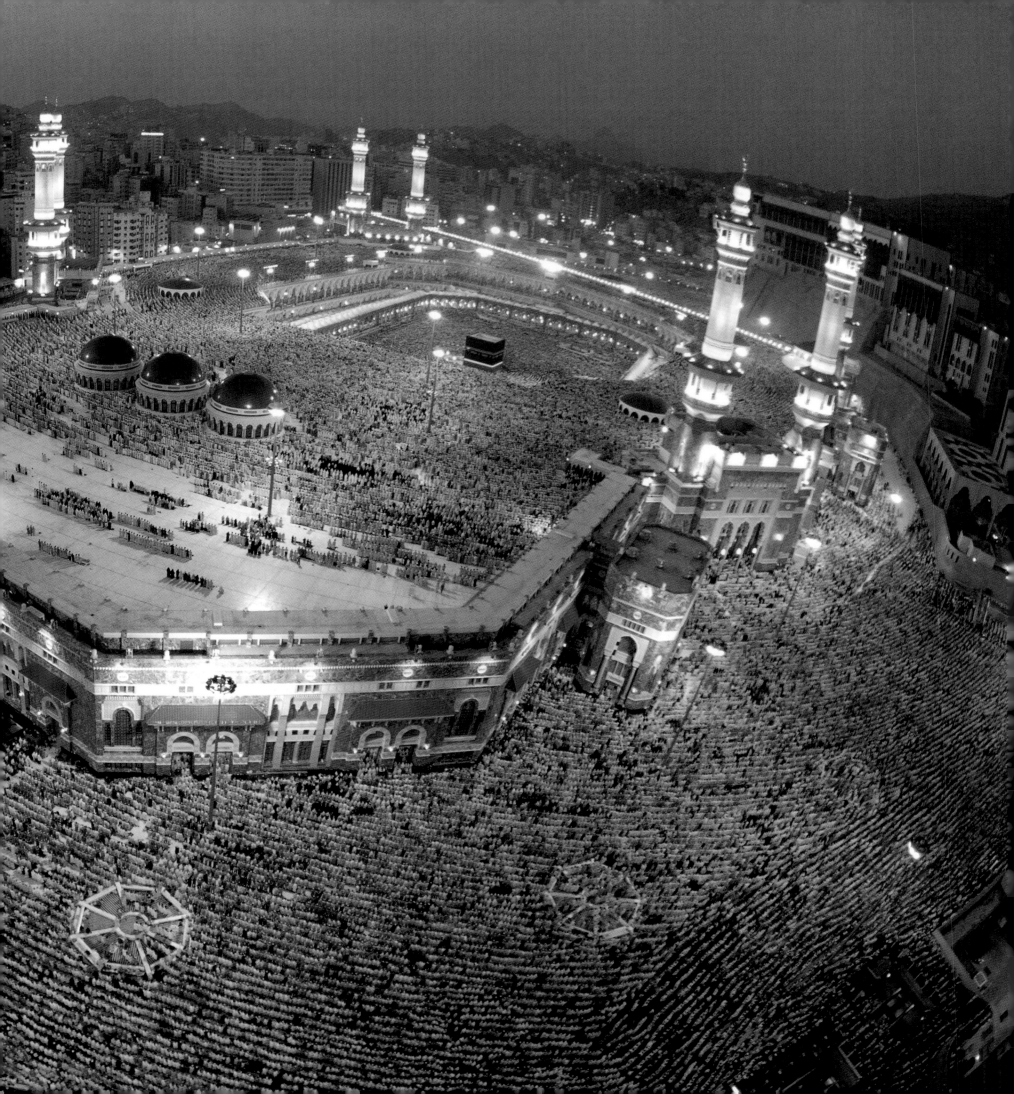

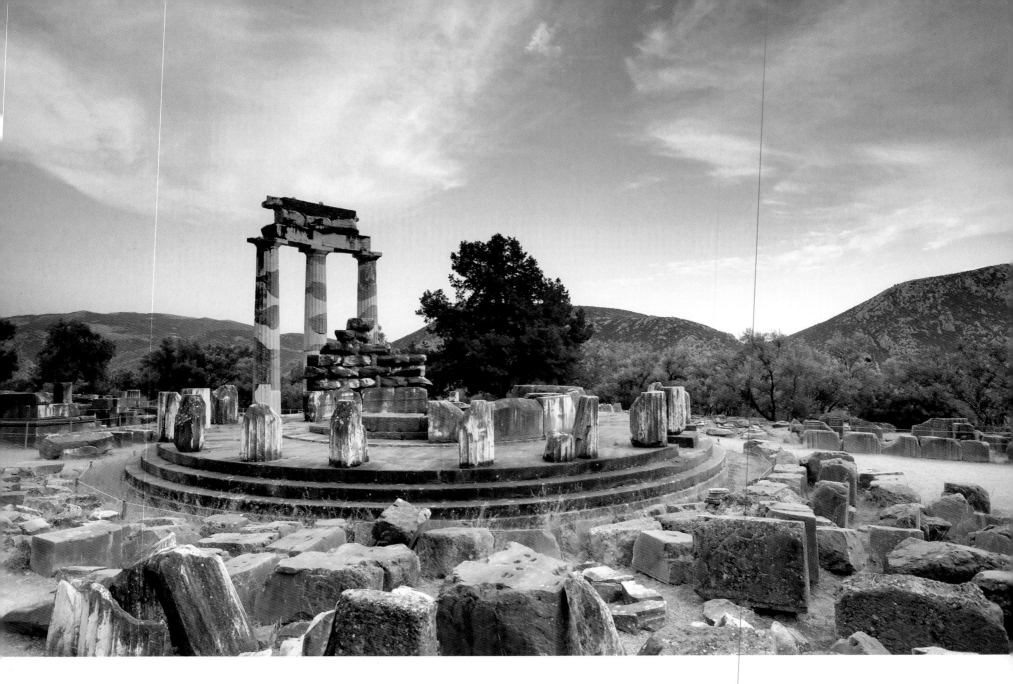

18.
Delphi

This sacred city, devoted to Apollo and built on the side of a mountain, was a center of classical Greek worship

RELIGIONS ARE AMONG THE GREAT UNIFYING threads of human civilization: Buddhists today share the same spiritual goals as those who first followed Siddhartha Gautama some 25 centuries ago, while Christianity has retained its power and appeal for 20 centuries and Islam for 14. But the pagan, animistic religions of classical Greece and Rome have fallen by the wayside, and the gods honored in those cultures endure today stripped of their ancient power and majesty, charming myths rather than fearsome divinities.

Yet there was an age when observant Greeks traveled into the mountains to the holy city of Delphi to pay homage to the gods and seek the counsel of the Oracle, who dwelled there in a cave, a young virgin who was be-

lieved to be able to predict future events. To the ancient Greeks the city of Delphi was the *omphalos:* the center, or navel, of the world. The site was sacred to Apollo, the god of light, reason and the sun, and many of Greece's city-states erected temples there, where their citizens could pay homage to him.

Thus, to walk through the ruins of Delphi today is to take a tour through the landscape of classical Greece, passing temples built by Athens, Sparta, Corinth and other cities. Not all the city's temples honored Apollo: the circular Tholos, above, which originally had 20 Doric columns, was dedicated to the goddess Athena; it is titled the Athena Pronaia (Athena Before the Temple) because it stands near the entrance to the sacred precincts.

19.
Historic Cairo

Within today's bustling,
crowded city is an old quarter
redolent of Islam's early days

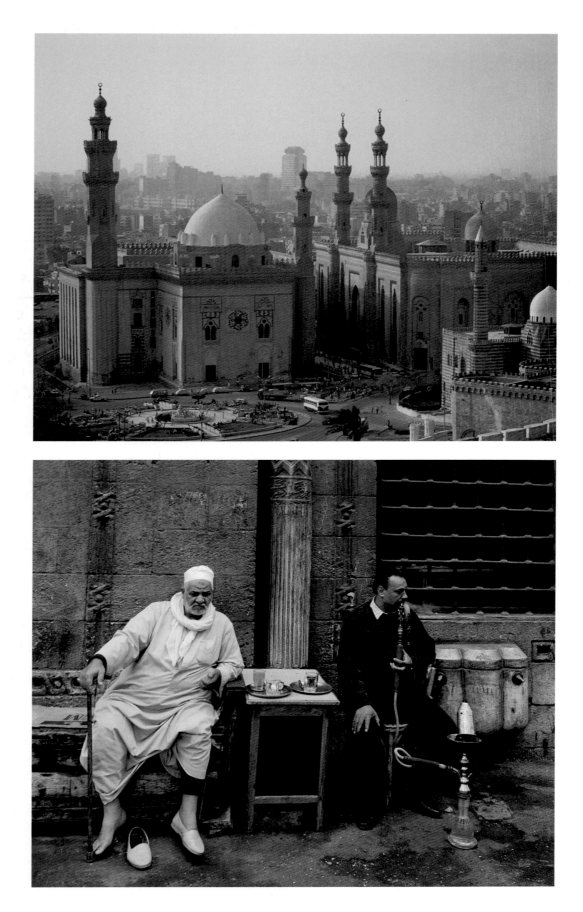

TODAY'S CAIRO IS ONE OF THE WORLD'S MOST bustling metropolises, a city so up-to-date that the peaceful revolution in early 2011 that forced longtime leader Hosni Mubarak to resign his post as President was driven by Facebook, Twitter and other digital media. Yet like Rome, Kyoto or Quebec City, Egypt's capital has retained many of its most historic buildings, and a walking tour through the city's center can become an exercise in time-shifting, as air-conditioned tour buses jostle for space before mosques and madrasahs that date back to the 10th century A.D. In designating ancient Cairo a World Heritage Site, UNESCO noted that the city's "historic center … includes no less than 600 classified monuments dating from the 7th to 20th centuries."

Islam came to Egypt in 640 A.D., only eight years after the death of the Prophet Muhammad, when the nation was conquered by the armies of the Caliph Omar. The new Muslim rulers initially erected their own capital outside Cairo, and it was not until the 10th century A.D. that they began to rule Egypt from Cairo, the ancient capital. The two buildings in the picture at top right are the Sultan Hassan Mosque, at left, and al-Rifa'i Mosque. The former was built circa 1363 A.D. and was noted in its time for its enormous size and advanced engineering, as well as for its four Sunni madrasahs. It was intended to have four minarets, but when one of them collapsed while under construction—and the eponymous Sultan died only 33 days later—two were left unbuilt. Al-Rifa'i Mosque is a much more recent building, completed in 1911 and designed to complement its historic neighbor.

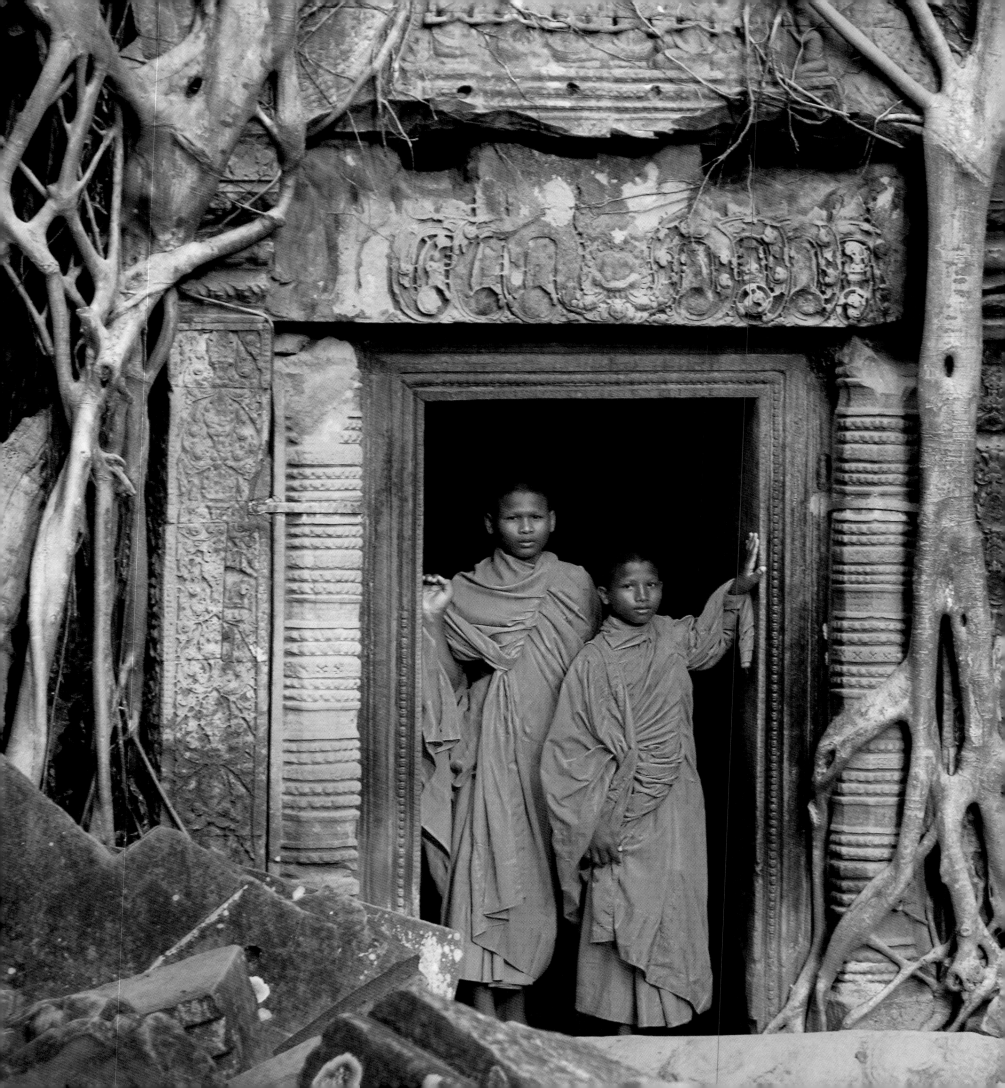

20.
Angkor Wat
Cambodia's treasure, once a secret, is now all too popular

JEWEL OF A FALLEN REALM, THE KHMER Empire that ruled Cambodia and much of Southeast Asia from the 9th to 15th centuries A.D., the temple complex of Angkor Wat is one of the world's largest religious precincts, covering some 203 acres of land deep in the jungle. A large moat, more than 60 ft. (182 m) wide, guards the complex from intruders. Yet Cambodia was so removed from the world's gaze that the complex was not known to most Europeans and Americans until the mid-19th century, when French traveler Henri Mouhot visited the site and published a report that called it "grander than anything left us by Greece or Rome."

The complex follows both of the classical styles of Khmer religious architecture. Soaring upward, its four towers gather around a taller central one, intended to represent fabled Mount Meru, sacred to Hindus, Buddhists and Jains. Sprawling outward, its long galleries, richly embellished with bas-relief rock carvings, reflect the "gallery temple" style also popular in South Indian religious buildings. But if its exterior has remained unchanged over the centuries, the gods who are honored here have changed: when built, the complex was dedicated to the Hindu god Vishnu, but within 150 years it became a center of Buddhist worship. Today this foremost repository of Cambodian history faces new threats, as throngs of awed visitors threaten to overwhelm its inadequate water supply and tourist infrastructure.

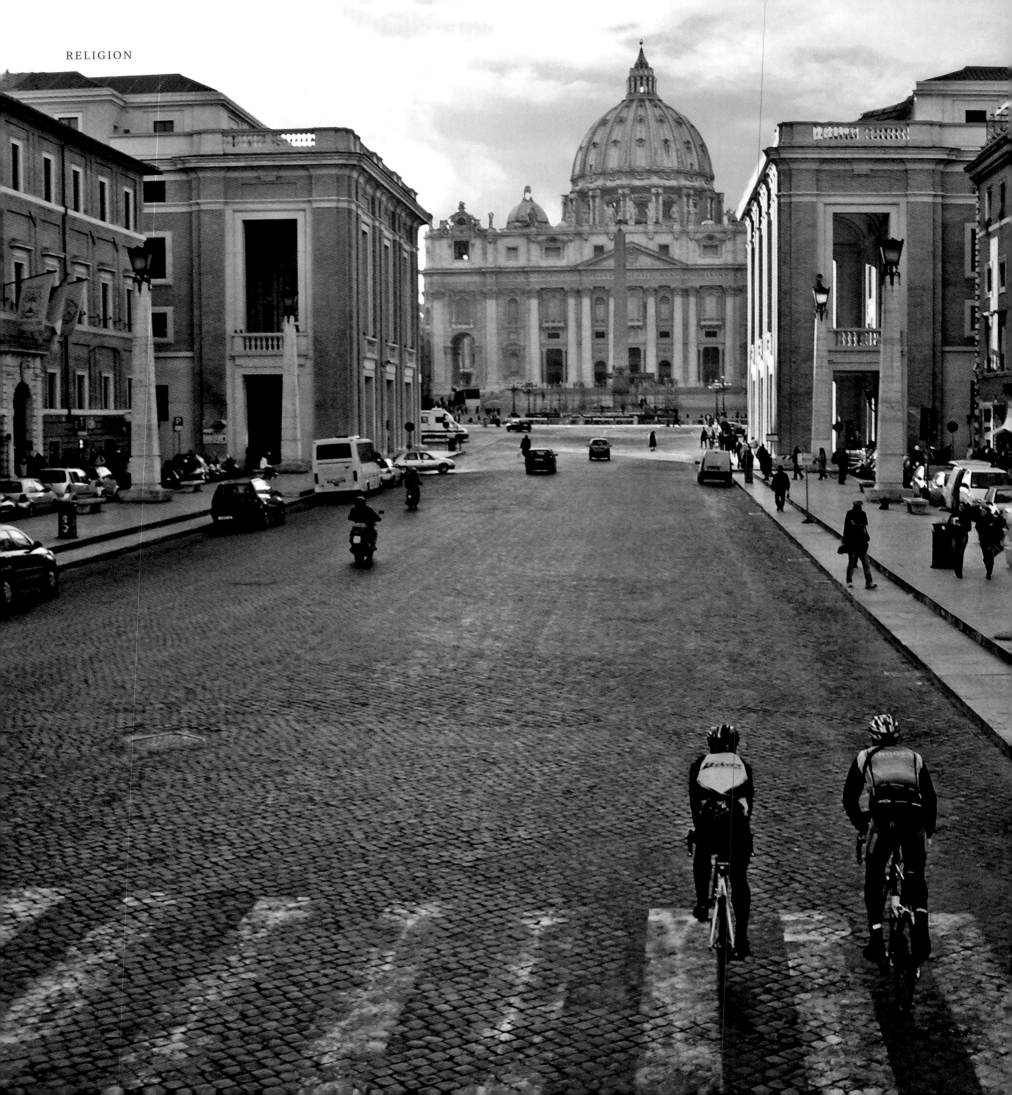

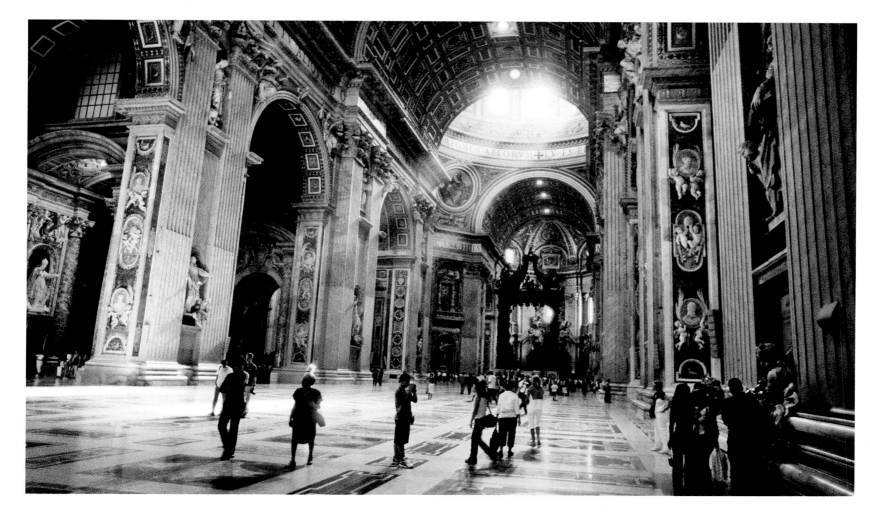

21.
Vatican City

Tucked into modern Rome is the spiritual home of some 1.2 billion Roman Catholics and a magnificent repository of Renaissance art

HIDDEN WITHIN THE BUSTLING STREETS OF modern-day Rome is one of the world's smallest sovereign states, Vatican City, the spiritual focus of the world's largest religion and the physical home of its leader, the Pope, and its central church, the vast St. Peter's Basilica. Indeed, Roman Catholics regard Christ's foremost disciple, St. Peter, as the first Pope, and his remains are said to reside beneath the main altar of the Basilica. This is one of the world's greatest pilgrimage sites, both for believers eager to pray at their church's primary sanctuary and for tourists hoping to see its magnificent artworks, which include Michelangelo's famed murals on the ceiling and walls of the Sistine Chapel, as well as a host of sculptures and paintings by Raphael, Bernini and many more Italian masters. Scholars also flock here to examine the unparalleled collection of ancient manuscripts, documents and artworks collected in the Vatican Library.

Ironically enough, most of the buildings that give Vatican City its special power date to the Renaissance, the era when a new focus on humanism emerged in Europe, and the Catholic Church's firm grip on every aspect of the lives of Europeans began to loosen. That process started in the 11th century, when long battles over theology and politics between the church's two wings, based in Rome and Constantinople (Istanbul), finally led to a complete schism between the two. The Roman church maintained its sway in Europe for the next few centuries, but even as a new St. Peter's Basilica was rising in the 16th century over an earlier church erected during the reign of the Christian Emperor Constantine (construction lasted for 120 years), the Catholic Church found itself under siege by the powerful new appeal of the Protestant Reformation.

Vatican City weathered that period of religious revolution; like the Catholic Church itself, it bestrides the ages, uniting the lives of such diverse figures as St. Peter, Constantine, Michelangelo and a recent Pope, John Paul II, who was beatified by his successor, Pope Benedict XVI, before a crowd of tens of thousands in Vatican Square on April 29, 2011.

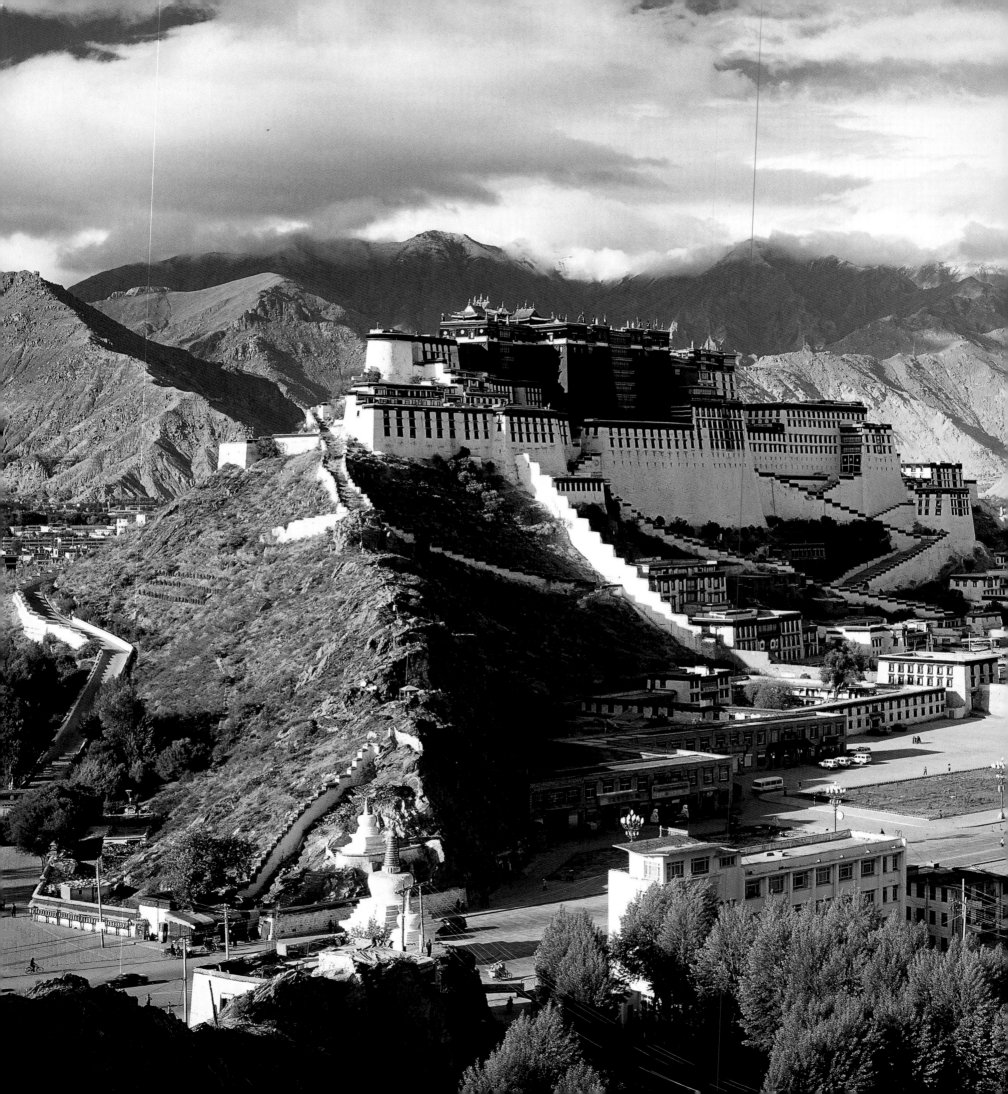

22.
Potala Palace

The colossal structure towers over the city of Lhasa,
but today both the palace and Tibet are endangered

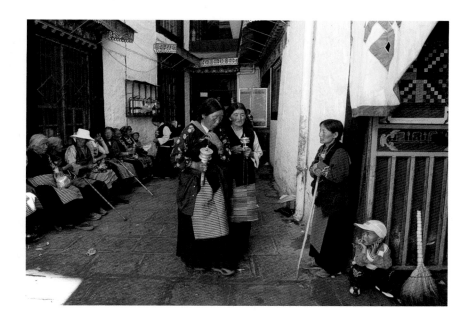

POTALA PALACE IS THE SPIRITUAL LODE-
stone of the Tibetan people, but this sacred
house is haunted: the spiritual and thus politi-
cal leader of Tibet, the Dalai Lama, fled his
holy residence in 1959 to avoid potential arrest
by the communist regime of China's Mao Ze-
dong. Once the Dalai Lama had fled, Chinese
troops moved into the nation, which Beijing
argues is an autonomous region of the People's
Republic rather than the independent, sover-
eign nation most Tibetans believe it to be.

If the great structure has lost its chief
resident, it has not lost its power to awe and
inspire the increasing number of visitors who
journey to Tibet's capital, Lhasa, to immerse
themselves in Tibetan culture. The current
structure was begun in A.D. 1645, replacing a
smaller palace dating to the 7th century A.D.
Its size and location make it one of the world's
most memorable sights. Its 13 stories cover the
summit of Lhasa's Red Mountain, topping out

at some 1,000 ft. (300 m) above the floor of the
valley below. The building is 1,312 ft. (400 m)
wide and 1,148 ft. (350 m) deep, and its roofs
shelter more than 1,000 rooms. The Red
Palace in its center was devoted to sacred pur-
suits; the White Palace that encloses it was the
realm of government affairs. Though Tibet's
culture and religion are a target of China's
wrath, the Chinese have preserved this
emblem of national culture, calling it a mu-
seum rather than a living religious institution.

TIME contributor Pico Iyer noted in a 2006
book review for the magazine that Lhasa
was "never as detached from modern life as
the starry-eyed like to believe." Even so, the
increasing migration here by Chinese citizens
of Han descent and the explosion of tourism
and capitalism in the city have ensured that,
in Iyer's words, "old Lhasa has been developed
into extinction." Tibet itself may soon resem-
ble Potala Palace, more museum than nation.

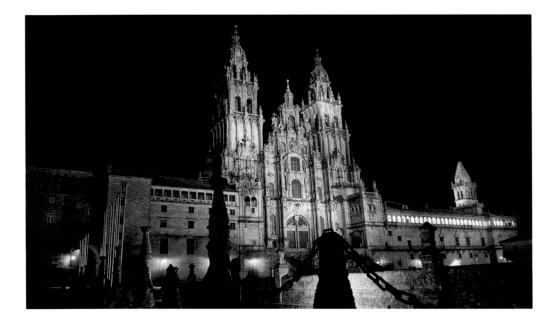

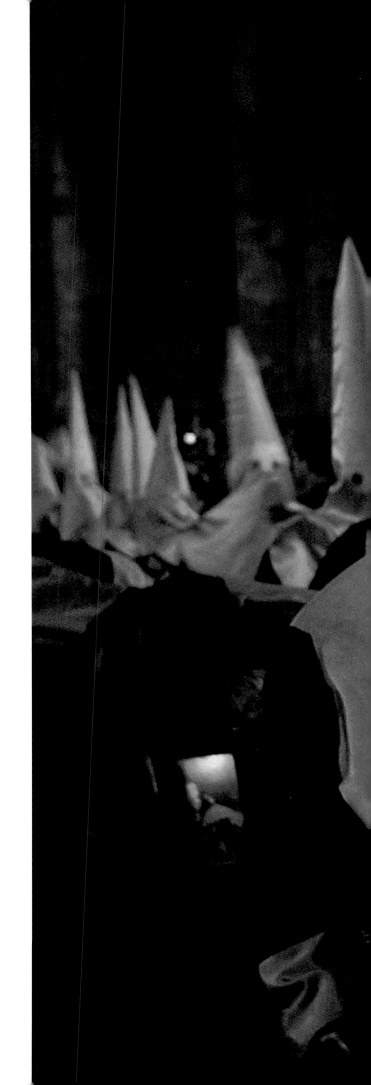

23.
Santiago de Compostela

Site of one of the world's greatest annual pilgrimages, this holy city in Spain offers a window into the past—and the future

FOR CENTURIES THEY HAVE COME, AND IN the 21st century they show no sign of stopping. The Roman Catholic pilgrims who follow the Way of St. James from France walk for hundreds of miles through the Pyrenees and across the breadth of Spain to the city of Santiago de Compostela in Galicia, near Spain's northwest coast, participating in one of the world's great sacred peregrinations. The magnet that draws them is the magnificent Cathedral of St. James, consecrated in A.D. 1121. It is believed to hold the bones of the saint, one of Christ's 12 Apostles, said to have been found in the early 9th century A.D. by a local hermit guided by a divine star.

The discovery gave embattled Christians a rallying point at a time when the Moors were conquering southern Spain. It has also proved a blessing to today's townspeople, who welcome some 100,000 pilgrims each year to their streets—and to the extensive network

of lodgings, restaurants and smaller shrines that dot the Way of St. James. Though most pilgrims make the journey during the spring and summer months, the celebrations around the feast of Easter are particularly striking, as shrouded, candle-bearing members of sacred brotherhoods, right, process through the narrow streets of the city's medieval quarter.

Yet if the pilgrimage, the city and the trappings of worship seem to emerge from a history book, this sacred site is not immune to change. As TIME reported in 2010, the cathedral has installed a "digital candelabra" that allows faraway visitors to light, remotely, a virtual candle through the website MiVela. com (translation: MyCandle). Simply type in your credit card information—each candle costs about $2—and in a dark corner of the ancient church, an onscreen taper will "light up." Hopefully the message will reach the various Facebook pages named "Saint James."

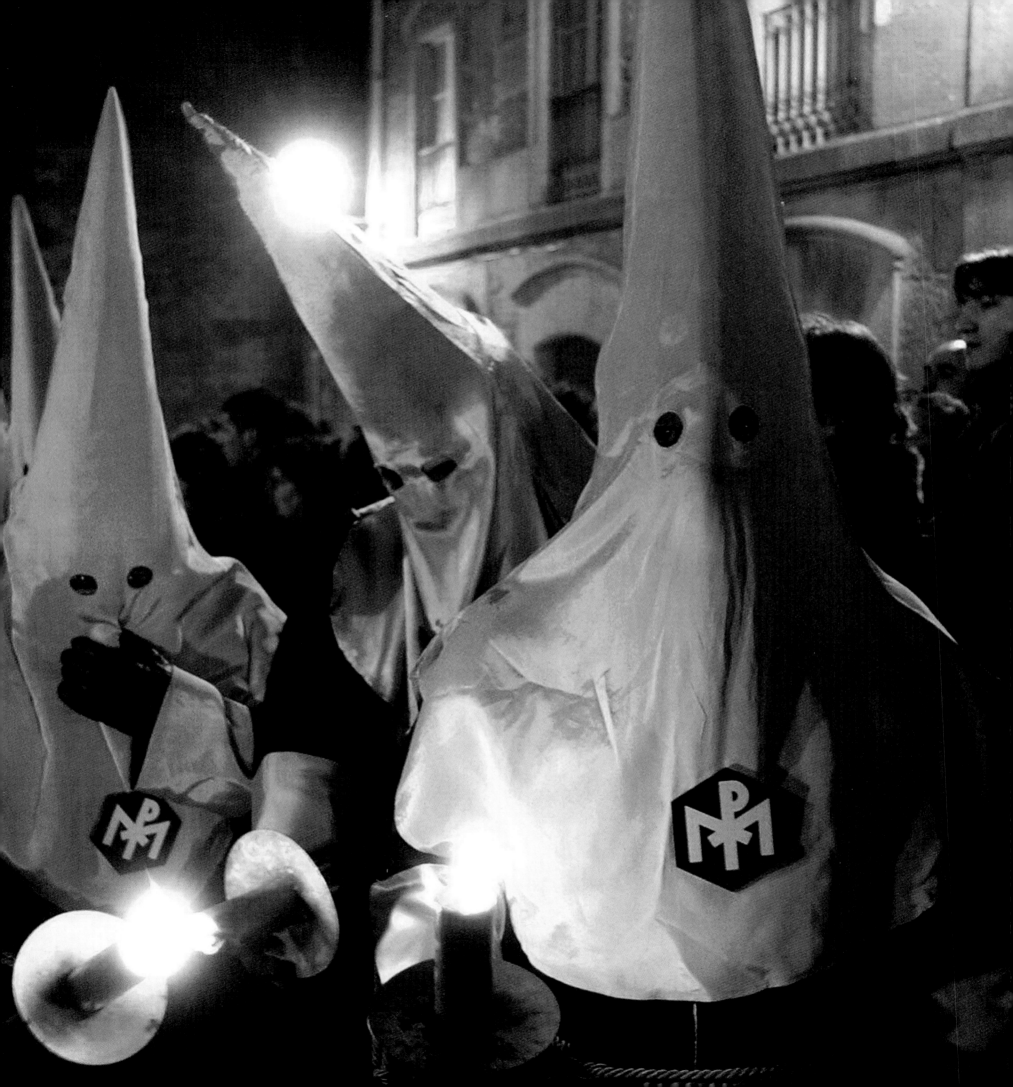

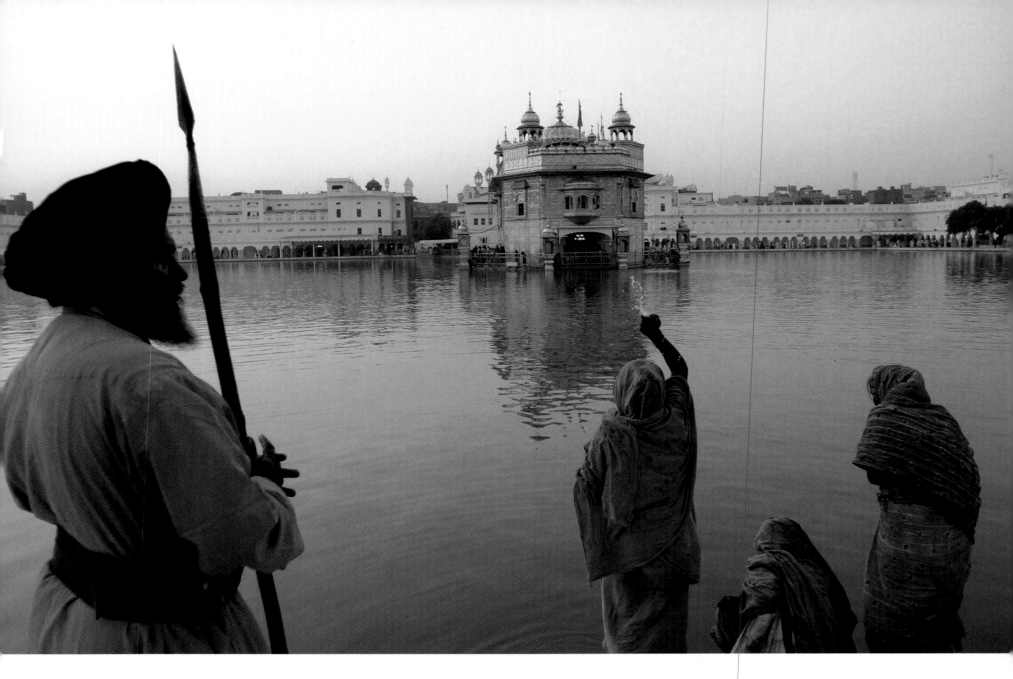

24.
The Golden Temple

The gilded shrine in Amritsar is the splendid home of India's Sikhs

THE BEST APPROACH TO THE GOLDEN TEMPLE in Amritsar is the one followed by the many pilgrims who visit the sacred Sikh site in the Punjab each year. The magnificent edifice is first viewed from a distance, through the gateway to the complex, the Darshani Deori, an arch that offers a view across the small lake that surrounds the temple. Following a causeway across the lake, pilgrims then walk around the building for a number of circuits before ascending the Har Ki Paure (Steps of God), which lead inside.

Elements of this journey were followed even before Guru Nanak, Sikhism's founder, received his spiritual enlightenment in a stream near today's temple in the early 16th century A.D. This serene lake is said to have

been a site of spiritual contemplation for centuries before Guru Nanak came to it, welcoming many seekers, including the Buddha himself, who is believed to have meditated here five centuries before the time of Christ.

The temple reflects the life of Guru Nanak, with its four great doors oriented to the four points of the compass, echoing the quartet of journeys he undertook to spread his teachings, which propose a single God who is best approached through meditation. Sikhism welcomes believers of all faiths—as does the Golden Temple itself, which was repeatedly destroyed by Muslim regimes in the first decades of its existence, only to be rebuilt in greater splendor time and again, until it assumed its final, shining form around 1767.

25.
Varanasi

India's sacred city on the
Ganges is the site of spiritual
rebirth—and physical death

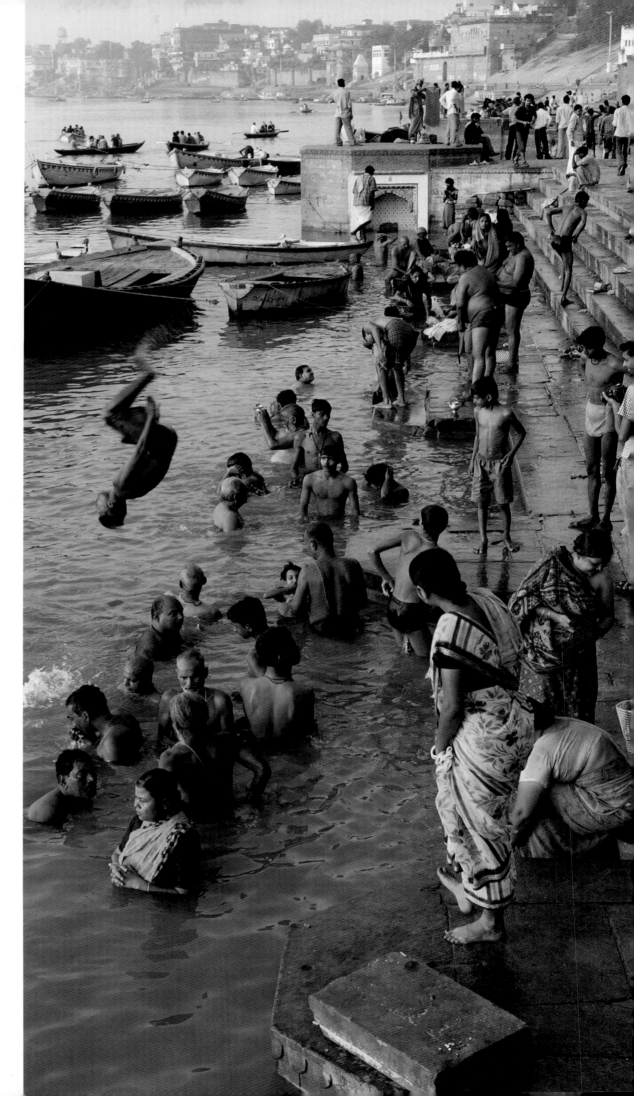

IN INDIA, A LAND BESOTTED WITH RELIGION, there is no holier site than Varanasi (Benares), the city in the nation's northeast that marks the site where two great rivers, the Varuna and the Assi, join the Ganges, believed by Hindus to be the most sacred of waterways. Many Hindus believe that immersion in the waters of the Ganges offers them absolution for their sins, not only in this life but also in past lives: a dip in these waters amounts to a short-cut on the great wheel of karma.

Like Amritsar, the city is also associated with the Buddha; it was in Varanasi, in a deer park, that the great teacher first delivered his message to his disciples. Small wonder some 1 million people each year are drawn to Varanasi and the waters of the Ganges, where the most faithful pilgrims rise early to offer their obeisance to the sun, or *puja,* in the first rays of dawn. These rituals are performed along scores of ghats, steps leading down into the river where visitors can take the water.

But if Varanasi offers spiritual life, it is also an abode of death, for devout Hindus believe it is not only a place of pilgrimage but also an auspicious place to die. As a result, death here is not morbid—it's a vibrant business. "This is where the sacred and the commercial comfortably converge," TIME's Aryn Baker reported in 2002. "The city of 2 million hosts more than 50,000 funerals a year, and shopkeepers are more likely to sell sandalwood logs, incense and tinsel garlands—in India, the paraphernalia of death—than savory samosas."

CHAPTER THREE
IN THE BEGINNING

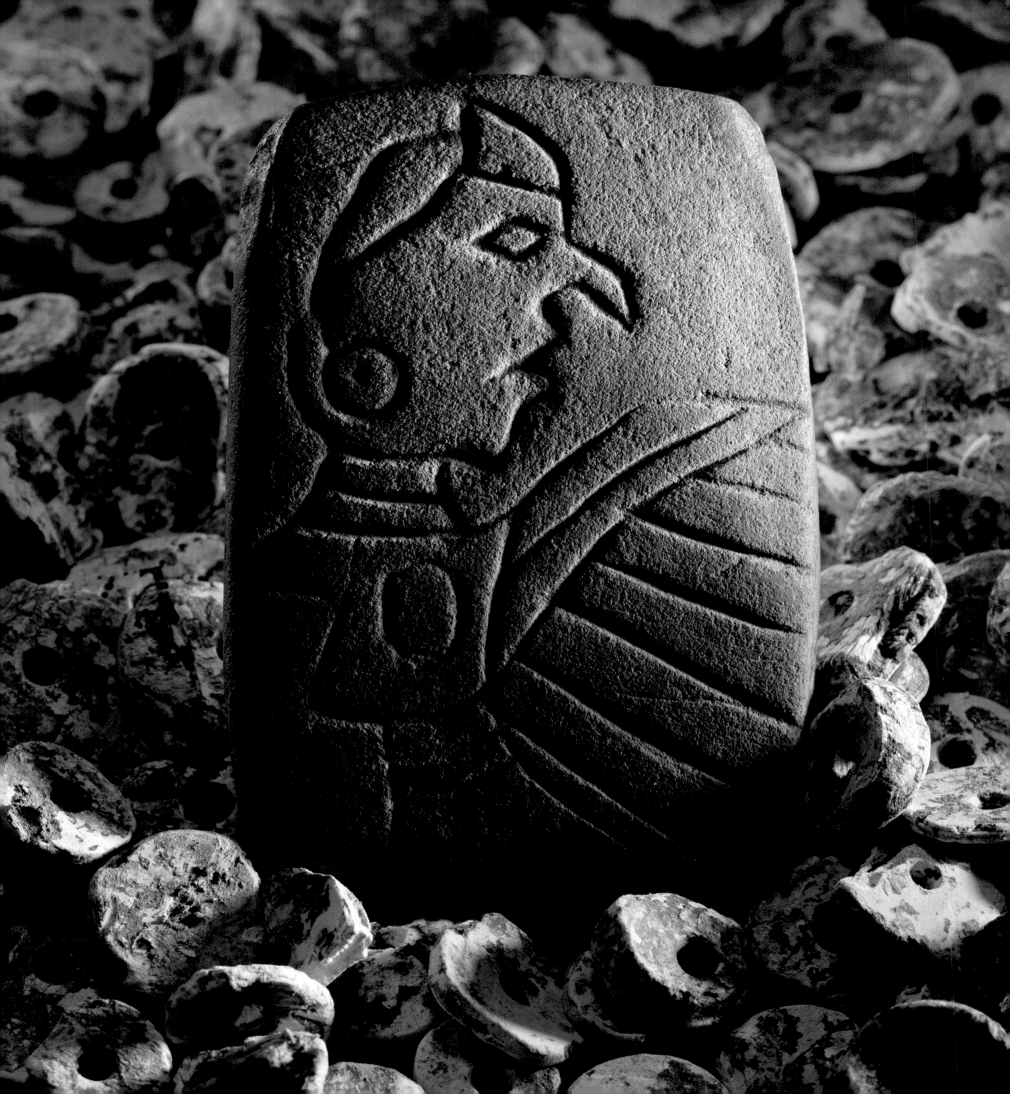

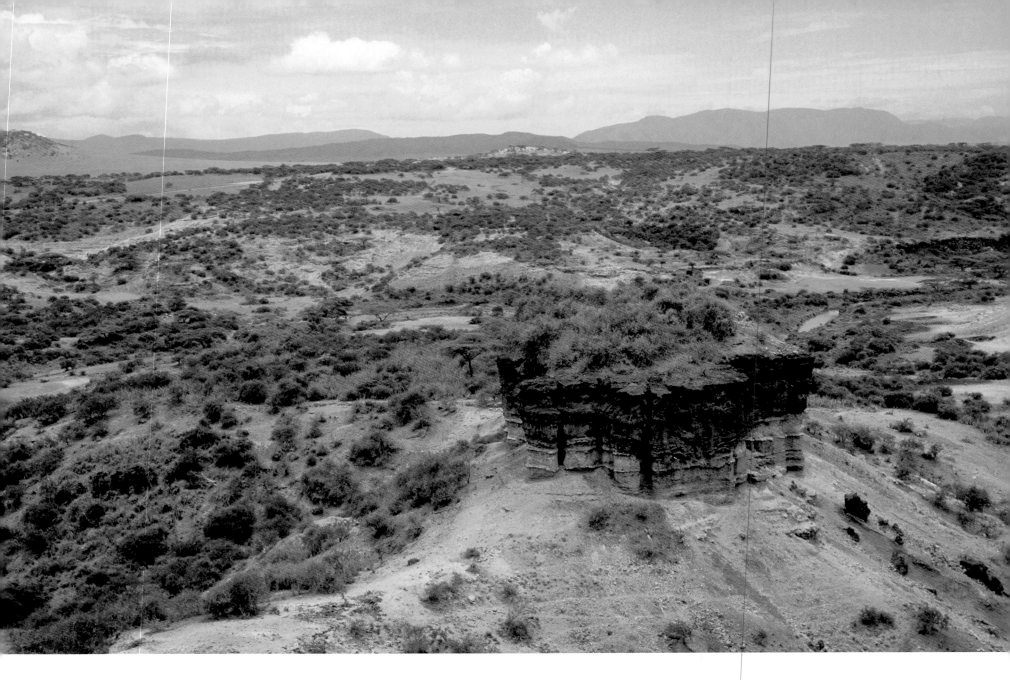

26.
Olduvai Gorge

Scientists have dubbed
a deep ravine in Africa
"the cradle of early man"

TO SEE OLDUVAI GORGE IN TANZANIA IS TO get a backstage view of the inner workings of Planet Earth. In this steep-sided ravine that stretches for about 30 miles (48 km) along the eastern edge of the Serengeti plains, the infrastructure of the planet is revealed. Once a large lake covered the ground, but it was covered by a thick layer of volcanic ash. Later, a river cut through the area, exposing layers of volcanic sediment, in which modern archaeologists have found revelatory remains of early hominids, the precursors of modern humans, and of the tools they employed, the beasts they hunted and the lives they led.

The gorge is synonymous with a famed archaeological family, the husband-and-wife team of Louis and Mary Leakey and their children, most prominently including son Richard. Louis Leakey first explored Olduvai Gorge in 1931, but the most important discovery to emerge from the ravine's walls came in 1959, when Mary unearthed the skull and jawbone of *Zinjanthropus boisei,* a member of an extinct species of the human family tree. As son Richard later recalled for TIME: "*Zinjanthropus* was determined to be 1.75 million years old. At the time, this was staggering ... It stretched back our evolutionary perspective ... in my opinion no other discovery has had the [same] impact on this field of human inquiry. The dating of the Olduvai strata began a new chapter in our understanding of human origins: it added the dimension of real time to evolution."

27.
Mohenjo-Daro

A great civilization rooted in India and Pakistan boasted a crowded early metropolis

THE ANCIENT CITIES OF THE INDUS VALLEY, which sprawls across some 300,000 sq. mi. in modern-day Pakistan and northwestern India, belonged to one of humanity's greatest civilizations yet one whose lineaments and language remain frustratingly unclear. There, since the 1920s, dozens of archaeological expeditions have unearthed traces of a 4,500-year-old urban culture, a sophisticated society whose towns had advanced sanitation, bathhouses and gridlike city planning.

The discoveries began at Mohenjo-Daro in today's province of Sindh, Pakistan, in 1922, and excavations continued into the 1930s. There scientists found evidence of trade with Egypt and Sumer in Mesopotamia, as well as the presence of mining interests as far as Central Asia, suggesting that the fertile Indus River basin could have been home to an empire larger and older than its more famous contemporaries in the Middle East.

The ruins at Mohenjo-Daro, which date to 2600 B.C., are among the most extensive located to date and indicate that the city may have been home to as many as 50,000 inhabitants, a staggering figure for deep antiquity. Yet the Harappan civilization, as scientists term it, left behind few such towering monuments. Instead we have clues in miniature: a very early pair of dice; a shattered carving of a man, perhaps a ruler or priest; a trove of delicately carved seals, like the one at lower right. Harappan writing remains undeciphered, but as TIME reported in 2009, a multinational group of scholars is harnessing computers to tackle the language, and they are optimistic they can crack the ancient code of Mohenjo-Daro.

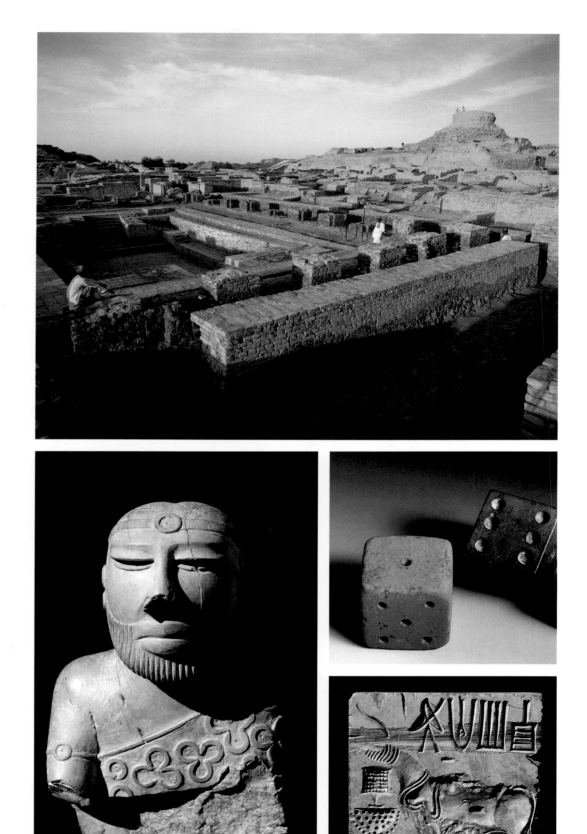

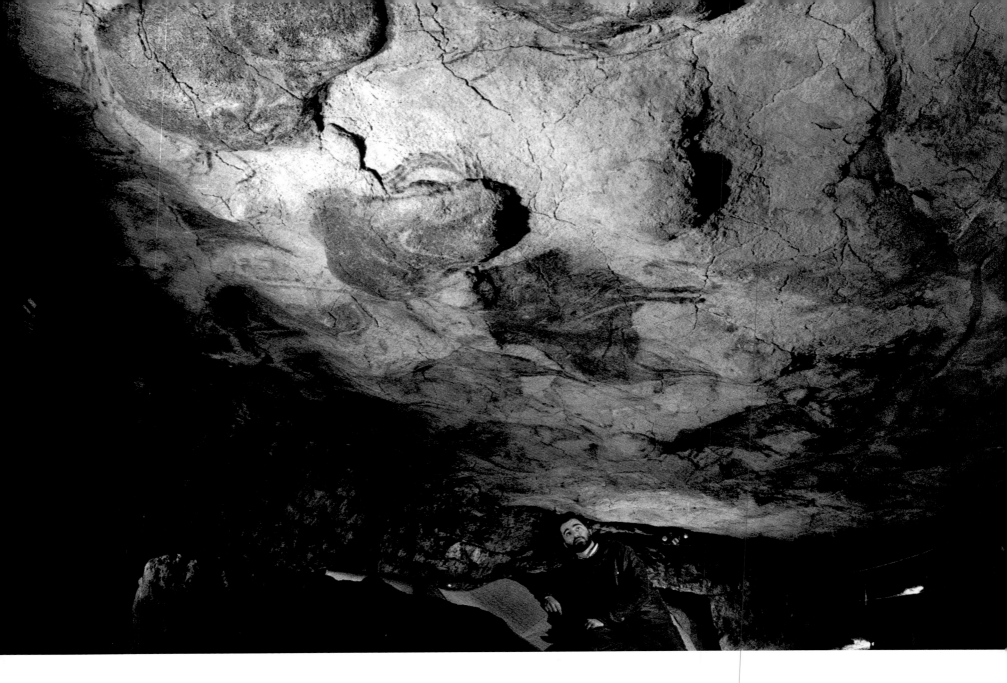

28.
Altamira Cave

Here, for the first time, modern eyes encountered the art of the distant past

THE REVELATION OF THE COLORFUL PAINT-ings of bison, goats, horses and other animals that adorn the ceiling of a cave near Altamira, Spain, marked a watershed in our understanding of humanity's earliest ancestors. They were the first prehistoric cave paintings to be found, and they featured such a high degree of skill in artistic representation that the emerging sciences of archaeology and paleontology were not equipped to deal with them.

Marcelino de Sautuola, a Spanish attorney and amateur archaeologist, first brought the paintings to public attention in 1880, after his 9-year-old daughter pointed them out on the ceiling of the cave in northeast Spain. When De Sautuola and Spanish paleontologist Juan Vilanova y Piera published an account of the lively paintings that included their supposition that they dated to the early Stone Age, their findings were ridiculed by mainstream European scientists. But the subsequent discovery of other caves adorned with early artwork convinced scientists that the colorful bestiaries were indeed made by early humans.

Today the paintings at Altamira are thought to have been created over an extended period dating from 19,000 to 11,000 B.C. Some 350 other caves boasting prehistoric art have been located in France and Spain alone. Sadly, at Altamira the crush of tourists (and the carbon dioxide they exhaled) was threatening to destroy the fragile paintings, and in 2001 Spanish authorities opened a replica cave that allows tourists to visit the past, virtually.

29.
Skara Brae

A Neolithic settlement in northern Scotland offers a glimpse of early human life

AS OLD AS STONEHENGE, AS OLD AS THE great pyramids of Egypt, the ruins of the small human settlement at Skara Brae in Scotland's northern Orkney Islands open a window into humanity's distant past. There, in a landscape that today is challenging, largely barren and washed by the chilly tides of the North Sea, Neolithic people lived and died some three millenniums before Christ. The small cluster of 10 rock dwellings was found in 1850, following a powerful storm that removed some of the earth from a large barrow on the Bay of Skaill, exposing the structures, although serious scientific exploration of the ruins was not conducted until the late 1920s.

Scientists now date the settlement here as having thrived between 3000 and 2500 B.C. The stone houses, sheltered from harsh winds by a covering of earth, held stone furniture, including seats and cabinets, and examples of a type of pottery, grooved ware, typical of this time and place. The small village boasted a relatively sophisticated drainage system, and some of the houses may have held stone toilets. Their inhabitants are believed to have been shepherds who tended flocks of cattle and sheep, grew cereal grains, hunted deer and also fed off the bounty of the sea.

Climate change may have played a role in the decline of Skara Brae. It may have thrived during a relatively temperate period for this section of northern Europe, only to be abandoned when the weather began to turn increasingly colder and wetter, around 2500 B.C. The settlement was named a UNESCO World Heritage Site in 1999.

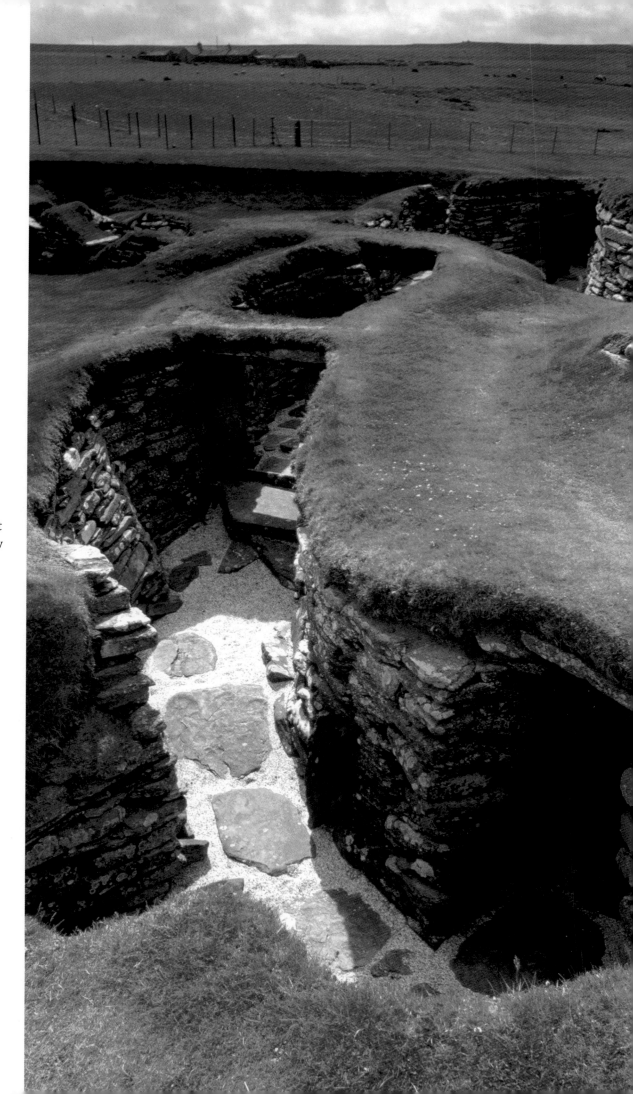

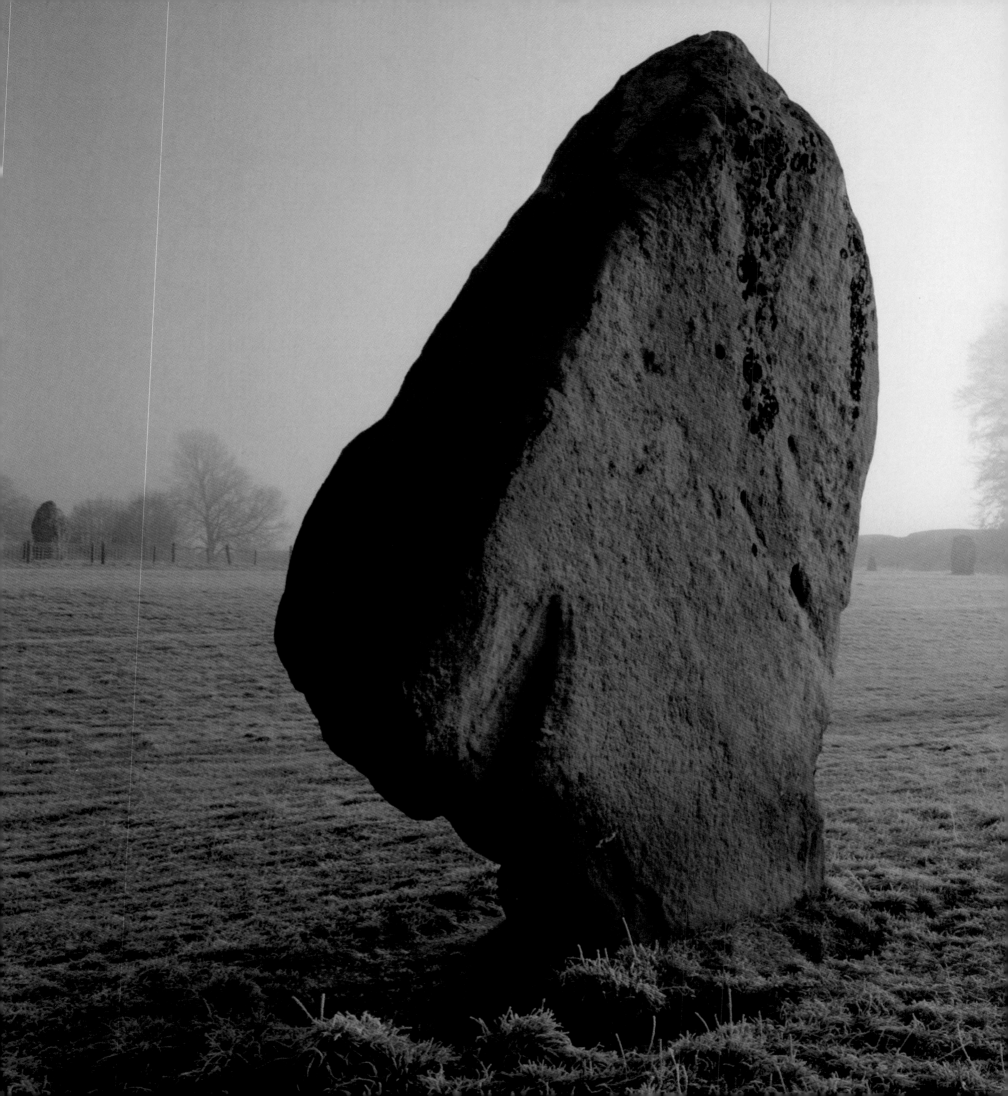

30.
Avebury
Europe's largest Neolithic ruin tantalizes modern eyes with its long-lost meaning

STONEHENGE IN SOUTHERN ENGLAND MAY BE the world's most famous Neolithic site, but it is only one of many such groupings of dolmens that can be found scattered across Europe. A dolmen is a group of large upright stones arranged to create a sacred space: a chamber tomb, a monument, a site for religious rituals or an astronomical calendar. Only 20 miles (32 km) from Stonehenge is a site that is now less picturesque and complete but in its day was far more impressive: Avebury. There a huge circular barrow encloses a sacred site that covers more than 28 acres and in its prime is believed to have held several hundred dol-

mens, some weighing as much as 50 tons. Far fewer of the big megaliths survive; scientists believe they were hauled from the same quarry at Marlborough Downs, some 6 miles (9.6 km) away, that yielded stones for Stonehenge.

The circular barrow at Avebury contains a large outer ring of standing stones and two smaller rings within it, and it extends to form two long avenues of upright stones, one of which leads to an enormous barrow at Silbury Hill, about 1 mile (1.6 km) south of the site. Scientists believe the entire site at Avebury forms what they call a "sacred landscape," but it is difficult for modern eyes to read the significance of these ancient formations, most of which date to around 2500 B.C. The site apparently survived mainly intact until the high Middle Ages, when zealous Christians destroyed much of it as the relic of a pagan civilization. Their success was history's loss.

31.
Knossos

Today's ruins only
hint at the grandeur
of this lost culture

AT THE PALACE OF KNOSSOS ON THE ISLAND of Crete in the Mediterranean Sea, we catch tantalizing glimpses of a great vanished civilization, the Minoan culture. Centered on the island 15 centuries before Christ, the seagoing Minoans once dominated the commerce and culture of the eastern Mediterranean. Yet their advanced civilization came to a sudden, catastrophic end. Great temples and lavish palaces fell into ruin. Traffic halted on a complex system of paved roads, elaborate viaducts crumbled, and most of the residents of Crete died or mysteriously disappeared.

The mazelike Cretan palace was explored and controversially reconstructed in some areas by an amateur British archaeologist, Sir Arthur Evans, in the early 20th century. Evans found wonderful Minoan artifacts: bare-breasted priestesses with snakes, nimble acrobats and sacred bulls. But it was English author Mary Renault who brought the Minoans to life for a wide audience in her novels *The King Must Die* and *The Bull from the Sea*.

Today scholars believe the Minoan culture was brought to an end by a pair of volcanic eruptions some 3,500 years ago, centered on the current island of Santorini, that may have been followed by destructive tsunamis. Those natural disasters could have put an abrupt end to the triumphant age of the Minoans.

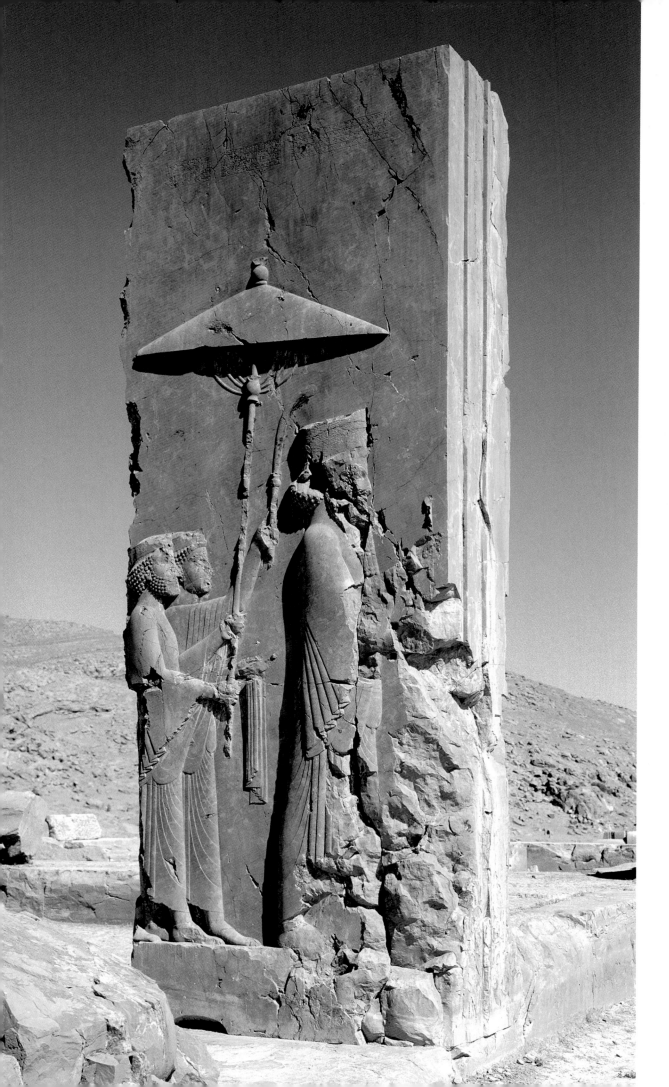

32.
Persepolis

A city built to boast of martial success was in turn conquered by force of arms

PERCHED ON A HIGH, WINDY, OTHERWISE barren plain in Iran, the ruins of Persepolis invite us to recall a world just emerging from the realm of fable and legend and entering history. In the millennium before Christ's birth, Iran ("Home of the Aryans") was settled by an Aryan tribe from what is now southern Russia. Cyrus, a leader of the Achaemenid dynasty of this tribe, was a warlord-conqueror who founded an empire that at its height stretched from India to the Aegean, and from the Danube to the Nile.

Cyrus's son Darius I ("The Great") founded Persepolis ("City of Persians") as his ceremonial capital; its earliest remains date to around 518 B.C. The sprawling, magnificent complex in south-central Iran, located some 43 miles (70 km) north of the city of Shiraz, was further glorified by subsequent Achaemenid kings. Darius's succesor, Xerxes, famous for his invasion of Greece, is depicted in the bas-relief at left in the building dubbed the Hall of a Hundred Columns, which he ordered built.

The city's primary buildings were military barracks, a great treasury and royal palaces and reception halls. Xerxes commissioned another of its lavish structures, a square edifice 82 ft. (25 m) on each side, of which a single gateway, the Gate of All Nations, still stands.

Persepolis, which rose to celebrate royal conquest, also fell by the sword. After Alexander the Great conquered the royal city in 330 B.C., it was plundered and burned. But whether its destruction was an accident or, as ancient historians aver, the result of a harlot's drunken suggestion, we may never know.

33.
Olympia

This ancient city in Greece is the original home of sport's greatest spectacle

THE LAST RACE IS LONG SINCE RUN. THE cheers have faded. But the spirit that drew ancient Greeks to the race track below in the mountains of the western Peleponnesus is still alive in the world, for it was here that the Olympic Games were first held. Such contests were not unique in Greece: eventually there were four series of Panhellenic Games, two of which were biennial. Of these various events, the Pythian Games were held in the spiritual center of Delphi. But the Olympics, held at this site, were much more important.

Legend holds that the Olympic Games began in 776 B.C., but some scholars believe they started some decades earlier. The power and appeal of the Games grew over time, eventually becoming so essential to Greek society that wars between city-states were put on hold during the athletic contests. Indeed, the calendar of ancient Greece revolved around the four-year cycle of the Games.

Today only ruins remain of the elaborate complex of buildings that developed there, including city treasuries, temples, a vast stadium

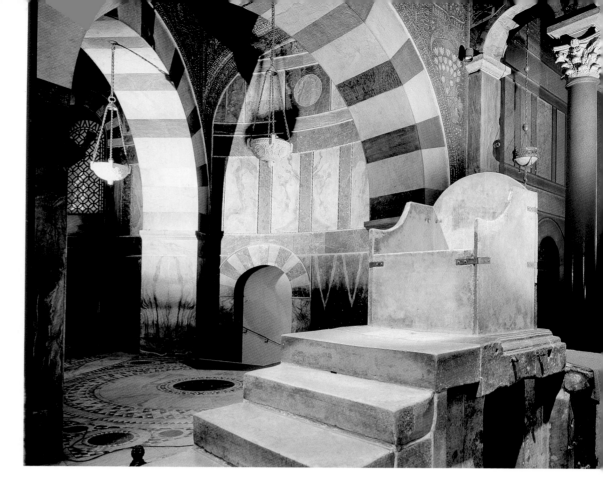

where foot races and the pentathlon were held, and a hippodrome for chariot racing. When the Romans conquered Greece—and in turn fell sway to the learning and ideals of Greek culture—they continued to celebrate the Games, until the Christian Emperor Theodosius I banned them as pagan in 393 A.D. Fifteen centuries later, in 1894, a Frenchman inspired by Olympia, Baron Pierre de Coubertin, spearheaded the creation of today's modern Games, which begin with the lighting of a torch by the sun's rays on this ancient site.

34.
Aachen Cathedral

Here, with the crowning of Charlemagne, Europe's centuries of darkness began to end

IF NATURE ABHORS A VACUUM, POLITICS ABHORS A POWER VACUUM. AND WHEN THE mighty Roman Empire collapsed early in the 5th century A.D., it left the Western world without its center of gravity. Energetic, ambitious, focused and progressive, the Romans had reigned over a period of civilizing progress throughout Europe, Africa and Asia Minor that lasted for centuries and which still can be seen in the form of aqueducts, temples, roads and bridges, from Spain to Turkey to Libya. Just as important was the empire's social infrastructure, which stressed justice and learning, philosophy and the arts. All roads led to Rome, where a supreme political power presided over the civilized world, ensuring that commerce, the courts, society and schools operated in harmony.

Outside this Latin-speaking world was an entirely separate, tribal society, the world of those the Romans called barbarians (bearded ones). Today we would call these Franks and Visigoths, Vandals and Huns, indigenous peoples. And with the collapse of Rome, political power necessarily flowed to these large tribes, whose warlord leaders battled for supremacy for the next centuries. The first tribal monarch and conqueror to unite the strands of the old Roman Empire was Charlemagne, who was crowned King of the Franks by Pope Leo III in Aachen Cathedral, the oldest cathedral in northern Europe, in the year A.D. 800. In the Palatine Chapel, above, the oldest part of the historic church in Germany and the site of Charlemagne's throne, modern visitors can still sense the moment when the warlord era began to subside in Europe and the Middle Ages began.

35.
Cahokia Mounds

The extensive remains of a vanished civilization are hiding in plain sight

BEHOLD THE CAHOKIA MOUNDS, THE MAGnificent creations of a great lost civilization that lie in today's Illinois just across the Mississippi River from St. Louis. There, on a site sprawling over 2,200 acres, one can stroll through the remains of a vast city, marked by 80 earthwork mounds, all that remain of 120 original mounds. At its peak, this city, Cahokia, may have been home to 20,000 Native Americans, the people anthropologists call Mississippians. This culture, which arose in the 8th century A.D., reached its peak around the 11th and 12th centuries A.D.

Mississippian culture was sophisticated, and Cahokia was its most important city. It was guarded by wooden watchtowers and boasted a 40-acre grand plaza, which scholars believe was reserved for religious and social rituals. Artifacts show that the Mississippians traded with other peoples from the Great Lakes to the Gulf of Mexico. Yet Cahokia and the people who built it had mostly deserted the site by the time the first Europeans arrived in the Americas. Scientists are still studying the reason for the sudden decline of this society, which recorded its grandeur in the alluvial soil of the floodplain of America's great river.

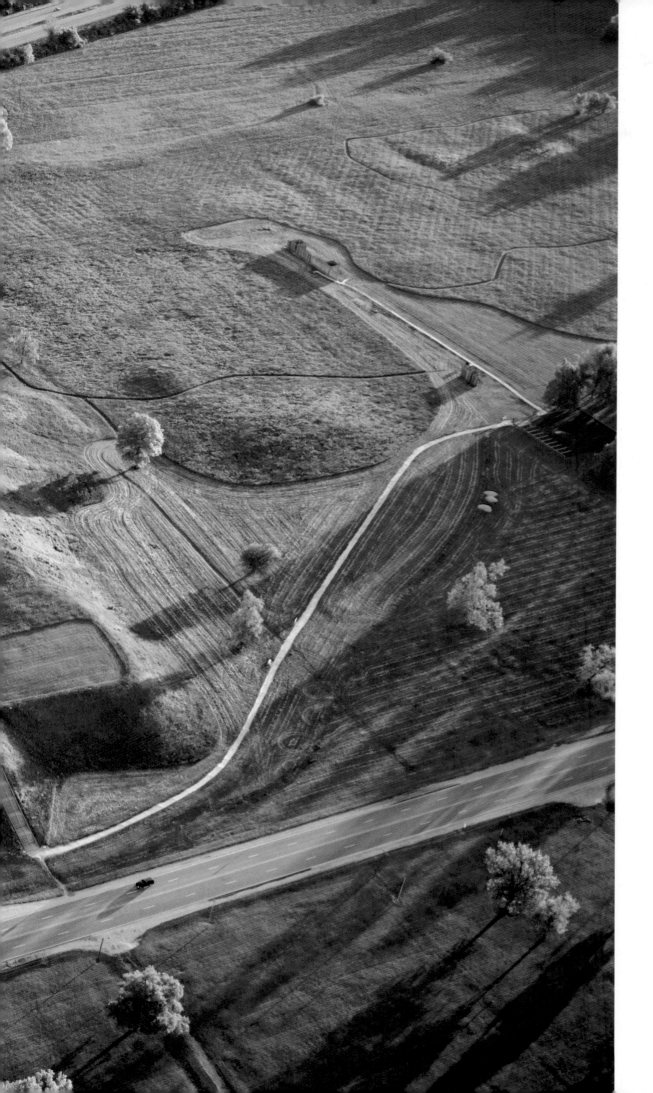

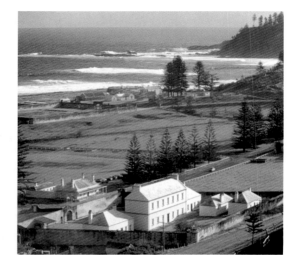

36.
Australian Penal Sites

A vast continent is peopled by the forced arrival of outcasts

WHEN WE STUDY THE ORIGINS OF HUMAN societies, we think of Avebury, Skara Brae, Knossos and other ancient sites. But when we turn to Australia, we encounter a modern society that was formed in its entirety within the past few centuries. Australia's indigenous people have dwelled on their isolated land-mass in the South Pacific for some 40,000 years, scholars estimate. But today's Australia is a creation of the great age of European colonization of the globe. Britain claimed posses-sion of the continent in 1770, at the height of that nation's imperial ambitions.

How was this faraway land to be settled? The solution was penal transportation, the movement of convicted criminals to Australia to create a society in Britain's image. The first fleet of ships bearing prisoners landed on Jan. 26, 1788, now celebrated as Australia Day. In all, some 165,000 convicts made the long pas-sage by sea. Above is the penal colony on Nor-folk Island, established only five weeks after those original settlers landed at Botany Bay. This system of peopling a continent continued for 80 years; the last ships arrived in 1868.

CHAPTER FOUR

BASTIONS OF POWER

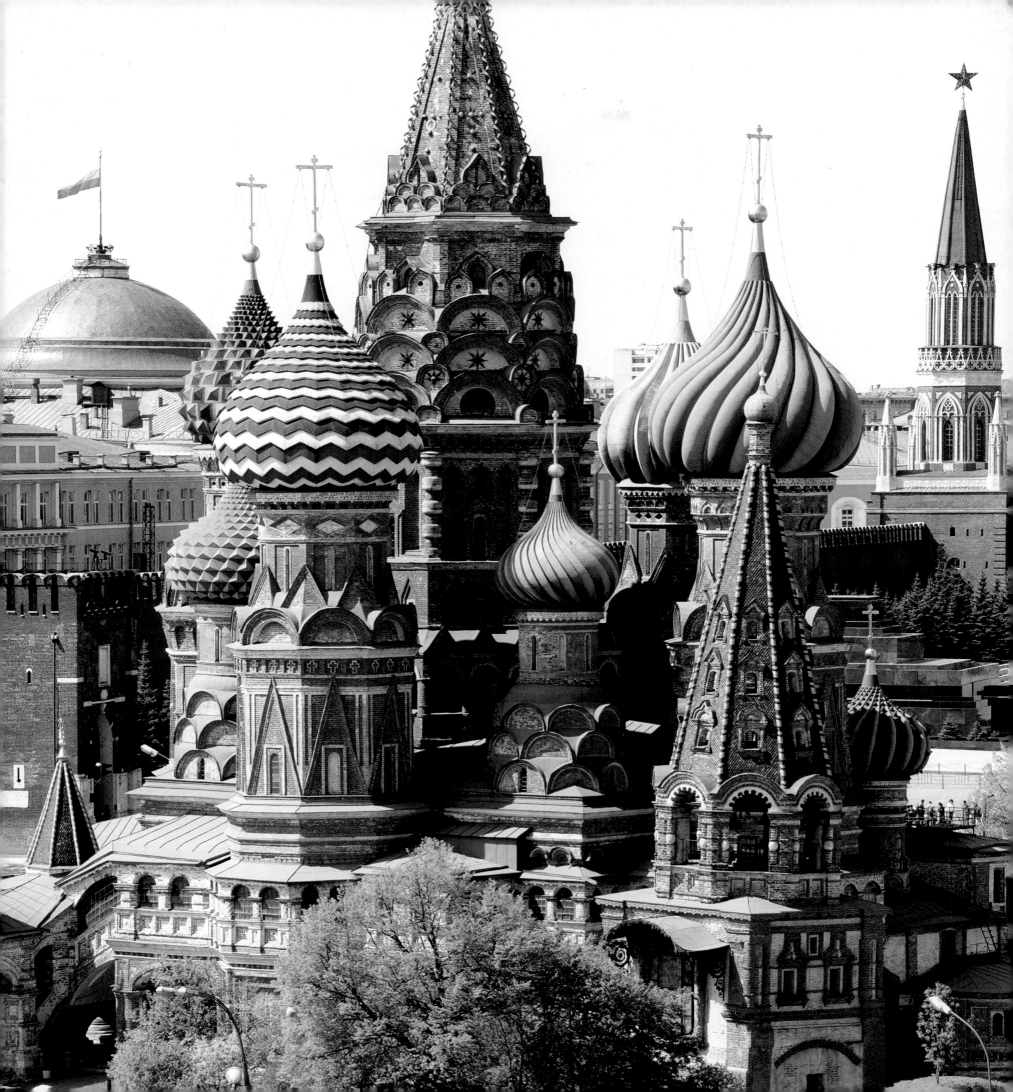

37.
The Forbidden City

Beijing's secluded royal compound preserves the grandeur of a bygone China

LIKE THE GREAT WALL OF CHINA, BUILT TO keep "barbarians" from breaching the borders of the great Asian nation, the Forbidden City in Beijing was designed to separate ordinary Chinese from the noble purity of the Emperor and his courtiers who dwelled within. An attempt to create a realm of celestial beauty on Earth, the complex was begun in 1406 A.D. under Zhu Di, known as the Yongle Emperor, the ambitious and accomplished third ruler of the Ming dynasty, after he moved the nation's capital from Nanjing to Beijing.

The complex is separated from the city by a moat and a wall that rises 32 ft. (10 m) high. It covers 178 acres and holds more than 900 buildings that date to the 15th century, the world's largest collection of wooden structures from this era. When the Ming dynasty was overthrown in 1644 by Manchuria's Qing dynasty, the Qing emperors also employed the Forbidden City as their seat of power, ruling there until the political upheavals that forever altered Chinese society began to unfold in the early 20th century.

The Palace Museum within the complex holds a fine collection of Chinese artifacts, silks and artworks gathered by the 24 emperors who ruled over China from this royal preserve. The last of them, Pu Yi, of the Qing dynasty, abdicated at age 6 in 1912; he is known to history (and worldwide movie audiences) as the Last Emperor. One wonders what the first, Zhu Di, would think of the hordes of tourists from around the globe who visit the no-longer-forbidden city each day, commoners invading his sacred domain.

38.
Tikal

Vast ruins in the jungle capture the rise and
fall of a great, vanished American empire

TODAY ITS MAGNIFICENT BUILDINGS PEEP OUT OF THE SURROUNDING
jungle like totems, but there was a time when Tikal in northern
Guatemala was the capital of a vast Mesoamerican empire that
stretched across large sections of today's Guatemala, Mexico and
Belize. To the Maya who ruled here, there was little difference between
politics and religion, and this urban area was used for both sacred
rituals and government administration. Even today, 12 centuries
removed from its glory days, it conveys the sense of the grandeur its
architects strove for, as five large pyramids and a panoply of large
plazas and palaces show off the artistry and know-how of the Maya.
This culture was perhaps the most advanced of all pre-Columbian
societies in the Americas, adept in architecture, mathematics, engi-
neering, astronomy and art. The large pyramid in the photo at right,
named Temple V by scholars, is the second tallest building in Tikal. It
stands 190 ft. (58 m) high and dates to around 600-700 A.D. The sculp-
ture below is located in the building now called the North Acropolis.

 Scientists have traced the origins of Tikal to about 300 B.C.; the city
reached its apex around A.D. 600 to 800, when it may have been home
to as many as 90,000 people, and it began to decline in the 10th century
A.D. For much of its existence, Tikal was at odds with the empire ruled
from Teotihuacán in Mexico, and there is evidence that the latter may
have conquered the former in the 4th century A.D. But now such an-
cient clashes seem far removed from these hushed, vine-covered ruins.

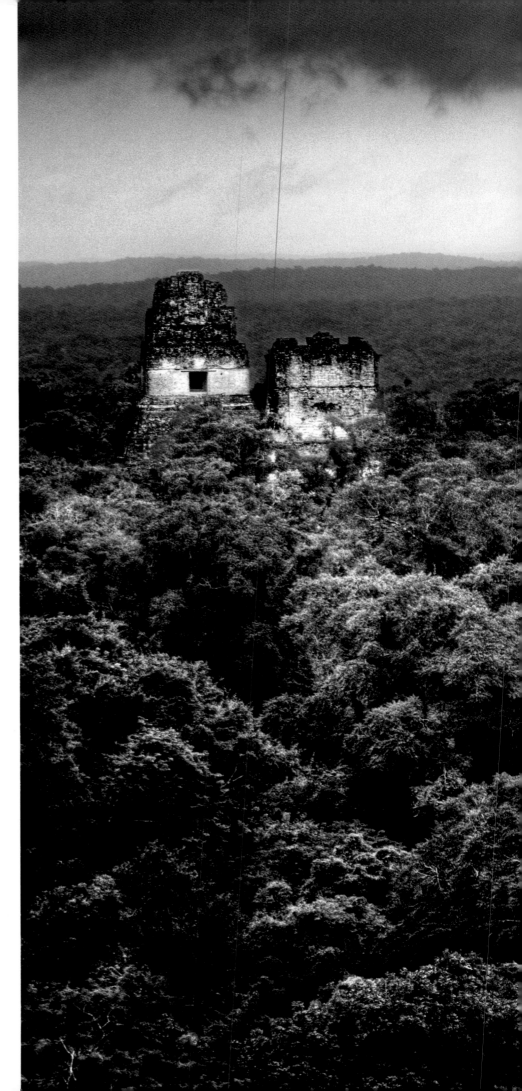

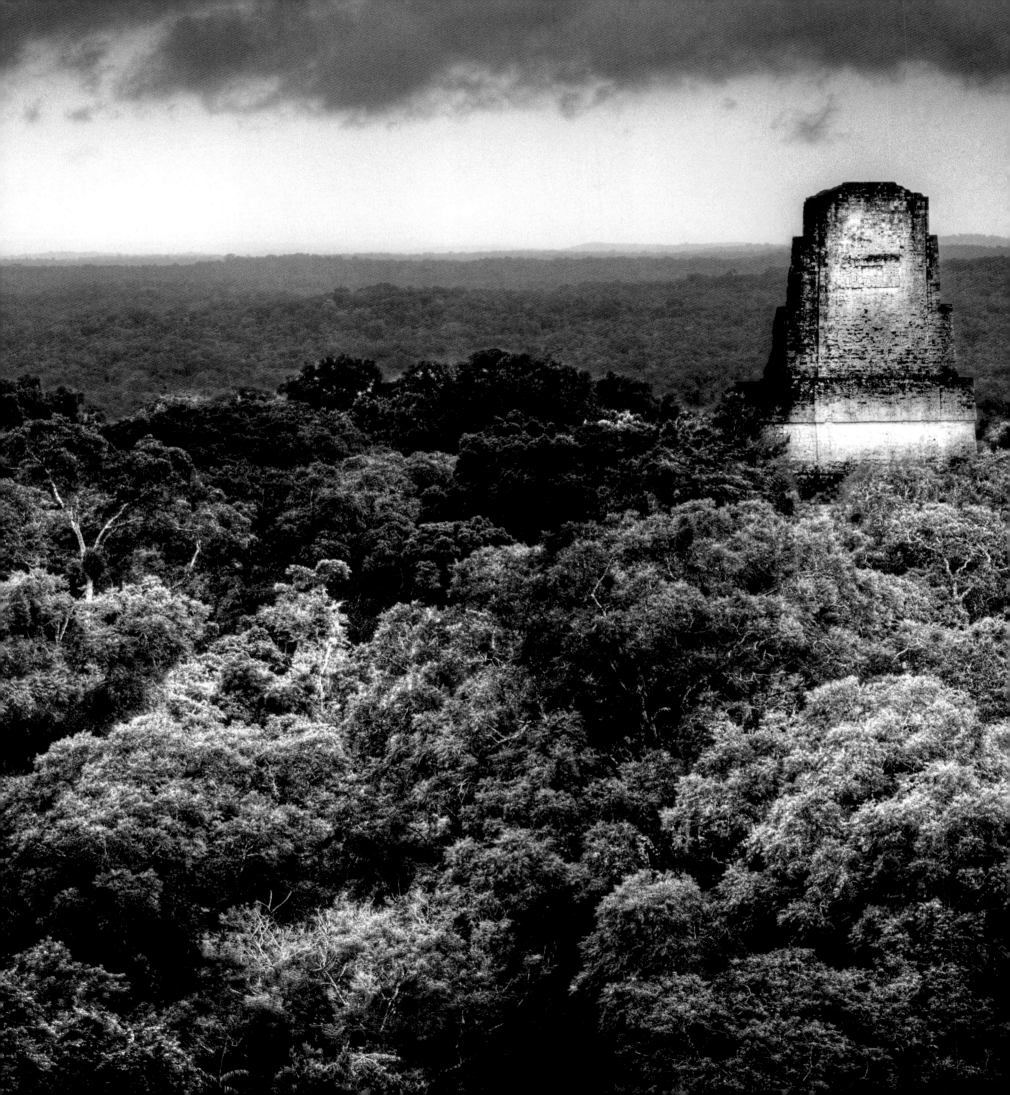

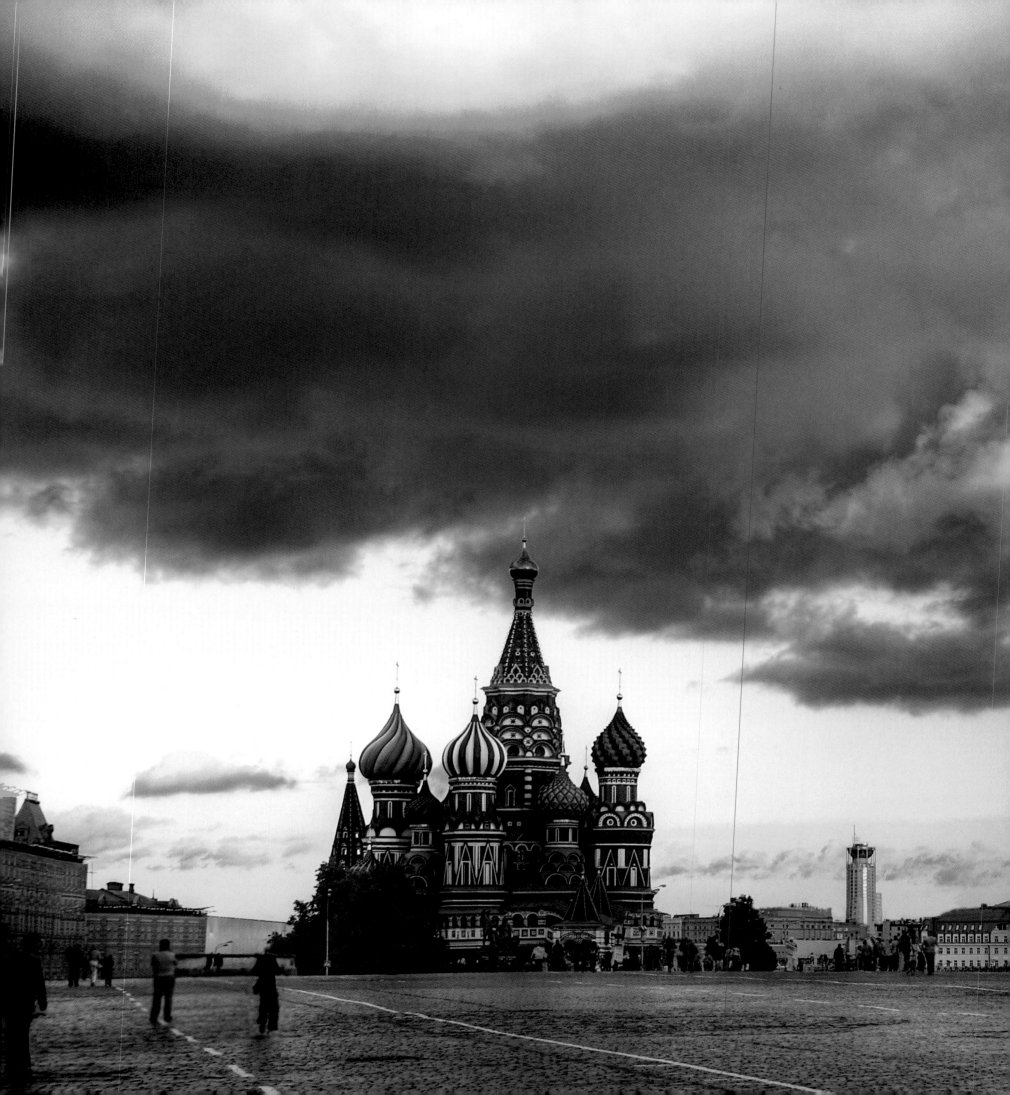

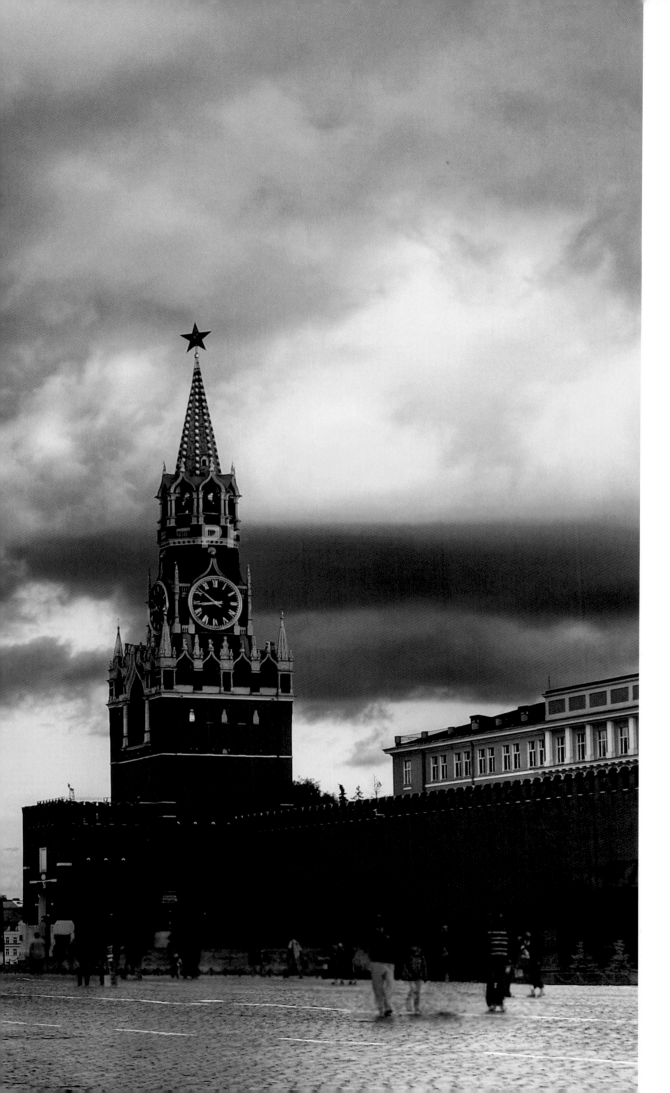

39.
Red Square

The ebb and flow of Russia's history are woven into the fabric of this great urban plaza

RED SQUARE IN MOSCOW OFFERS VISITORS A core sample of the history of power in Russia. Here, much as geologists read layers of sedimentary rock to study ancient events, one can read the evolving history of this great nation. All Moscow's roads converge here—as do all the currents of Russian society. At left in this picture is St. Basil's Cathedral, built in 1554-60 by the order of Czar Ivan IV ("the Terrible"). Its colorful bouquet of nine onion-shaped domes makes it among the most recognizable sacred buildings in the world.

When the Bolsheviks seized power in Russia in 1917, the church was secularized as part of V.I. Lenin's campaign against organized religion. But the Soviet regime also did Red Square a great favor: Czar Peter I ("the Great") had moved the nation's capital to his created city, St. Petersburg; the Soviets made Moscow once again the capital, choosing the Kremlin, the historic fortified complex, at right in the picture, as the center of their government. The sprawling, high-walled complex, begun in the 12th century, contains palaces, cathedrals and government residences and offices.

Not shown here is Lenin's Tomb, its pickled occupant a reminder that power is fleeting. Also missing are those who wield great clout in Moscow today: the oligarchs who have profited by Russia's turn to capitalism. For now, they hold great sway in Red Square—but they may be too busy getting and spending to heed the lessons of St. Basil's and Lenin's Tomb.

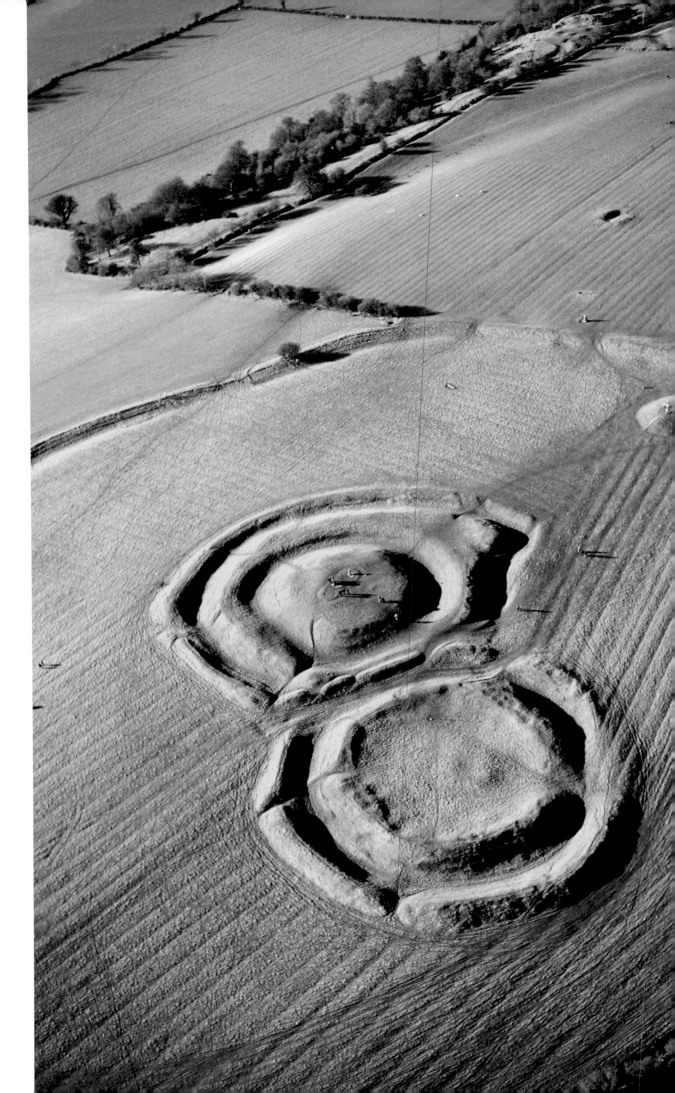

40.
Hill of Tara

This pinnacle of land is said to be the coronation site for generations of Irish kings

NO ONE DISPUTES THAT THE HILL OF TARA has played a major role in the history of Ireland. But nailing down exactly what role it played makes for a long, satisfying dispute. The site itself befits royal aspirations: the hill in County Meath stands some 500 ft. (152 m) over the valley of the River Boyne, along whose banks scientists continue to discover significant remains of Neolithic life. Small wonder, legend holds that as many as 100 of Ireland's ancient kings were crowned here.

That makes for a fine story, but modern scholars argue that Tara's significance to the Irish people, while indisputable, rests more upon myth than fact. The scientists are more interested in the Hill of Tara's significance in Neolithic times. Its summit is crowned by a long earthen barrow and ditch that enclose two linked circular earthworks, a barrow traditionally known as the Royal Seat, top, and a fort, bottom, called Cormac's House. At the center of the barrow is a small standing rock called the Stone of Destiny, said to have been used in royal coronations. A narrow passage tomb is nearby; it has been dated to around 2500 B.C. Scholars believe many of the Neolithic monuments that dot the Boyne Valley are part of a vast "sacred landscape" whose extent and purpose are yet to be delineated.

No matter what scientists say, to many Irish people the Hill of Tara is an emblem of national and cultural pride. Perhaps attracted by the same urge that drew Iron Age people to this site, thousands gather here each year on Midsummer's Eve to watch the sun set—and to steep themselves in dreams of Celtic glory.

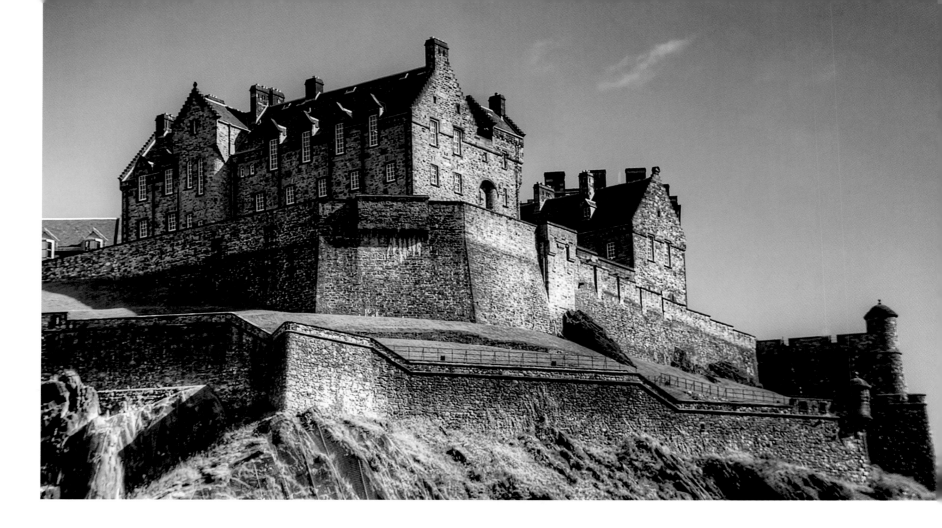

41.
Edinburgh Castle

It occupies a lofty, commanding perch, but for long
centuries, this fortress lacked subjects to command

FEW CENTERS OF POLITICAL MIGHT TOWER
over their domains with the loft of Edinburgh
Castle, the enormous fortress built atop a
thrusting, frozen surge of volcanic rock,
Castle Rock. The city of Edinburgh seems
to huddle at its feet, radiating outward from
this most recognizable emblem of Scottish
power and pride. Archaeological digs have
confirmed human habitation atop Castle Rock
since 1,000 B.C. The location may have been
used as a fortress as early as Roman times,
when imperial troops battled the local
Votadini tribe. In the Middle Ages, a fortress
here was known as "Maiden Castle," though
the origins of the name are obscure.

The history of the castle becomes clearer

under the reign of King David I, who in the
12th century reinforced an existing castle,
added a chapel and used the complex for royal
assemblies. In the 14th century the outlines of
the present complex began to take shape, but
amid the religious wars that dominated the
reign of Mary, Queen of Scots, the fortress was
subjected to what Scots call the "Lang Siege"
in 1571-73, when some of its buildings were
reduced to rubble by English cannons.

The fortress was rebuilt, but under the 1707
Treaty of Union that joined England and
Scotland in the United Kingdom, the fortress
was handed over to the English, and it served
as a garrison for British soldiers until 1923.
However, it did play a role in the two main

Jacobite uprisings, in 1715 and 1745, that failed
to restore Scotland's sovereignty.

One of the most moving moments in the
history of this lofty citadel came in 1818, when
Walter Scott, the author whose romances of
bygone grandeur did so much to restore Scots'
pride in their country, led a group that en-
tered the palace's shuttered Crown Room and
located in an old chest the treasures of Scottish
identity that had been untouched since they
had been hidden from English hands in 1707:
the crown, royal sword and sceptre of Scot-
land. These treasures were displayed in May
1999 during the first session of the new Scot-
tish Parliament, as Scotland began to reassert
its stature as an autonomous nation.

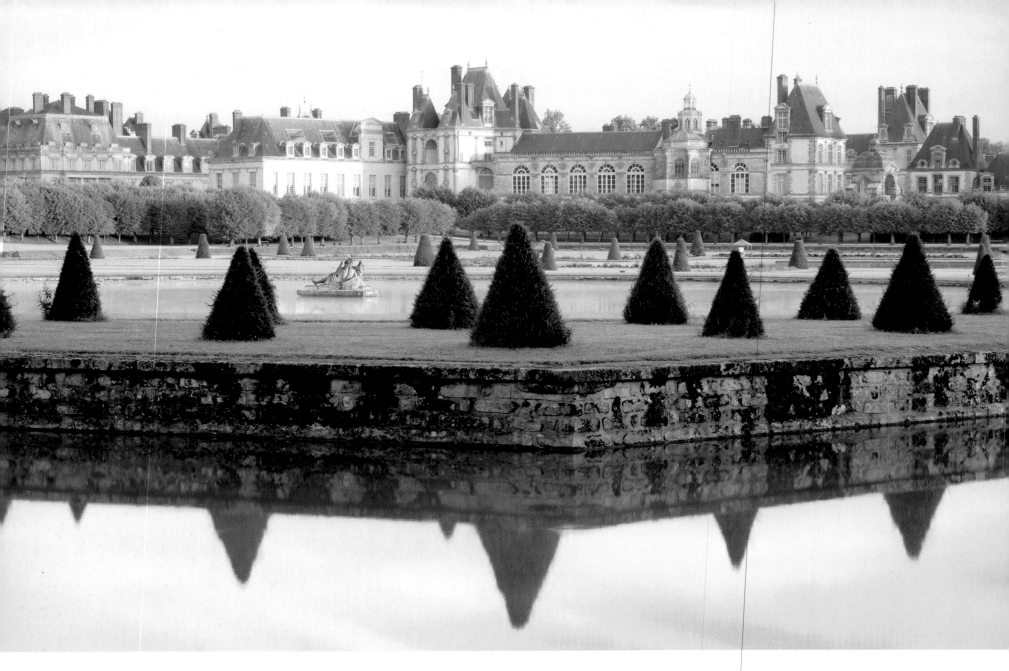

42.
Château de Fontainebleau

In a gilded age when French kings ruled by divine right, a heavenly home was de rigueur

AS SYMBOLS OF FRENCH ROYAL EXCESS GO, the palace of Versailles outside Paris will always take pride of place. But in the days when French kings bestrode Europe like colossuses, Versailles was not the only example of colossal excess—it was just the latest model. Consider the Château de Fontainebleau, which served as the country home of French monarchs before Versailles was built. This magnificent palace boasts 1,500 rooms set amid 130 acres of lavish courtyards, water features and gardens. Though a royal hunting lodge on this site dates back to the 12th century, work on the palace as we know it was begun under King Francis I in 1528, as the Renaissance was dawning in France. The King turned to Italian artisans and craftsmen, then leading the

world in design, to create and adorn his estate, which is some 34 miles (55 km) outside Paris.

Subsequent kings, including Henry II and his wife, the Florentine noblewoman Catherine de Medici, vied to outdo each other in enlarging and adorning the château. Its Italian Mannerist style, which features elaborate ornamentation that leaves few lilies ungilded, soon became the de facto style for royal residences across Europe. Fontainebleau was put in the shade when King Louis XIV turned his attention to another country place, Versailles, in 1682. But after the 1789 revolution upended France's social order, Fontainebleau enjoyed a glittering second act, as Napoleon restored it and made it once again his nation's most prestigious address.

43.
Revolutionary Philadelphia

Down these humble streets
walked those who put an end
to Europe's colonial sway

IN THE CENTURIES FOLLOWING CHRISTOPHER
Columbus' voyages of discovery, Europeans
called the Americas the New World. Those
words proved more prophetic than they were
intended to be, for when the 13 British colonies
in eastern North America revolted against
their mother country, they ushered in a period
of shattering social change that ended in the
destruction of Europe's old order. No longer
would a privileged few taste the pleasures of
royal châteaux, even as millions starved.

After the passage of more than two cen-
turies, the sense of that colonial America
still lingers in the older cities of the Eastern
Seaboard: Boston, Baltimore, Charleston.
But it can best be felt in Philadelphia, cradle
of the Revolution, where such giants as Ben
Franklin, Thomas Jefferson, John Adams and
George Washington gathered to declare the
colonies' independence and win their freedom.
Every tourist wants to visit Independence
Hall and the Liberty Bell, but a more authen-
tic sense of a nation just emerging into the
dawn's early light can best be found in such
colonial-era streets as Elfreth's Alley, right.

Named for blacksmith Jeremiah Elfreth,
this well-preserved and carefully restored
byway is one of the oldest continually inhab-
ited streets in the U.S. Its simplicity stands
in stark contrast to the excesses of Fontaine-
bleau, and that's the point: in colonial Amer-
ica, the energies of industrious middle-class
people were unleashed as never before, and
soon the privileges and pomp of European
aristocrats were exposed as hollow posturing.

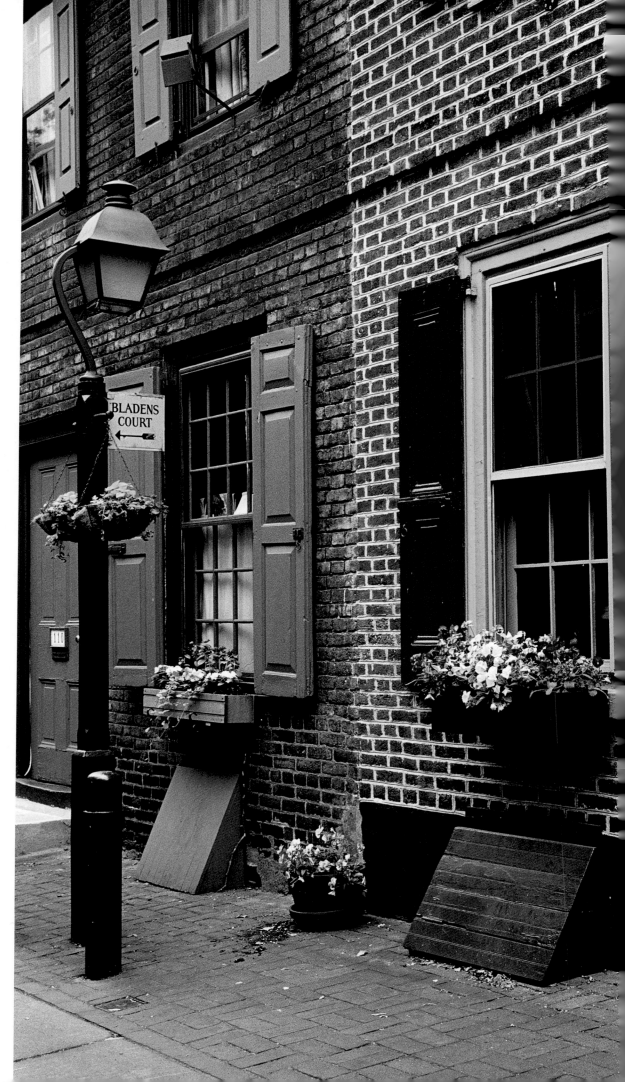

44.
Brandenburg Gate

For centuries, it has embodied
Germany's pride and ambition

ITS DESIGN MAY HAVE BEEN BASED UPON THE
Propylaea, the gateway that welcomes visi-
tors to the Acropolis in Athens, but there is
something so resoundingly Teutonic about
Berlin's Brandenburg Gate that it has become
an eternal symbol of German nationhood—
even before there was such a nation and when
it was later cloven in two. Erected in the 1780s,
when Berlin was still the capital of Prussia,
this ceremonial passageway has been woven

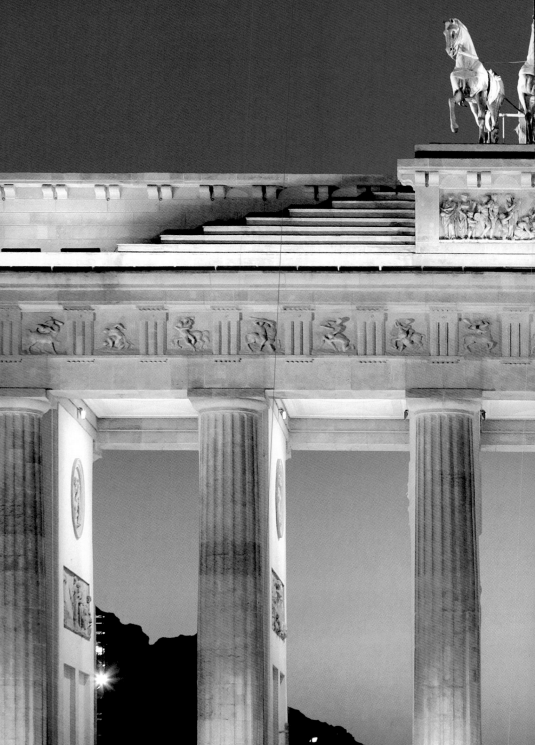

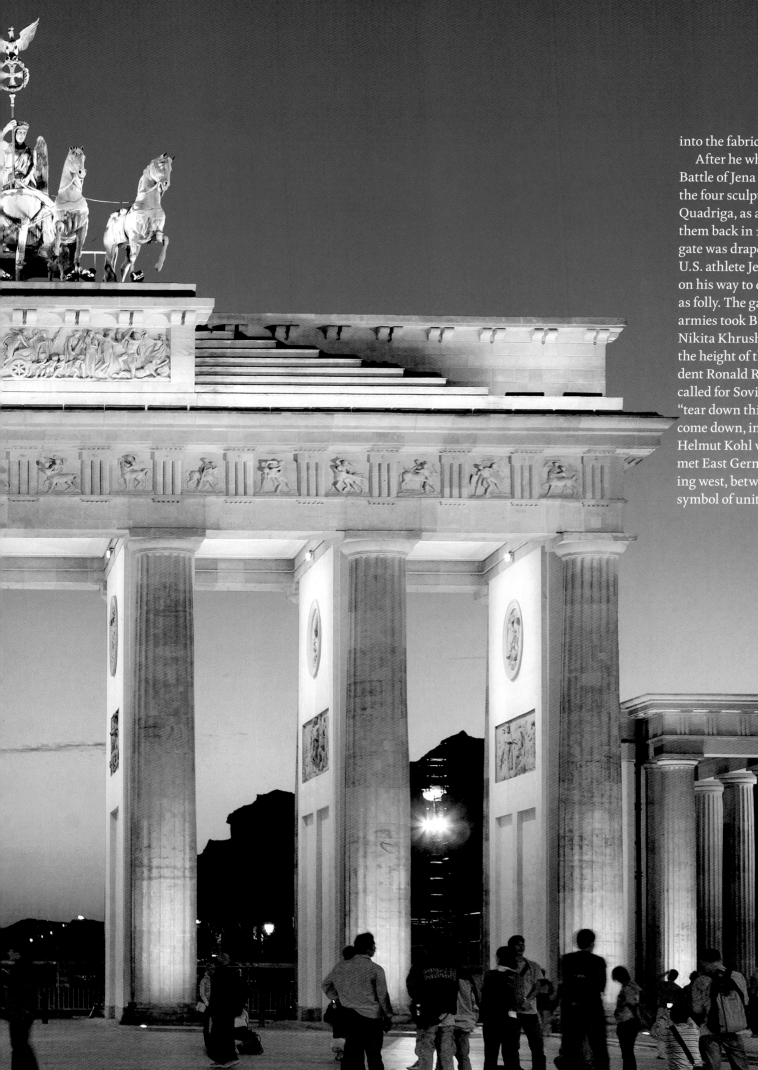

into the fabric of subsequent German history.

After he whipped a Prussian army at the Battle of Jena in 1806, Napoleon snatched the four sculpted horses on its pediment, the Quadriga, as a souvenir; the Prussians took them back in 1814. Under Adolf Hitler the gate was draped with a giant swastika banner; U.S. athlete Jesse Owens walked beneath it on his way to exposing Hitler's racial theories as folly. The gate was damaged when Soviet armies took Berlin in 1945, then closed by Nikita Khrushchev when he divided the city at the height of the cold war in 1961. U.S. President Ronald Reagan stood here in 1987 and called for Soviet leader Mikhail Gorbachev to "tear down this wall." Weeks after the wall did come down, in 1989, West German Chancellor Helmut Kohl walked east toward the gate and met East German P.M. Hans Modrow, walking west, between its columns, once again a symbol of unity rather than division.

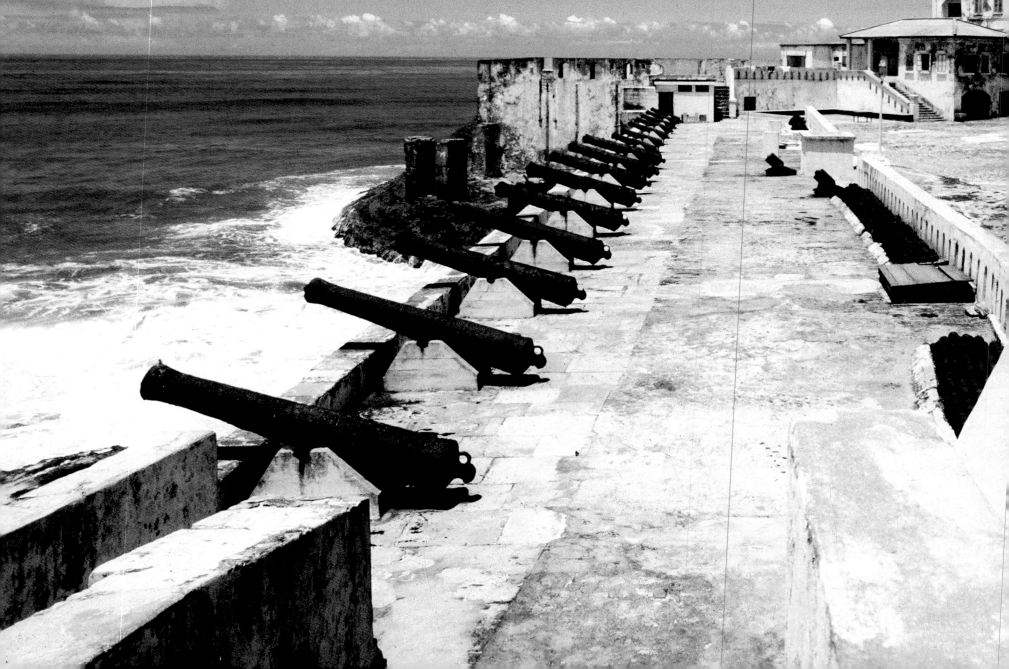

45.
Cape Coast Castle

Built by Swedish traders, this fortress in Ghana later became a transit point in the global trade in humans

THE LONG BATTERY OF CANNONS STILL TAKES aim at the seaways off the Atlantic coast of Ghana at Cape Coast Castle west of the capital, Accra. Today the social injustice this 17th century fortress served for much of its existence—human slavery—is just as outmoded as these once potent weapons. But in its heyday, the fort guarded commerce in a commodity that held a grip on human affairs as firm as that of the oil industry of today.

Individuals captured by slave traders across Africa were brought here to be sent upon the notorious Middle Passage to the Americas, where they toiled on the large plantations of the Caribbean and the U.S.

South. So essential was this form of energy to global commerce and society that when British and U.S. abolitionists sought to end slavery on moral grounds, they were met with bitter opposition. Yet the abolitionists eventually prevailed, and the last slaves departed from this building in the late 19th century.

On July 11, 2009, a U.S. President visited this building with his family. Speaking to young Ghanaians, Barack Obama reminded them that his grandfather had been a goatherd in Kenya and recalled the burdens their ancestors had overcome. "Freedom is your inheritance," he said. "Now it is your responsibility to build upon freedom's foundation."

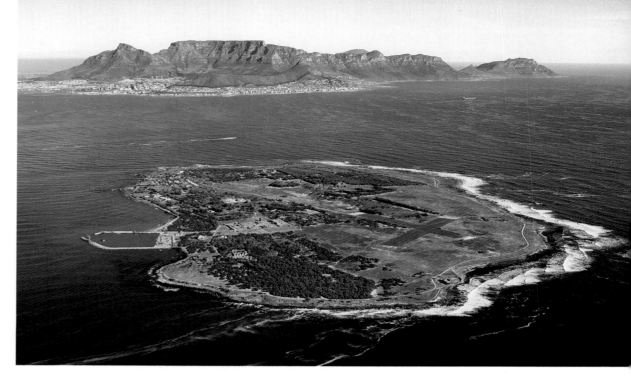

46.
Robben Island

A small jail cell reminds us that real political power resides not in palaces but in the individual will

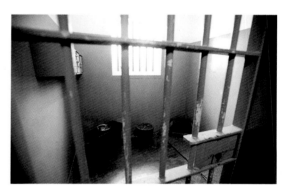

FROM THE CRAMPED PRISON CELL SHOWN at right, on a prison island in Table Bay off Cape Town, South Africa, a single man moved the world with the power of his conscience. It was here that Nelson Mandela, once a successful lawyer in Johannesburg, served much of his 27 years of confinement after he was found guilty of treason in 1964 for his deeds as leader of a militant wing of the African National Congress, Umkhonto we Sizwe, which opposed the nation's racist apartheid regime.

During their long years of captivity, Mandela and his fellow leaders of the anti-apartheid movement used their time to educate themselves and an increasing number of followers in politics and philosophy. By the 1970s, young opponents of apartheid who were convicted and sentenced to Robben Island declared that they were going to attend "Mandela University." By the mid-1980s, despite his incarceration, Mandela had succeeded in winning worldwide support for his cause, becoming a global icon of resistance to racial oppression. Meanwhile, outside his cell,

South Africa had become a pariah nation, its large black majority in open revolt against a brutal white police force and its goods boycotted by nations around the world.

In 1985, after he had been imprisoned for 21 years, South Africa's regime offered to release Mandela in exchange for his agreement not to oppose apartheid once freed. Mandela refused the offer with words that will echo through time: "Only free men can negotiate; prisoners cannot enter into contracts. Your freedom and mine cannot be separated." The price of his refusal: five more years in prison.

CHAPTER FIVE
WHERE CIVILIZATIONS COLLIDED

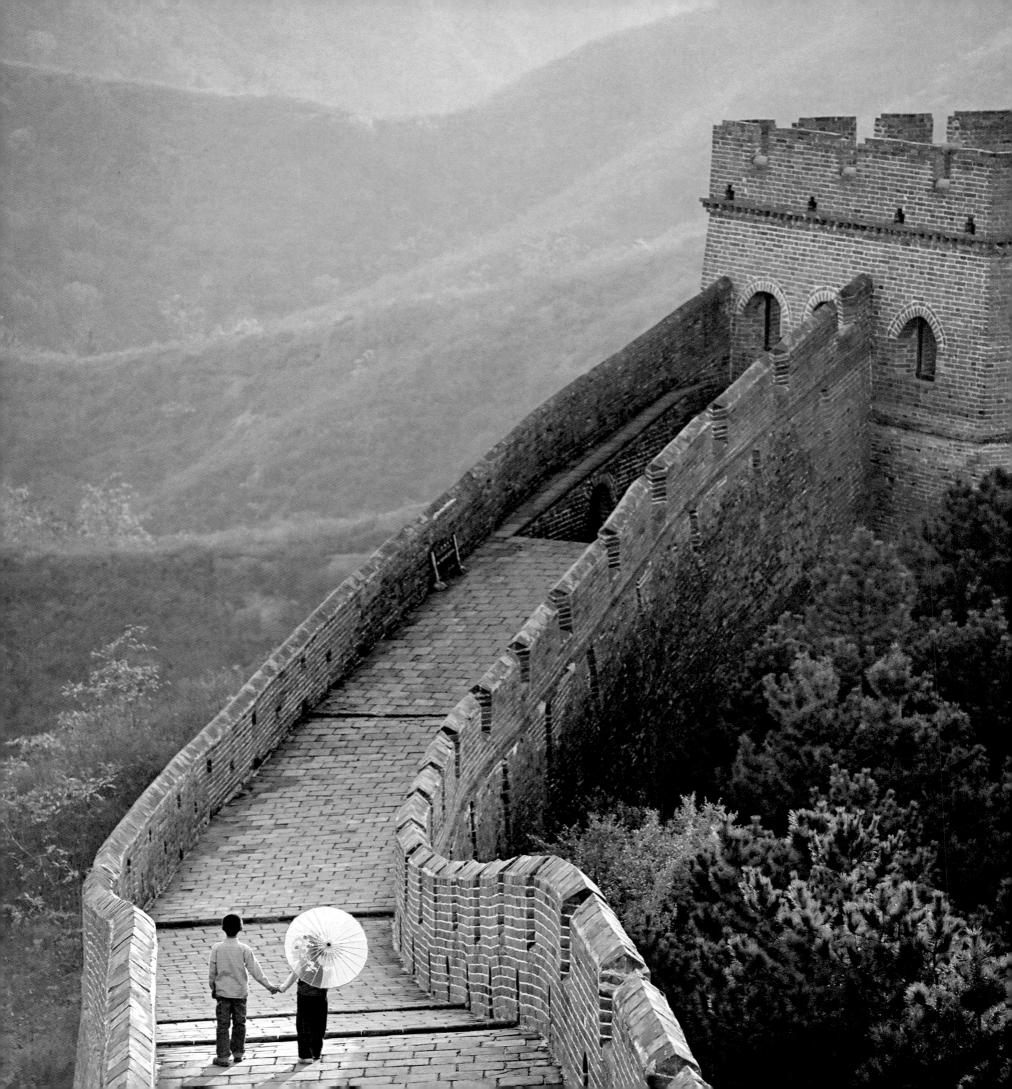

47.
Hadrian's Wall

The Roman Empire's domain in Britain was defined not by a line on a map but by a border of stone

WHEN STARKLY DIFFERENT CULTURES RUB and chafe against each other, the result can be as ugly as the Berlin Wall or as harmonious as Spain's Alhambra. The axiom that good fences make good neighbors predates Robert Frost's famous poem by at least several millenniums. When adjacent homeowners don't trust each other, a dividing line is in order—and despite the enormous cost, some civilizations have followed the same path, creating long linear barricades to keep out the unwanted.

One such barrier is Hadrian's Wall on the island of Great Britain, erected by Roman armies after a series of invasions succeeded in conquering the lower, more wealthy and populous half of the island only to bog down in a lengthy, expensive guerrilla war with Caledonian tribes in the upper island.

Conquering these "barbarians" was simply not a cost-effective strategy for the Romans. Visiting the island in A.D. 122, Emperor Hadrian ordered the building of a fortress wall that bisects the island at one of its narrowest points. Main construction lasted for six years, and when it ended, the wall stretched for some 73 miles (117 km), along a line that passed through today's Newcastle-upon-Tyne in the east and Bowness-on-Solway in the west. Protected by ditches on both sides and by small forts, called milecastles, that straddled it at regular intervals, it marked the precise northwestern edge of the Roman Empire in Europe. As Roman control of the British north country grew, a second barrier, the Antonine Wall, was built farther north. But it proved to be a ridge too far: after a few decades it was gradually abandoned, and Hadrian's Wall again marked the limits of Rome's sway before all its legions finally left the island in A.D. 410.

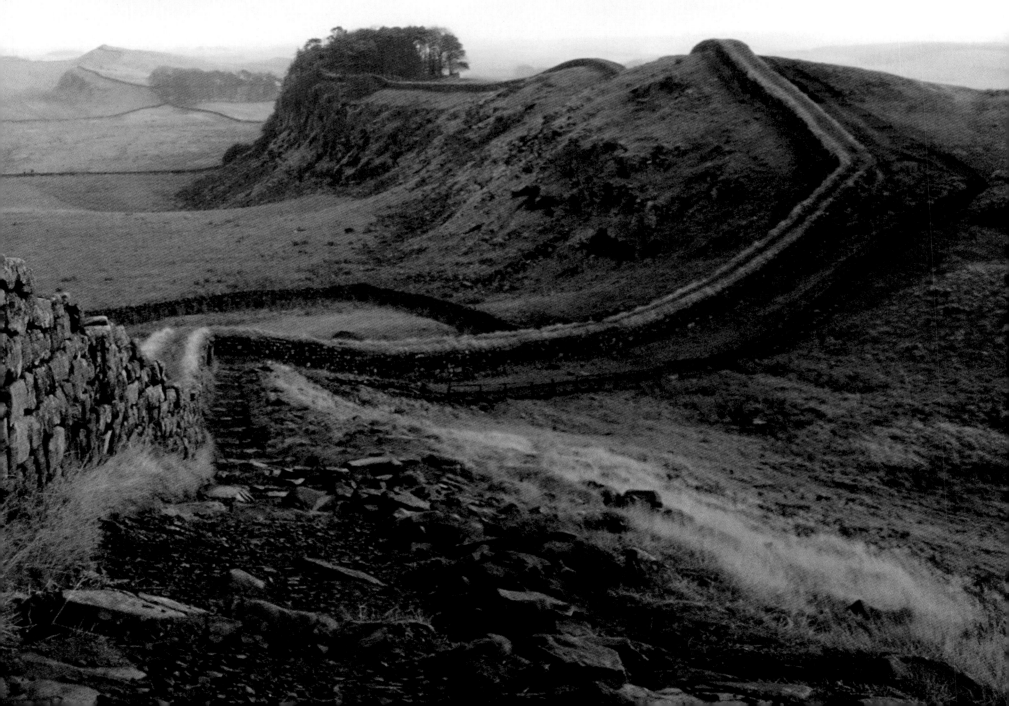

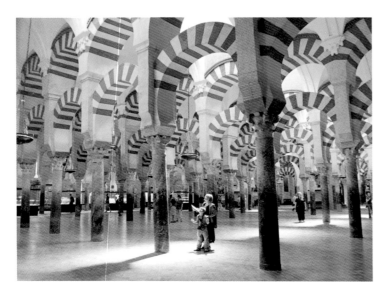

48.
The Great Mosque Of Córdoba

A great structure of Moorish Spain
still stands, converted to Christian use

POWERED BY RELIGIOUS ZEAL THAT IN PART EXPRESSED
itself in a thirst for conquest, the new faith of Islam sprang
out of the Middle East following the death of the Prophet
Muhammad in A.D. 632 with eruptive force. After sweeping
across northern Africa, Muslim armies crossed the Strait of
Gibraltar in A.D. 711 and quickly won control of almost the
entire Iberian Peninsula. Their stunning string of victories
was halted in 732, when the Muslims, seeking to cross the
Pyrenees into France, were defeated by Christian Franks.

Portions of Spain remained under Muslim control for the
next seven centuries. The Moors, as the Islamic conquerors
came to be called, proved highly tolerant of Iberia's Christian
and Jewish minorities, and the hybrid Arab-European culture
that emerged was far in advance of much of the rest of Europe.
An architectural high point is the Great Mosque of Córdoba,
begun in 784 and blessed with a magnificent array of arches,
above, supported by 856 columns of jasper, onyx, marble
and granite. Converted to Christian use when Córdoba was
reconquered by Christians in 1236, the great building remains
a remarkable synthesis of cultural cross-fertilization.

49.
Historic Istanbul

This ancient city is perched on
the boundary line of cultures

WITH ITS REMARKABLE ARRAY OF DOMES
seeming to sprout like mushrooms across a
series of ascending terraces, the Blue Mosque
in Istanbul (officially the Sultan Ahmed
Mosque) is one of the greatest works of
architecture in this city on the Bosporus,
which for its entire history has rested on the
fault lines where Europe, Asia and the Middle
East converge, geographically and culturally.

The Blue Mosque's neighbor on its sublime
hilltop location is a building that is a millenni-
um older and that has borne witness to many

of the cultural revolutions that have rocked this ancient city, the Hagia Sophia (Holy Wisdom). Construction of the church is believed to have been ordered by Constantine the Great, the first Roman Emperor to embrace Christianity, who established Constantinople as the capital of the Eastern Empire in A.D. 330. Today's Hagia Sophia is the third cathedral to occupy this site; its great dome collapsed during an earthquake in 558 and was rebuilt, in an even loftier form, by 562.

Hagia Sophia reigned over Constantinople when the city was the capital of the Byzantine Empire, becoming the primary basilica of the Orthodox Christian faith when the Eastern church split with the Roman church in 1054. It was converted into an Islamic mosque after the city fell to a Muslim army in A.D. 1453. Constantinople then served as the center of the Ottoman Empire for almost almost 500 years, until that empire collapsed in 1923, following World War I. In Istanbul, as the city has been called since then, time is measured not only in years but in civilizations.

50.
The Silk Road

The great commercial route also transported religion and culture

LIKE A LONG SKEIN OF THE DAZZLING FABRIC it was named after, the Silk Road stitched together vastly different civilizations across a span of centuries. One of history's great commercial trade routes, it also served as a camel-powered pipeline for cultural give-and-take. Italian explorer Marco Polo, above, was the most famous European to traverse this ancient route, but he was only one among millions, over many centuries, who joined the caravans that passed from the Middle East across Persia, climbed the mountain passes and high plains of central Asia and descended into China.

Among the goods exchanged via the Silk Road were herbs, spices, medicines, jewelry and works of art and craft. Yet, according to British scholar Oliver Wild, "the most significant commodity carried along this route was not silk, but religion." The road carried Buddhism from India to China and Islam from the Middle East to central Asia. Today, the ancient lure of the Silk Road can still be glimpsed. At near right, a silk dealer shows his wares in Kashgar in China, one of the road's eastern terminals. In the center is a market in Samarkand, the fabled oasis in Uzbekistan. At far right is an Indian carpet-weaver in Rajasthan.

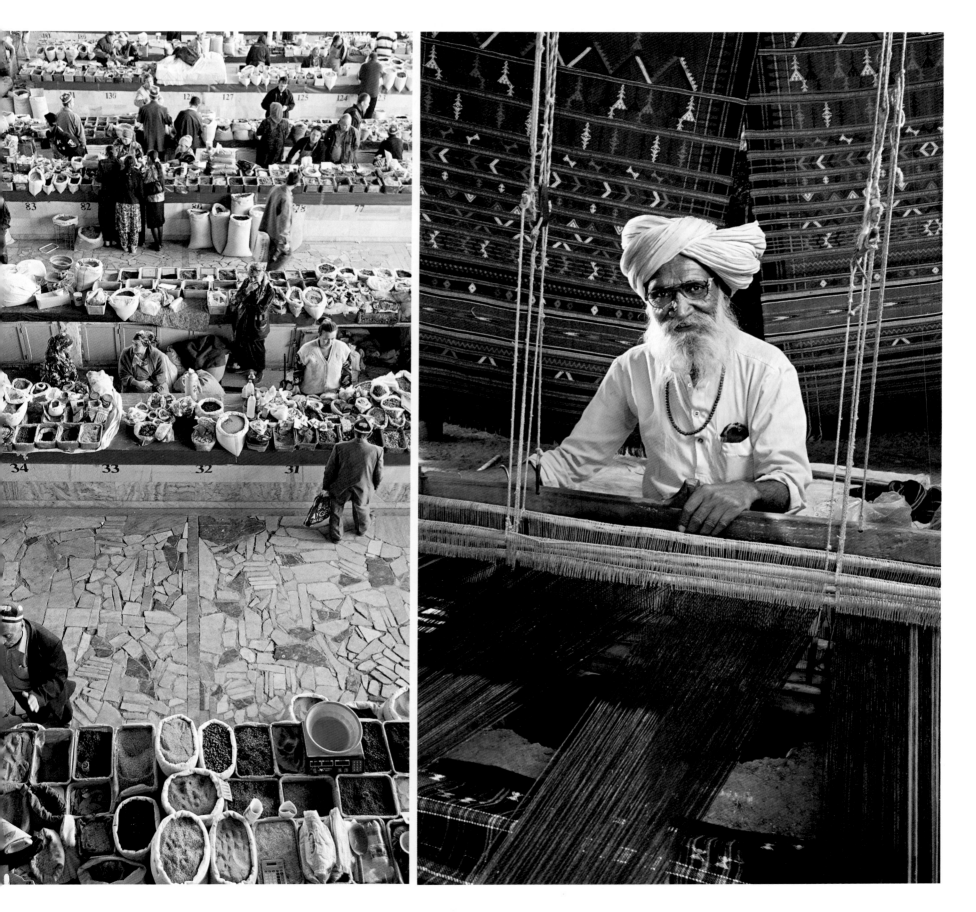

51.
The Great Wall Of China

This rambling barrier was built
to keep hated enemies outside
an Emperor's hard-won domain

YING ZHENG, CHINA'S FIRST EMPEROR, WAS seldom idle. The man who unified China in the 3rd century B.C. conquered six other feudal states to do so, began a national system of roads and planned a splendid bodyguard for his remains: the famed retinue of more than 7,000 terra-cotta soldiers that was found in 1974. Once, in a fit of pique, he may have buried hundreds of scholars alive—there's some dispute as to whether they were alive. But there's no dispute about his grandest stroke: he ordered up the Great Wall of China.

Designed to keep "barbarian" outsiders from entering China's exalted realms, the first Great Wall was begun in 220 B.C. and was built by a resource China has always held a monopoly on: manpower. The First Emperor's wall was built in only 10 years, thanks to the 300,000 peasants who labored to construct it.

Only fragments remain of that original Great Wall; the massive linear fortification we see today was mainly built under the Ming dynasty in the 15th century A.D. Running roughly across the southern edge of Inner Mongolia, it meanders across hill and hollow for some 5,500 miles (8,851 km). Now that China has opened its doors to hordes of barbarians (uh, tourists), it is thronged with visitors. TIME Beijing correspondent Simon Elegant offers this advice for visitors: "Simatai is two-plus hours from Beijing ... But the effort is worth it. Not only is the scenery here—with the wall snaking up and down plunging cliffs and jagged ridges—the most dramatic, but the crowds are also thinnest." The First Emperor, we suspect, would approve.

52.
Lindisfarne

A tidal island off Britain's
northern coast was the site
of the first great raid by
Norsemen seeking plunder

WHEN THE MIGHTY ROMAN EMPIRE FINALLY fell before the repeated onslaughts of native European tribes, the social ties that had bound the empire from Libya to Turkey to Britain frayed, and many who valued knowledge and the arts found themselves huddling in monasteries along the edges of the former empire, oases of civilization in a warlord world. Such a place was Lindisfarne, the "holy island" off Britain's northeast coast, where a priory founded in A.D. 635 by the Irish-born St. Aidan became an outpost of learning. There the fine illustrated manuscript known as the *Lindisfarne Gospels* was most likely created.

In 793 the peace of this sacred sanctuary was violated when Norse invaders, the Vikings, invaded the island, killed many of its monks and pillaged the treasures of the priory. The sensational raid rocked Europe as the news spread: it marks the moment when the Vikings, formerly peaceful traders, first showed they would also pillage and plunder. The prayer uttered frequently and fervently at the close of the first millennium—"From the fury of the Northmen, O Lord, deliver us"—bore memories of Lindisfarne.

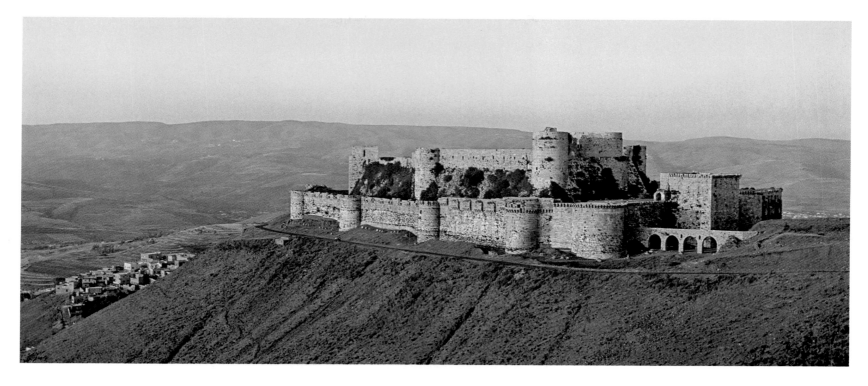

53.
Crac des Chevaliers

A well-preserved relic of the Crusades is a reminder
of the deep emotions that drive religious wars

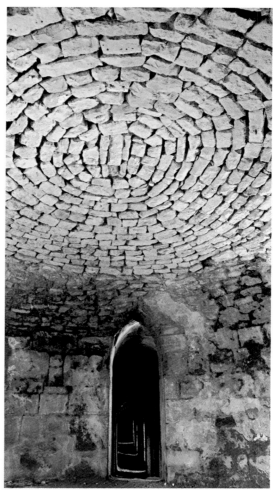

WORLD WAR II CAME TO AN END IN 1945, BUT by the 1960s, the two great enemies that had been beaten in the war by the U.S. and its allies, Germany and Japan, had become firm friends with their ex-foes. Yet 902 years after European Christians capped the First Crusade by pillaging the holy city of Jerusalem, Muslim zealot Osama bin Laden described the attack he launched on the U.S. on Sept. 11, 2001, as payback for the Crusades. Religious wars, it seems, touch humans far more deeply than do campaigns launched to win land and wealth or establish a new political order.

Crac des Chevaliers is one of the best-preserved sites from the era of the Crusades. This "Fortress of the Knights," located 90 miles (145 km) west of Damascus, is perched upon a highly defensible natural plateau that looms

some 2,100 ft. (650 m) over the surrounding landscape. Built by a local emir in A.D. 1031, it was captured briefly during the First Crusade in 1099, reverted to local control for 11 years, then was retaken by Christians in 1110. For the next 161 years, it was an important European outpost, serving as the headquarters of the Knights Hospitallers, the medieval chivalric order that cared for Christian soldiers and protected pilgrims to the Holy Land.

At its height, the fortress was a mini-city, home to a garrison of some 2,000 Christians. Its defenders successfully resisted a siege by the great warrior Saladin in 1188, but the outpost fell to a Muslim army in 1271, thanks in part to trickery: its besiegers presented a forged letter from a European commander ordering the Hospitallers to surrender the post.

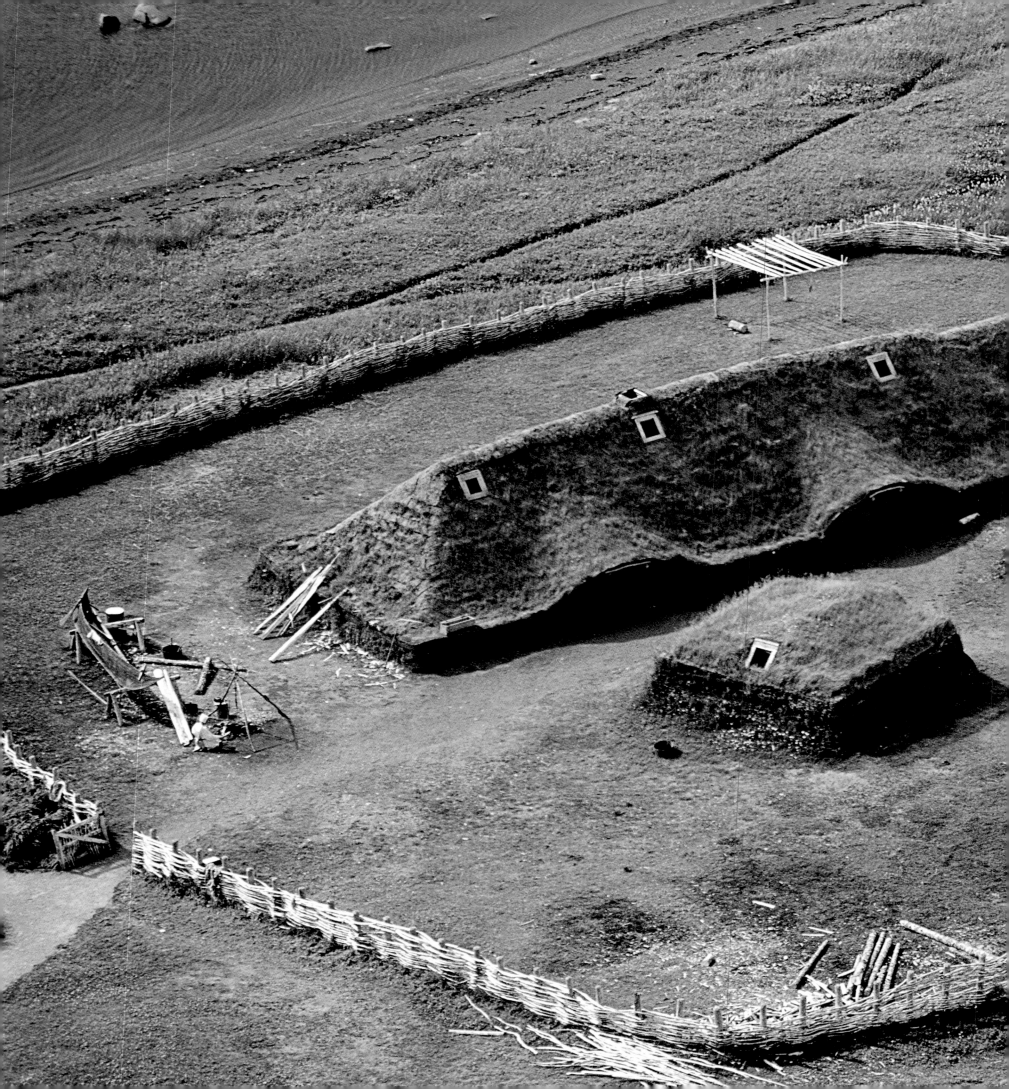

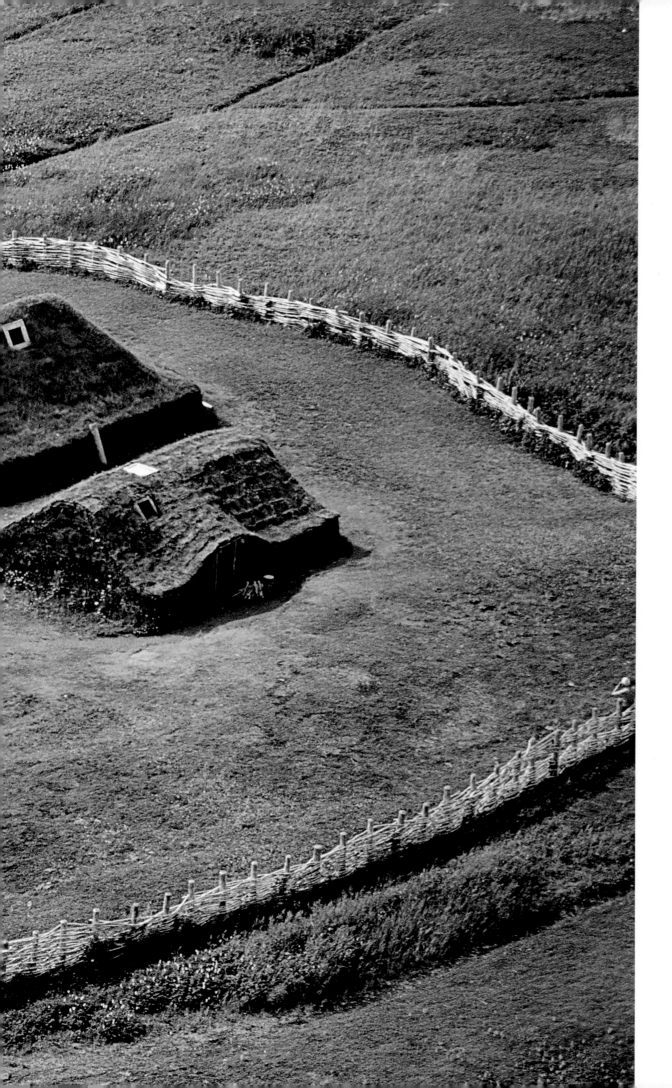

54.
L'Anse aux Meadows

Ten centuries ago, hardy Norse mariners became the first Europeans to visit the Americas

WHEN CIVILIZATIONS COME TOGETHER, THEY don't always collide. The discovery and short-lived settlement of North America by the Norse mariner Leif Ericsson and a small band of fellow pioneers was more *Brief Encounter* than *War of the Worlds:* it left no imprint on history. The Vikings landed in Newfoundland around A.D. 1002-03, drawn by stories of a mysterious land west of Greenland, where Ericsson's father Eric the Red presided over a well-established Norse settlement.

Ericsson and his associates built a small settlement in the area known today as L'Anse aux Meadows (Jellyfish Cove), which consist-ed of three large timber-and-sod longhouses as well as five less imposing buildings. After a few years the Vikings departed Newfound-land; they may have quarreled with local peoples. For more than 900 years, their story, though cited in ancient Norse sagas, was con-sidered a fable. Then, in 1960, a husband-and-wife team of Norwegian history sleuths, Helge and Anne Ingstad, found the remains of the Norse settlements after more than a decade of searching the coasts of Canada for them.

Today the three largest Viking buildings have been restored, offering a fascinating glimpse of a challenging, severe life lived on the edge of civilization. An iron smithy was the most advanced technology on the site; other artifacts include a spindle for weaving and rivets from a presumed boatyard. After Ericsson and his colleagues pulled up stakes, it would be almost 500 years before other Euro-peans would trod on the soil of the Americas.

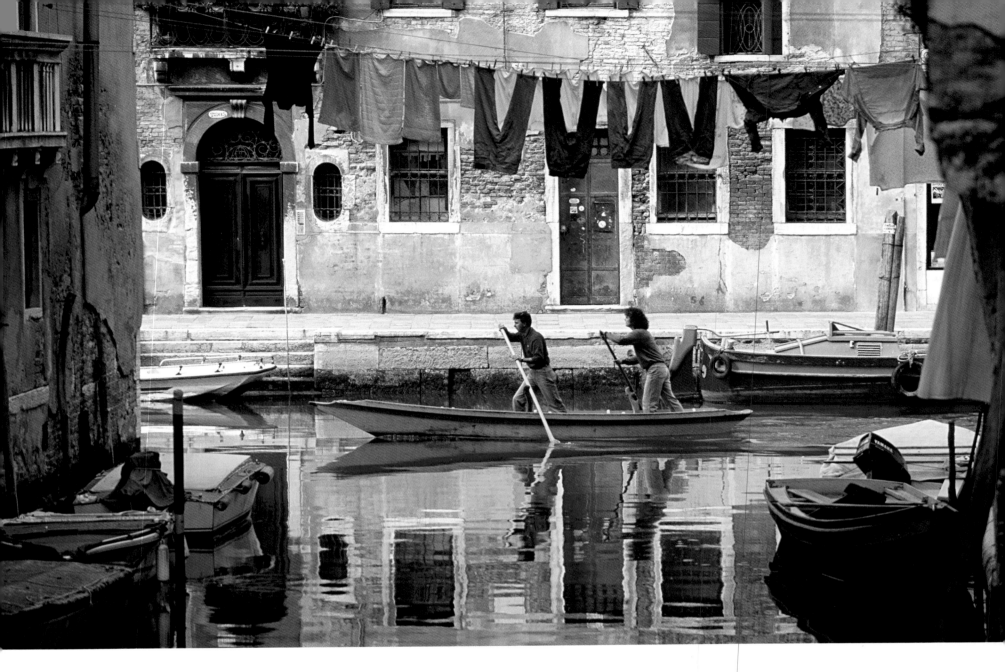

55.
The Ghetto, Venice

This venerable Jewish neighborhood has lent its name to minority districts around the world

IN THE LONG CENTURIES OF THE DIASPORA, the scattering of the Jews that followed the destruction of Jerusalem by Roman armies in A.D. 70, the exiles became the most noted wanderers of the Mediterranean region, settling in cities from Spain to northern Europe to Asia Minor. Famously, they preferred not to assimilate themselves fully into local cultures, as they fought to maintain their unique cultural identity and mores.

Broadly speaking, relations between Muslims and Jews were more peaceful than those between Jews and Christians: in Moorish Spain, Jewish scholars like Moses Maimonides were honored. But relations between Christians and Jews were often fraught, exacerbated by Christian teachings that branded Jews with the killing of Christ and popular lore that associated Jews with satanic rites.

By the Middle Ages, Jews often occupied separate quarters of European cities, and this geographic isolation first acquired a name in Venice, where officials ordered Jews to reside only in their traditional sector in the Cannaregio area, part of which was built over a foundry slag dump. *Ghetto* was derived from *geto*, foundry, or *getto,* a casting. (An old theory that the word was derived from *burghetto*, an Italian word for "small city," has been discounted.) The term spread, becoming the universal word for any district—from London to New York City to Warsaw—where minority populations are confined, victims of the prejudices that are sparked when cultures collide.

56.
Mostar Bridge

Spanning a river—as well as vast gulfs in culture and religion— it again unites a Balkan city

FEW REGIONS OF THE WORLD HAVE SUFFERED more from ethnic and religious divisions than the Balkans, where Roman Catholics, Muslims, Jews and Orthodox Slavs have rubbed shoulders—and brandished arms—for centuries. Memories and antagonisms live long: the Battle of Kosovo, in which Muslim Turkish invaders prevailed over Slavic Serbs, is recalled so frequently that one might assume it occurred in 1989 rather than 1389. The assassination that triggered World War I took place there, and after World War II the smallish states of the region were cobbled into the unlikely state known as Yugoslavia.

After the death of World War II hero and figure of national unity Josip Broz Tito in 1980, the Balkans reverted to status quo; as Shakespeare might have put it, ancient grudges broke forth in new mutinies. The constituent parts of Yugoslavia declared independence amid a series of ethnic and religious conflicts in the 1990s. One victim of the war was a symbol of vanished unity: the Stari Most, a bridge that had stood since 1566, linking the Muslim quarter of the city of Mostar in Bosnia and Herzegovina with the Christian sector. During the Croat-Bosnian war of the early '90s, the bridge was shelled by Croat artillery in what many believed to be a deliberate act of historical and cultural vandalism, as the bridge had been commissioned by the great Muslim leader Suleiman the Magnificent. But this story has a happy ending: after peace was brokered in 1995, international donations helped build the new bridge at right.

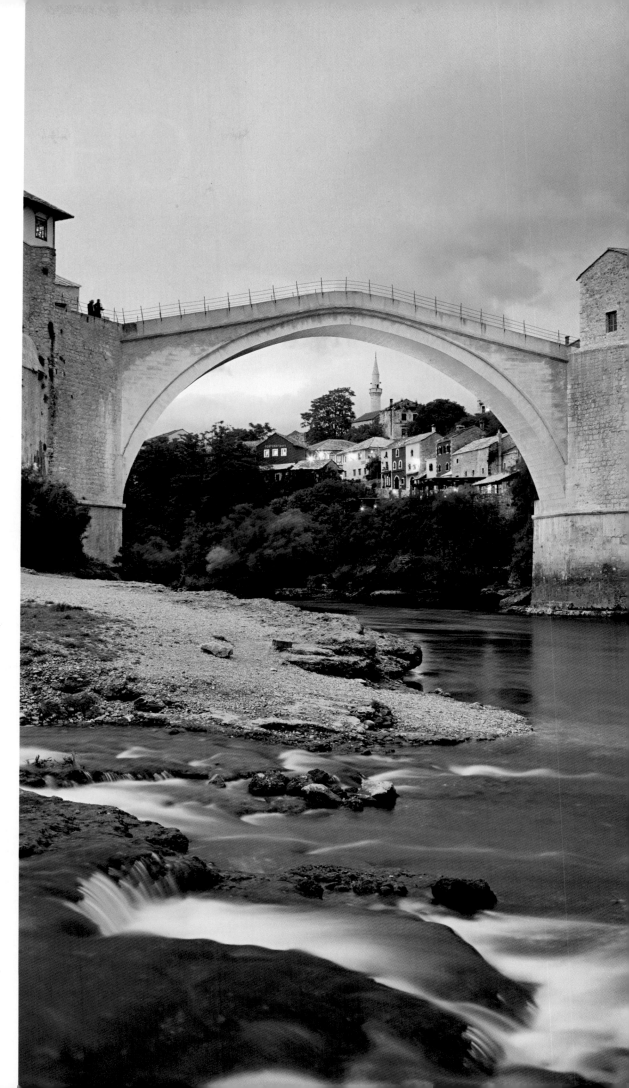

CHAPTER SIX

WHERE BATTLES WERE WAGED

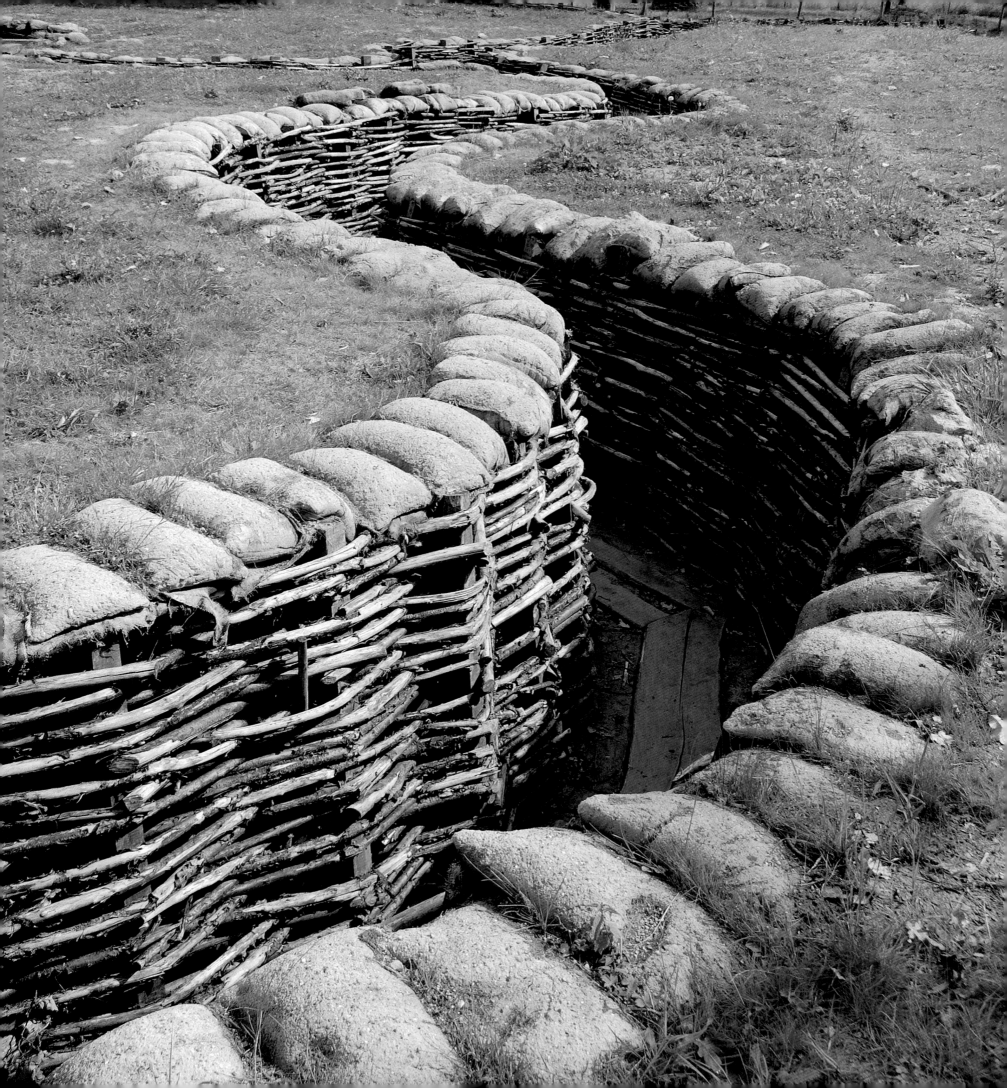

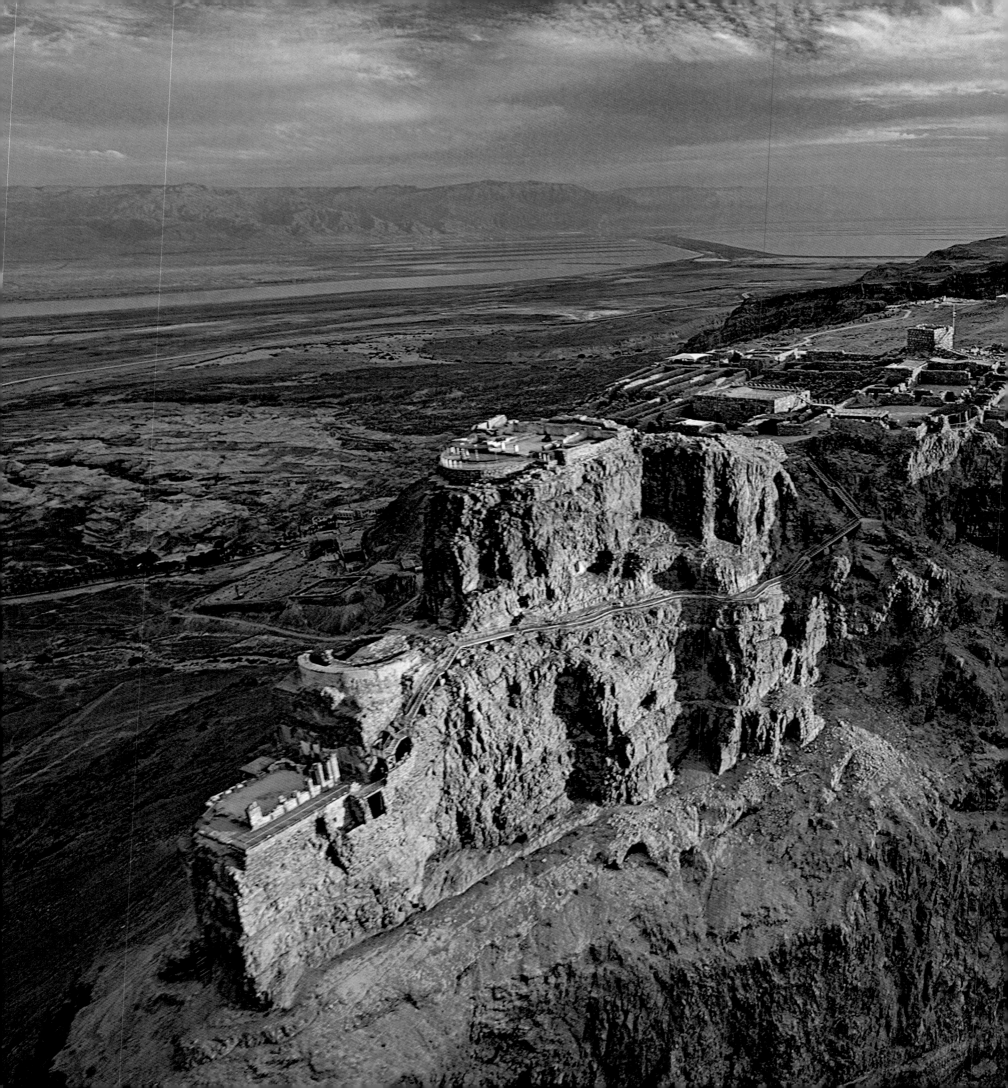

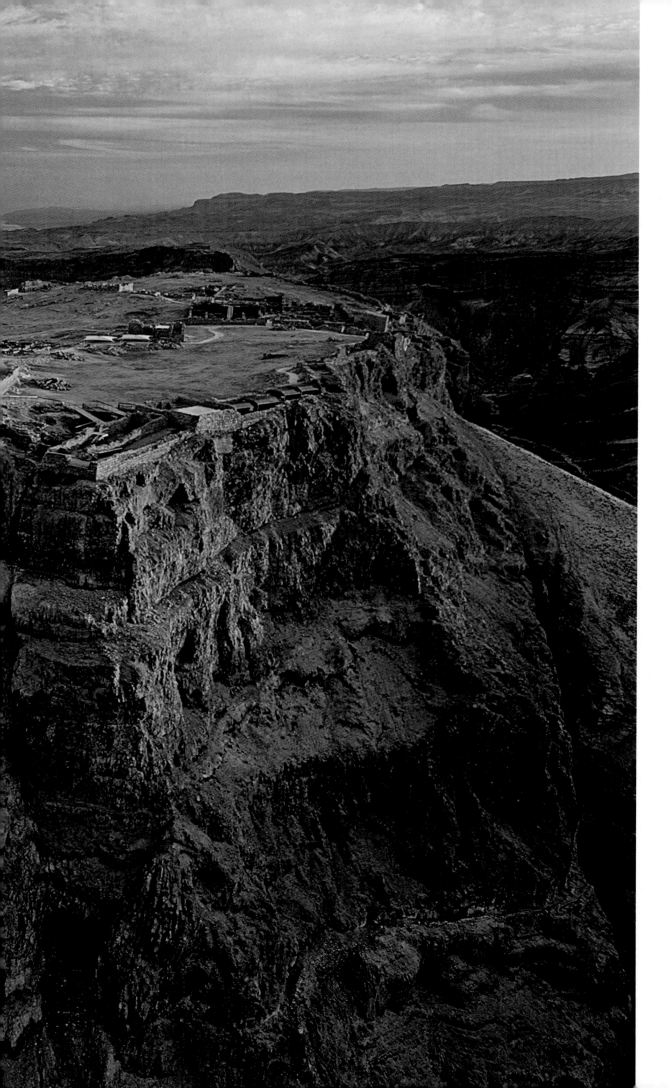

57.
Masada

When Jewish rebels dared to challenge Roman occupation, the empire struck back

ONE OF WARFARE'S GREAT "LAST STANDS" was waged at one of history's most picturesque battlegrounds, the fortress of Masada in today's Israel, atop a plateau that rises more than 1,300 ft. (400 m) above the desert plains and the nearby Dead Sea. This highly defensible location had been turned into a citadel by Herod the Great circa 31 B.C. Some 100 years later, around 68 A.D., a group of militant Jews took control of the site and made it a base for guerrilla actions against the Romans. These were the Sicarii, members of the rebellious Zealots who strongly opposed the Roman Empire's occupation of Judea. In the next two years, their harassment of Roman soldiers and civilians became a serious problem, so the Romans set out to capture Masada.

The Romans began by building a wall around the fort, placing its estimated 960 inhabitants under siege. Then they constructed a ramp to the plateau's western side, its lowest. (Recent geological studies have shown that this ramp connected the fortress to a nearby tor, as opposed to rising from the ground up.) In April of 70 A.D., the Romans breached the wall of the fortress, but they were denied the chance to put the Sicarii to death, for the fort's defenders had taken a mass suicide vow: 10 of them slew all the others, and then one man was chosen by lot to slay his nine associates before committing suicide himself. That's the way the Roman historian Josephus told the story. So far, archaeologists have found evidence supporting most of the details of his account—but the remains of bodies killed in a mass suicide is not among them.

58.
The Plains of Abraham

On a lofty plateau in today's Canada, the future of
two nations was decided in a quarter of an hour

THE MOST DECISIVE BATTLE EVER FOUGHT IN
the Americas lasted little more than 15 min-
utes. Yet if the conflict was brief, the stakes
were enormous, for the fate of an entire conti-
nent was settled on this day. The setting was
equal to the occasion: the Plains of Abraham
sprawl across a plateau that towers over the
St. Lawrence River as it flows past Quebec
City to the sea. The French explorer Samuel
Champlain had selected this highly defen-
sible site for the city he founded here in 1608
because it commanded access to the interior of
Canada. Now, as part of the long conflict that
pitted Europe's colonizing powers against one
another, which Americans call the French
and Indian War, the future of New France
and Britain's colonies in North America
was in play.

On Sept. 13, 1759, following an ineffective
British siege that lasted three months, a Brit-
ish army under General James Wolfe caught
French forces under the Marquis de Montcalm
napping. Believing his lofty position to be
impregnable, Montcalm failed to guard his
perimeter thoroughly. Wolfe's troops landed
upriver of the Plains of Abraham, secured a
foothold and quickly marched upon the foe.
Rather than wait for reinforcements, who were
on their way, Montcalm drew up his troops
to meet the challenge. In the brief battle that
followed, the French were routed, and both
generals were mortally wounded. The battle
began the rapid decline of French dominion
in Canada, although that nation's heritage re-
mains strong today in the province of Quebec.

59.
Concord Bridge

The first salvos of American
independence were fired here

AS A RESULT OF THE 1759 BATTLE ON THE
Plains of Abraham, Britain's sway in North
America increased and French influence
waned. Seldom has such a small battle
exerted so much leverage upon the future. But
only 16 years later, in the British colony of
Massachusetts Bay, a pair of minor skirmishes
on a single day also proved momentous, kick-
ing off the American Revolution in earnest.

The day was April 19, 1775. The two small
frays took place in Lexington and Concord,
just north of Boston; both were hotbeds of
anti-British sentiment. Exasperated at the
growing number and power of the colonial
militiamen, or Minutemen, in Massachusetts,
British leaders decided to march to Concord
and seize a large cache of arms that was stored
there—and to arrest two prominent voices of

rebellion, John Hancock and Samuel Adams,
believed to be hiding in Lexington.

Alerted by silversmith Paul Revere, the two
rebels had fled by the time 700 British troops
arrived in Lexington, where a small line of
some 77 Minutemen waited on the village
green. Shots were exchanged: eight Americans
died and 10 were wounded, but no Britons
fell. The British now marched on to Concord,
where more Minutemen were dug in on the
hills. As the British began to ransack the
town, the Americans charged across the Old
North Bridge and routed them. The British
fought a desperate rearguard action to return
to Boston, but by day's end some 200 Britons
were dead, wounded or missing. For both
sides, there would be no turning back. On this
small bridge, a great revolution had begun.

60.
Gettysburg

In the bloodiest conflict ever fought on U.S. soil, General Robert E. Lee's Confederate army was forced to retreat

AFTER ROBERT E. LEE TOOK COMMAND OF THE ARMY OF NORTHERN VIRGINIA IN 1862, he led his soldiers to a number of victories that humiliated the Union Army. Lee fought off a number of Federal invasions of Virginia with a brilliant array of military tactics. Dividing his armies to outflank his foes and quick-marching them to arrive at battlefields by surprise, Lee out-thought and out-fought his foes. It seemed he could have played defense forever, but the general knew that the Confederacy, far outmatched by Union manpower and resources, must force an early conclusion to the war—or lose it. In September 1862 he invaded Maryland, hoping to take Washington, D.C., but he was turned back, at a massive cost in blood, at Antietam. Ten months later, he again marched his men north, this time planning to swing through the rich farmlands of Pennsylvania before striking the Union capital.

As Lee's troops moved north once more, they feasted off the bounty of the land. When they finally butted heads with a batch of Union armies converging on them in the small town of Gettysburg, Pa., Lee decided it was time to hunker down and roll the dice in a classic set-piece battle. The three-day affair that followed was the largest and bloodiest conflict of the war. On July 3, its last day, Lee boldly marched Southern troops head-first against well-entrenched Union forces in the desperate attack called Pickett's Charge, and the Confederates were slaughtered. Gettysburg's toll: more than 16,000 Confederate dead and wounded; more than 17,000 Union dead and wounded. Lee staged a hasty retreat, saving many lives, but after losing this gamble, he must have sensed that he was now leading a lost cause. "It was all my fault," he told the troops who so admired him, as they trudged, beaten, back to Virginia.

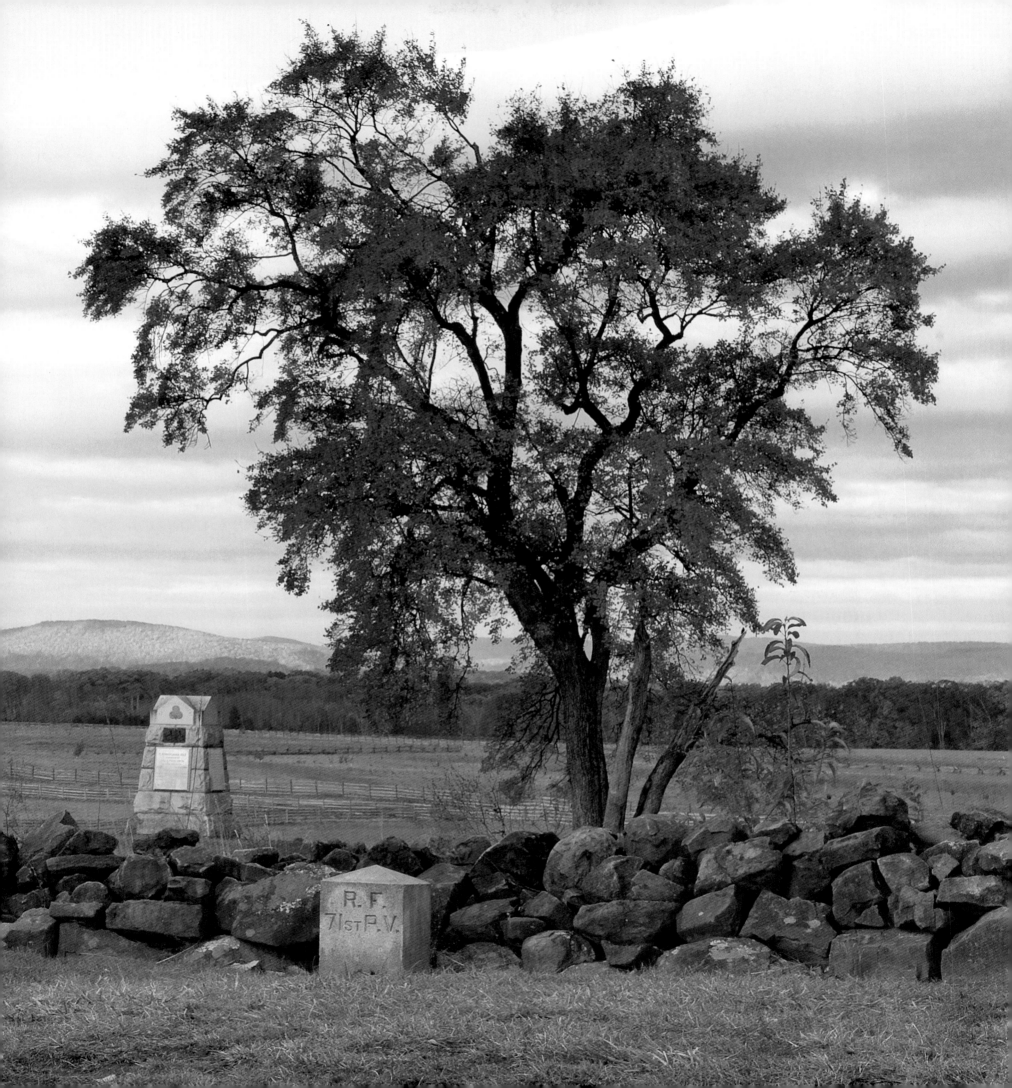

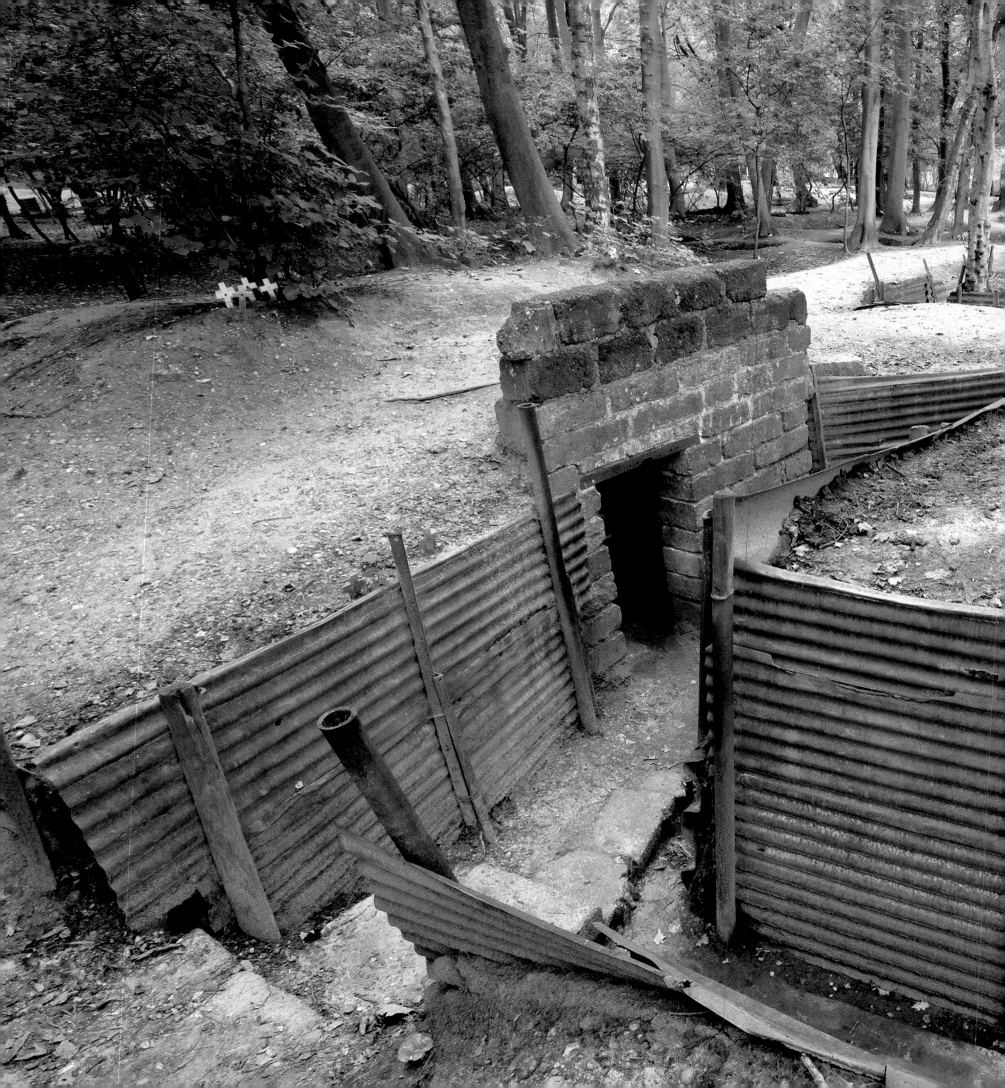

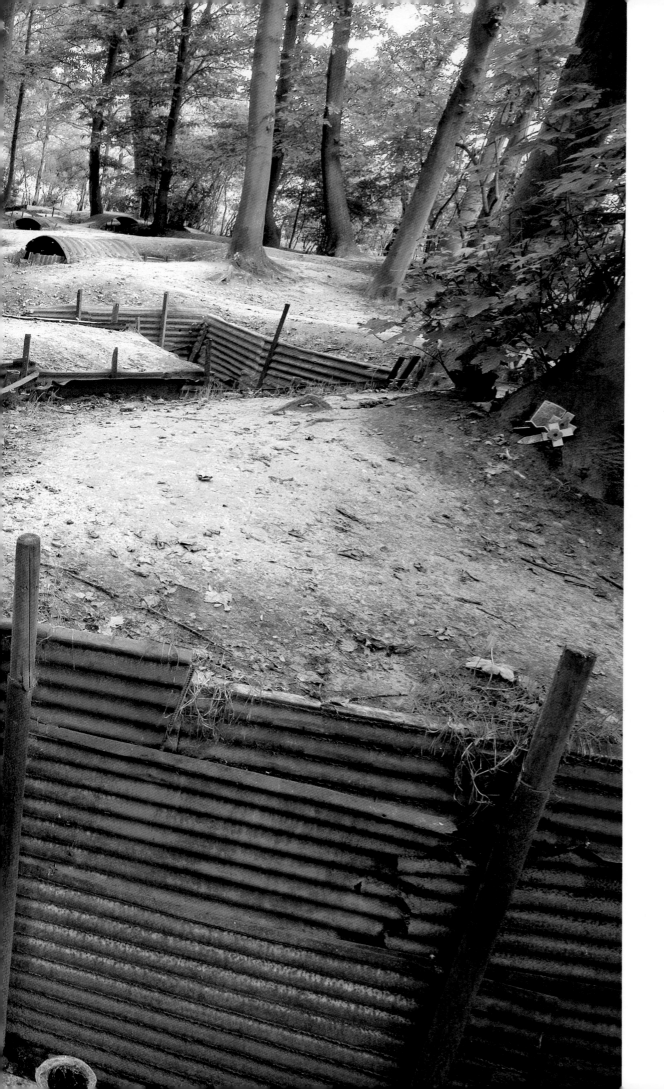

61.
Trenches of World War I

When defense trumped offense, a bloody stalemate ensued

THE ENDGAME OF THE U.S. CIVIL WAR ON THE critical Virginia front bogged down into a long siege of the town of Petersburg, Va., a critical supply route for the nearby Confederate capital of Richmond. For 10 months, the two sides devoted their energies not to the open-field battles of infantry, artillery and cavalry that had characterized warfare for centuries. Instead, the armies dug in, creating trenches and barricades that turned war into a defensive waiting game interrupted by occasional offensive forays, a recipe for a bloody draw.

Fifty years later, European armies fighting the first great global war of the 20th century found themselves locked in a very similar stalemate. Early in the war, German armies made impressive advances against British and French armies on the war's Western Front. But when their charge was halted, both sides went to ground, creating elaborate series of underground entrenchments along a front line that stretched more than 400 mi. (644 km) across Belgium and northern France. At left are a few of the trenches preserved as memorials at Sanctuary Wood near Ypres, Belgium.

With defensive tactics far outpacing offensive technologies, World War I devolved into a war of attrition that at times was little more than mass slaughter. Years passed and millions died, to no avail. When the exhausted Germans finally accepted peace terms, an entire generation of young men had been systematically wiped off the face of the earth— almost 10 million of them. Sadly, the new world order created after this bloodbath only stimulated an even deadlier sequel.

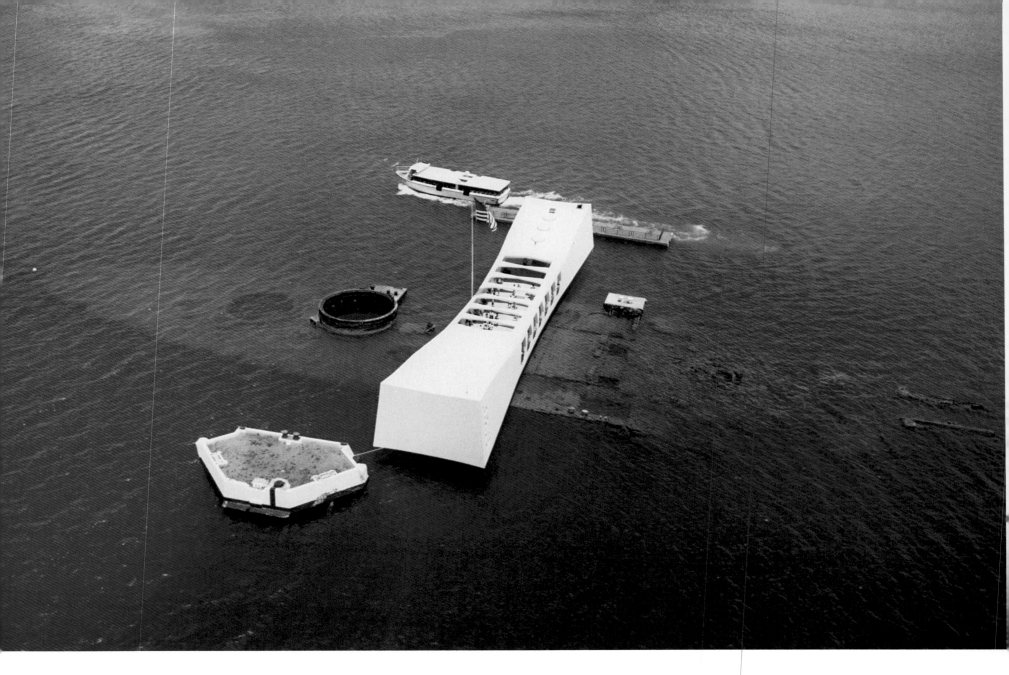

62.
Pearl Harbor

A war memorial bestrides
a sunken graveyard at
this first U.S. battleground
of a great global conflict

THE U.S.S. *ARIZONA* MEMORIAL IN PEARL Harbor, Hawaii, spans the midsection of the big U.S. Navy battleship that was sunk here on the morning of Dec. 7, 1941. The deteriorating ship is the final resting place for the remains of many of the 1,177 crewmen who died here, the largest component of the 2,403 Americans who lost their lives when Japanese planes conducted a stunningly successful surprise attack on the large U.S. naval base in the Pacific.

"Torpedoes launched from bombers tore at the dreadnoughts in Pearl Harbor," TIME reported in its issue dated Dec. 15, 1941. "Dive-bombers swooped down on the Army's Hickam and Wheeler fields. Shortly after the attack began, radio warnings were broadcast. But people who heard them were skeptical until explosions wrenched the guts of Honolulu. All the way from Pacific Heights down to the center of town the planes soared, leaving a wake of destruction."

The deadly raid's impact was lessened by pure good fortune: several U.S. aircraft carriers normally berthed at the harbor were out at sea. The raid was a mighty coup for Japan, but it aroused a slumbering giant: for years, American isolationists had argued that the U.S. must remain aloof from the conflicts that were consuming Asia and Europe. Now, with a single stroke, Japan had forced America's entry into a war on two fronts, not only in the Pacific but also in Europe, where Japan's Axis ally, Adolf Hitler's Germany, had conquered France and was threatening to invade Britain.

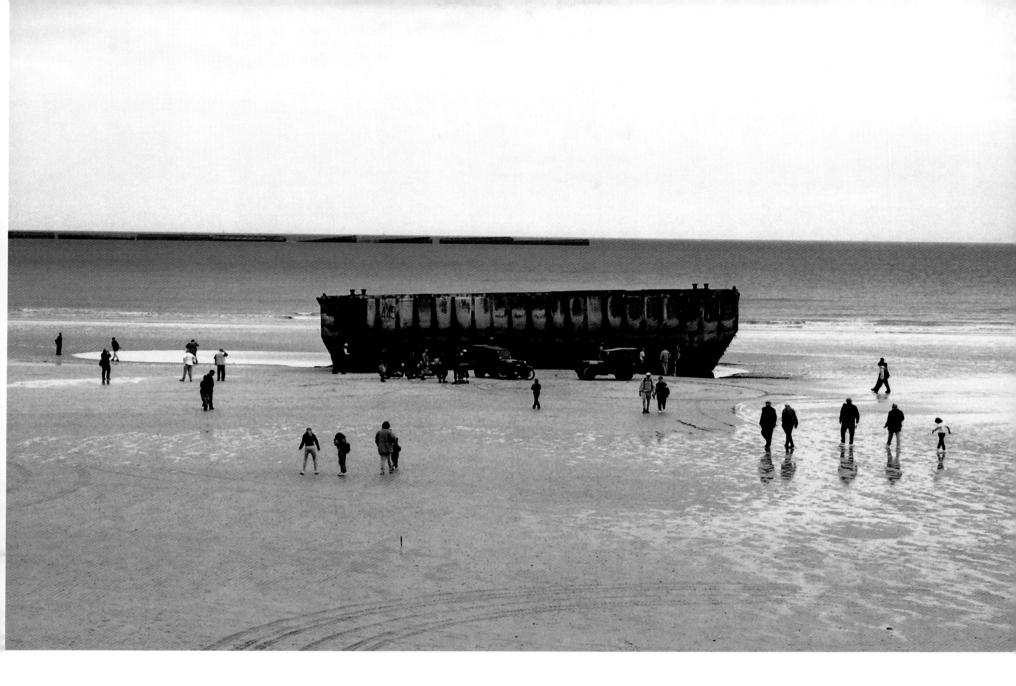

63.
Normandy Beaches

For Americans, World War II commenced on an island in the Pacific—and began to end on the coast of France

SURROUNDED BY CURIOUS VISITORS, THE rusting hulk of a World War II landing craft shown above could be a relic from centuries past. Yet fewer than seven decades have passed since U.S., British and Commonwealth soldiers swarmed ashore on the coast of northern France on the morning of June 6, 1944, in history's greatest amphibious invasion.

The shingle of land above, near the town of Arromanches, was dubbed Gold Beach by Allied war planners. Some 25,000 British troops landed there in one of the less costly landings of D-day in terms of Allied lives lost; the deadliest fighting was at nearby Omaha Beach, where the U.S. suffered some 2,000 casualties. When Gold Beach was secured, engineers began putting in position a prefab-

ricated artificial harbor that allowed Allied ships to tie up and unload the tons of supplies that would be needed for the battles ahead.

The troops who took part in the invasion were thrilled to be finally taking the offensive against Hitler. One story sums up the bravery on display that day. A titled Scottish commando leader on a troop ship hailed a landing craft that was heading back from Gold Beach to bring in a second wave of soldiers. The craft was riddled with bullet holes and held a number of wounded men. A single man was standing, clinging to the wheel, blood running down his face. "How was the landing?" hollered Brigadier Simon Fraser, 15th Lord Lovat. The soldier straightened up, made a V-for-victory salute and replied, "A piece of cake."

Hiroshima

The city's Peace Memorial Museum recalls a day of horror

THIS LOVELY SCENE, WITH COLORFUL LANterns gleaming on the waters of the Motoyasu River, commemorates a hideous event: the dropping of an atom bomb on the city of Hiroshima in Japan, which helped bring World War II in the Pacific to a sudden end. The new weapon had been perfected in an accelerated program so secret that U.S. Vice President Harry Truman was not briefed on it until he was sworn in as President following the death of Franklin D. Roosevelt in April 1945.

Truman was faced with a grim calculus in deciding whether to use the bomb against Japan, but he believed that the deaths of tens of thousands of Japanese civilians in the bombing would far offset the millions of U.S. troops and Japanese soldiers and civilians projected to die if the U.S. were to invade Japan.

The bomb was dropped on Hiroshima at 8:15 a.m. on Aug. 6, 1945. Some 70,000 people were killed almost instantaneously, and another 70,000 died of radiation poisoning in the months and years ahead. Only after a second bomb was dropped, on Nagasaki, did the Japanese finally agree to surrender. Today one of the few buildings that still stood after the bombing, the A-Bomb Dome, a former industrial exhibit hall, right, has become a memorial to the sufferings of Hiroshima. This lantern festival is held each year on Aug. 6, a glowing response to the darkness of war.

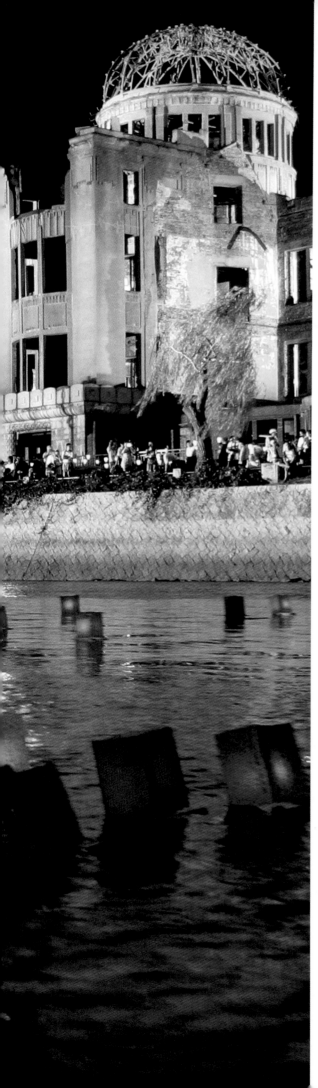

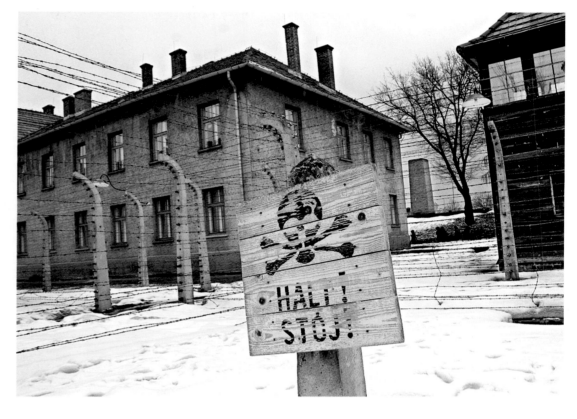

65.
Auschwitz

The deadliest of a network of Nazi extermination camps bears witness to humanity's basest instincts

NEVER FORGET: THIS IS THE POWERFUL MANdate imposed on later generations by those who experienced the horrors of Auschwitz in Poland and other facilities in the network of concentration camps operated under Adolf Hitler's National Socialist regime in Germany. The camps are the black holes of 20th century history, turning ethics and reason into warped parodies of themselves and defying our notions that human history constitutes an ongoing ascent from barbarism to civilization.

At Auschwitz and five other "extermination camps," the process of murder was industrialized and then practiced upon people whose only sin was to have been born into a hated race or religion. When the Nazis orgy of killing finally ceased, some 6 million people had died in these death factories, an estimated 1.1 million of them at Auschwitz alone.

Why did UNESCO name this abode of horror a World Heritage Site? The organization explains, "as evidence of [an] inhumane, cruel and methodical effort to deny human dignity to groups considered inferior, leading to their systematic murder." UNESCO further notes the battles that were waged here: "It is also a monument to the strength of the human spirit, which in appalling conditions of adversity resisted the efforts of the German Nazi regime to suppress freedom and free thought and to wipe out whole races ... The site is a key place of memory." In other words: Never forget.

CHAPTER SEVEN
WHERE INQUIRY FLOURISHED

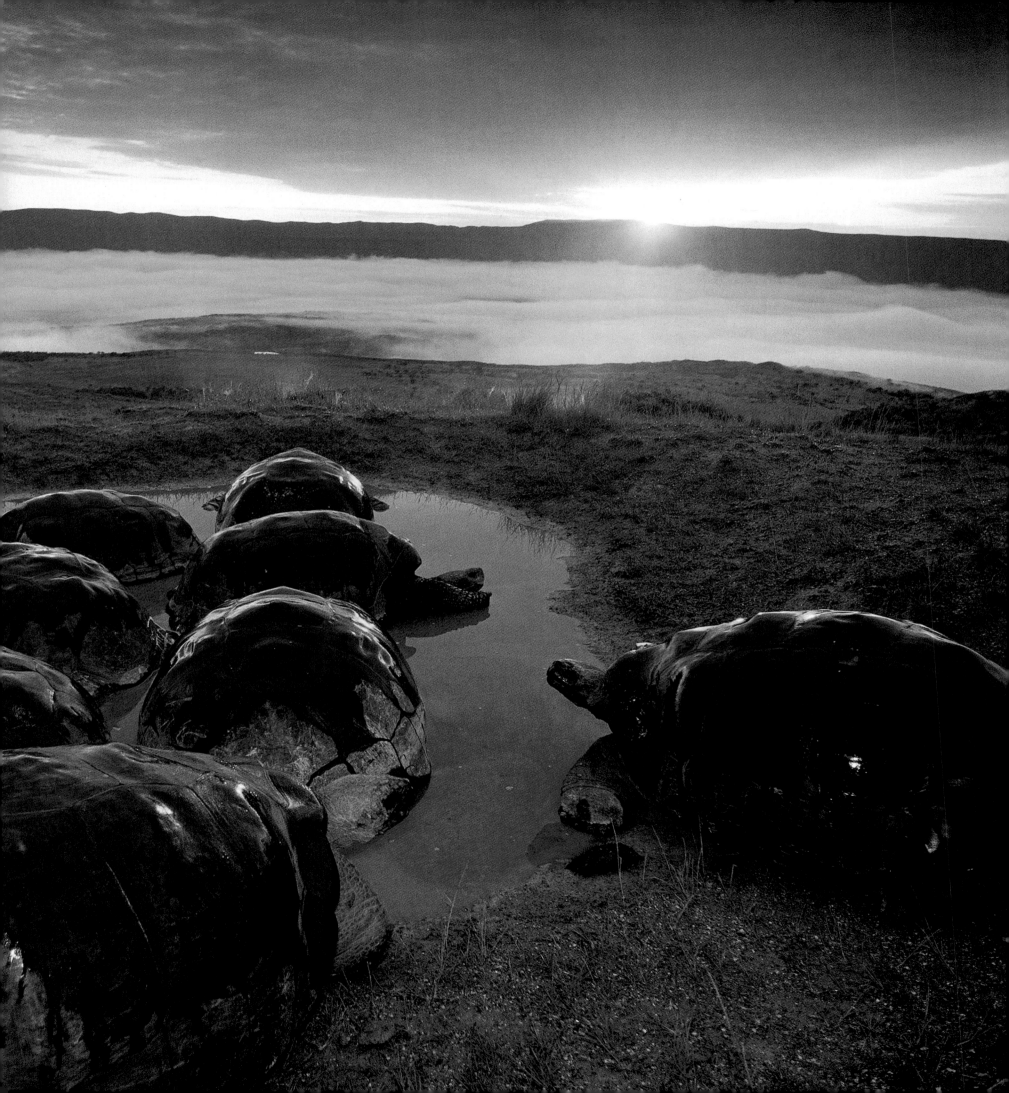

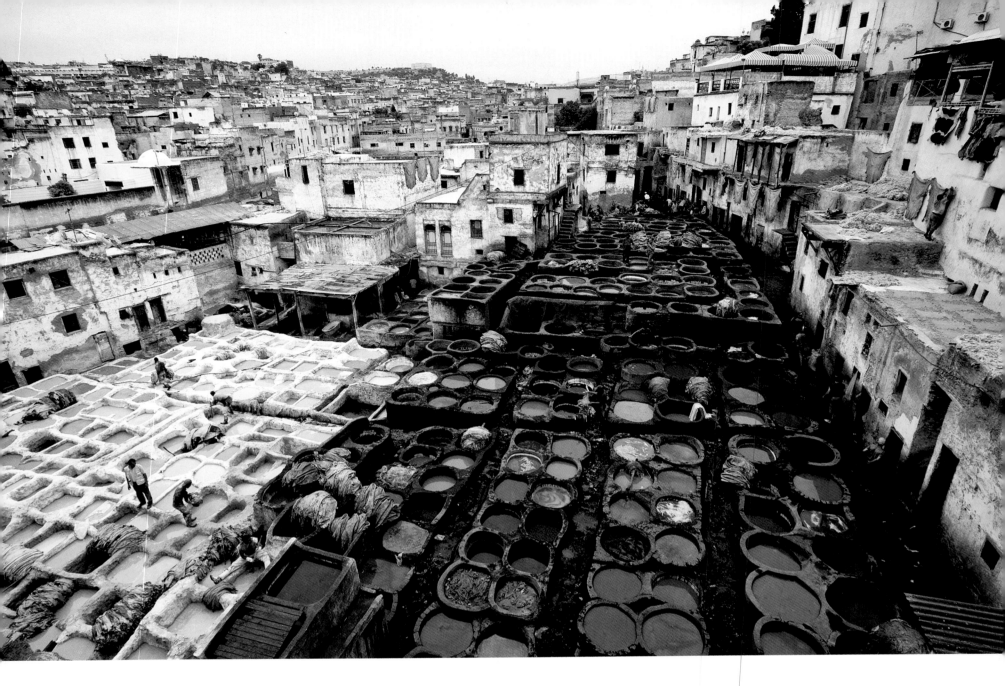

66.
Medina Of Fez

An early center of Islamic scholarship, the walled Old City retains its character today

THE ANCIENT MEDINA IN FEZ—THE WALLED inner city that was the first iteration of today's bustling, dense urban Fez in Morocco—was once one of the greatest centers of learning in the world. For even as Europe languished in the centuries following the decline of the Roman Empire, the Middle East, Asia Minor and Africa were enjoying the great flowering of culture that arose in the wake of the Prophet Muhammad's founding of Islam.

Perhaps only the scholars in Baghdad rivaled those of Fez in its prime, which ran roughly from the 9th to 15th centuries A.D. The madrasah here is considered by some to be the oldest degree-granting university in the world. The University of al-Karaouine, founded in A.D. 859, predates such early

European institutions as the University of Bologna and the Sorbonne in Paris by centuries. The scholars who gathered here include such noted minds as Moses Maimonides, the celebrated Jewish scholar and physician; Muhammad ibn Rushayd, the travel writer; and the saintly Berber mystic, Abu Imran al-Fasi.

Today Fez is a congested, colorful city whose desert climate allows tanneries like the one shown above to operate in open air. But its ancient medina, named a World Heritage Site by UNESCO in 1981, still retains some of the serene flavor of its past: its old streets are so narrow that automobiles are not permitted within the ancient walls that separate the medina from the modern city. It is believed to be the world's largest car-free urban zone.

67.
Jagiellonian University

Poland's oldest institution of higher learning boasts some influential alumni

EUROPE'S FIRST UNIVERSITIES AROSE FROM the schools associated with Roman Catholic cathedrals and monasteries, where students and teachers pursued knowledge. Such schools had existed for centuries, but they began to flourish and improve their standards in the wake of the ecclesiastical reforms instituted by the forward-looking Pope Gregory VII in the late 11th century. These schools for young clerics gradually began to assume the rough shape of modern universities: the University of Bologna was first out of the gate, in 1088 A.D., and many others followed.

Poland's oldest institution of higher learning is the Jagiellonian University in Cracow, which dates its founding to 1364. Called the University of Cracow for more than 400 years, it was rechristened to honor the Jagiellonian dynasty that ruled much of this area of central Europe between the 14th and 16th centuries. Its scholars excelled in such fields as mathematics, geography, chemistry and astronomy; the last two were such inchoate disciplines when first taught in Cracow that they were called alchemy and astrology.

The university's greatest graduate actually moved the world: Nicolaus Copernicus (Class of 1495) often attributed his groundbreaking thesis that the earth circles the sun to his studies in Cracow. In modern times, another graduate rose to change history's trajectory: Karol Wojtyla's undergraduate career was cut short when Nazi occupiers closed the university in 1939, but he later returned to graduate and then teach at the school. He was elected Pope in 1978, taking the name John Paul II.

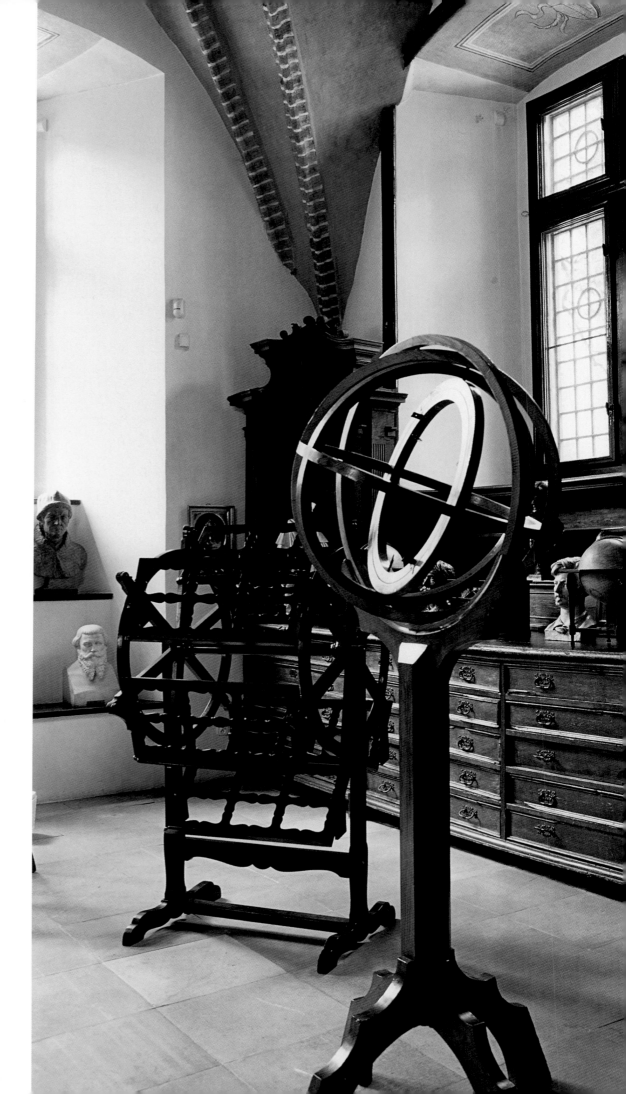

68.
Mosques Of Timbuktu

It seems obscure today, but the city on the edge of the Sahara was once a center of trade and scholarship

ITS NAME MAY NOW BE SHORTHAND FOR ANY PLACE THAT'S OFF THE BEATEN path, but back in the day, Timbuktu was one of northwestern Africa's greatest centers of commerce. In its glory days, roughly from 1100 to 1600 A.D., a traveler on the path to this city in today's Mali would have found it well beaten indeed: gold and ivory, salt and spices, camels and slaves were traded there, on the southern edges of the Sahara, only 8 miles (12 km) from the Niger River.

Historic Timbuktu was also renowned as a center of Islamic scholarship, which centered on the city's three great mosques, collectively called the University of Sankoré. One of them, Djinguereber Mosque, shown here, was built in 1327; it was named a UNESCO World Heritage Site in 1988. It is made almost entirely of compacted earth, mixed with such agents as wood and straw.

Scholars flocked to the university, and by the early 14th century, it was said to hold the largest collection of manuscripts in the Muslim world. But Timbuktu, which had flourished under the Songhai Empire beginning in the later 15th century, began to decline after it was conquered by the ruler of Morocco in 1591. By the 19th century it had become a synonym for geographical obscurity, and today it is threatened by desertification—so much so that in recent years the government of Mali has established the Ahmad Baba Center, named for Sankoré's most noted scholar, writer and historian, in hopes of saving as many as possible of the city's remaining, imperiled manuscripts.

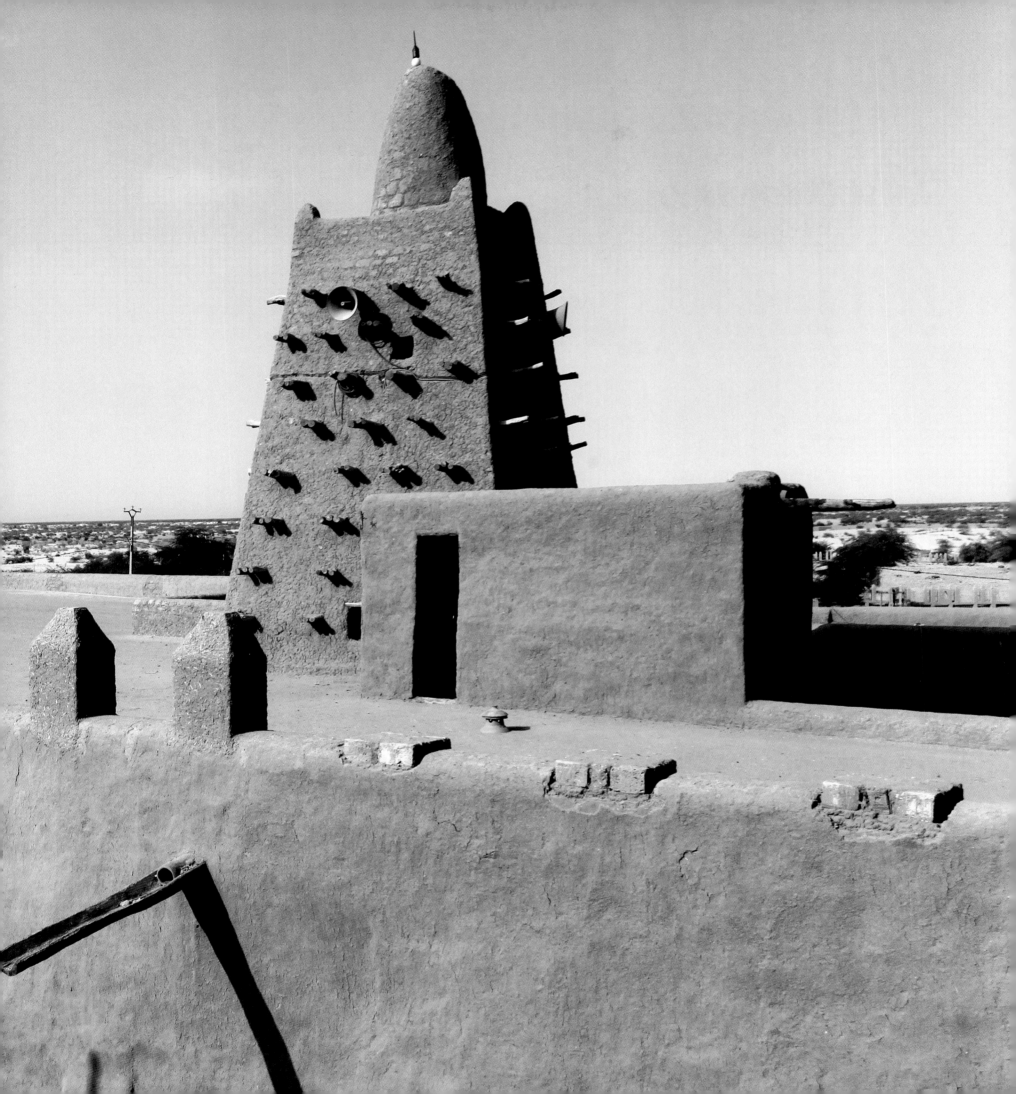

69.
Royal Observatory

What time is it—and where are you? The
answers can be found in this district in London

MORE THAN BUCKINGHAM PALACE AND
Trafalgar Square, the Royal Observatory in
London's Greenwich district reflects the
British Empire's pre-eminent position in
the world at the height of its global sway.
The facility was commissioned by King
Charles II, and when its original home,
designed by Christopher Wren, opened in
1675, it was the first building erected in the
British Isles that was completely dedicated
to scientific studies.

For scientists, the Royal Observatory was
not simply the symbolic center of the world;
it became the planet's measuring stick when
geographers drew an arbitrary line there that
became the prime meridian, the starting
point for the grid system of navigation that
has helped mariners and geographers locate
any position on the planet from the days
of Lord Nelson to the age of GPS and
Google Maps.

In addition to being the gold standard for
distance, the observatory also serves as the
planet's arbiter of time. The world's clocks
are set to Greenwich Mean Time, also named
for this building, though the actual atomic
clocks that officially track time's passage are
no longer located there. Then again, the prime
meridian, once marked by a brass line in the
observatory floor, is now also denoted by a
green laser beam. The lesson of the observa-
tory is clear: the times, they are a-changin'.

70.
Bodleian Library

Scattered in a maze of buildings at the University of Oxford is a singular repository of learning

LOOKING FOR ONE OF THE WORLD'S GREATEST COLLECTIONS OF BOOKS? THE ASSIGNMENT TO visit the Bodleian Library at the University of Oxford can make for a fine day of sightseeing, as a visitor wanders the college town's medieval streets trying to track down the sprawling institution's branches. They occupy a number of buildings throughout the city, including one of the library's first homes, the Tower of the Five Orders at the Old Schools Quadrangle; the stately, octagonal Radcliffe Camera building, which dates to 1748; and the so-called New Bodleian building on Broad Street. "New" is a relative term, of course, amid the dreaming spires of this venerable university, where classes have been held since 1096 A.D.: the New Bodleian opened its doors in 1940. It will undergo a complete renovation and re-open as the Weston Library in 2015.

And then there are the parts you can't see: beneath the streets of the city lie long rows of underground stack rooms, but even so, the need for more room sparked the construction of a Book Storage Facility at Swindon, outside Oxford, which opened in 2010, boasting 153 miles (246 km) of shelving. Time for one more question, class: who was Bodley? The library's eponymous early leader, Thomas Bodley, took charge of the institution in 1602 and made it one of the world's greatest repositories of knowledge.

71.
Royal Botanic Gardens

Queue up at Kew to see the past and future of horticulture

EACH YEAR SOME 2 MILLION VISITORS ARRIVE at the Royal Botanic Gardens at Kew, in southwest London, which at one time was a suburb of the city. They enjoy the opportunity to stroll through some of the world's most extensive and beautiful gardens and to view such buildings as Kew Palace, a onetime royal residence; a Japanese Gateway; a Chinese pagoda; and several venerable structures designed to house unique collections, including the Orangery,

the 19th century wrought-iron-and glass Palm House and the neoclassical Nash Conservatory. Yet it's the part of the complex visitors don't see—its backstage laboratories and libraries, where some 650 scientists toil—that makes it a powerhouse of research into plants and their cultivation, preservation and propagation.

The facility began as a private royal park in the early 18th century, and in the decades that followed, as British ships plied the world's seas and returned with rare plant specimens, it had begun to assume its current role as a global leader in botanical research.

Among the gardens' newest buildings is the fourth iteration of its Alpine House, which sports a semicircular halo of glass that rises 33 ft. (10 m) into the sky, allowing air to circulate and ensuring that every one of the facility's collection of thousands of high-altitude plants enjoys a climate that's as cool as—well, as the Royal Gardens themselves.

72.
Galápagos Islands

Here a young scientist studied
nature's bounty and processes

TO UNDERSTAND WHY 19TH CENTURY NATU-
ralist Charles Darwin learned so much in the
Galápagos Islands off the coast of Ecuador,
take a gander at the snazzy feet below. On the
left is a blue-footed booby, *Sula nebouxii,* one of
the diverse species of the booby family. On the
right is a red-footed booby, *Sula sula,* a member
of a different species of the same order, whose
Manolos are substantially less splendid. It was
the sheer profligacy of nature and the minute,
seemingly insignificant distinctions among
the animals he found here that helped lead the
young British scientist to his groundbreaking
theory of natural selection and the "preserva-
tion of favoured races in the struggle for life."

The Galápagos were the perfect laboratory for Darwin to explore the astounding diversity of species in the wild. The islands are geographically isolated from the mainland, allowing species to develop that are not found elsewhere, including the Galápagos tortoise, the marine iguana, the lava lizard and the Galápagos green sea turtle.

Darwin arrived at the Galápagos in 1835 aboard H.M.S. *Beagle,* a British surveying vessel charged with exploring and charting the world's seas. His observations of the tiny distinctions among local fauna, which appeared to offer some individuals a better chance for survival than others, were integral to the development of his theories, which startled the world when published in 1859 in the book *On the Origin of Species.*

Darwin's account of his five-year adventure, *The Voyage of the Beagle,* plunges readers directly into the day-to-day life of an inquisitive naturalist given a rare opportunity to embark on a literal voyage of discovery. Today, tourists flock to the Galápagos to savor its uniquely beautiful landscape and creatures—and to walk in the footsteps of a man who changed our understanding of our world.

73.
Lowell Observatory

At this place, one man's private vision helped expand the entire world's view of the heavens

FOR CENTURIES NOW, SCIENCE HAS BEEN A DRIVING WHEEL OF HUMAN progress. Yet its ascent has been recent: as Richard Holmes reminds us in his absorbing tour of the period when science first became a profession, *The Age of Wonder* (Pantheon; 2009), the term scientist was coined by Briton William Whewell in 1833 to describe the work of those who devoted their lives to studying nature's laws. Previously, such inquisitors of the world around them had been called "natural philosophers."

Astronomy is a domain in which amateurs have always flourished—and continue to do so. One of the great amateurs of astronomy at the turn of the 20th century was Percival Lowell, of the noted Boston family. The gifted mathematician and student of Japanese culture was an avid skygazer who used his considerable fortune to build a private observatory outside Flagstaff, Ariz., in 1894. He selected the site for its clear desert skies, and Flagstaff has led the world in fighting the astronomers' plague, light pollution. Lowell's professional reputation suffered when he became one of the most vocal proponents of the theory that Mars was the home of a civilization based around irrigation canals. But the observatory he founded has contributed important findings to astronomy, including the 1930 discovery of the planetoid Pluto by young astronomer Clyde Tombaugh, who chose the Roman god's name because its first two letters salute Percival Lowell.

74.
Svalbard Global Seed Vault

The world's safety net for plants is tucked deep within a mountain near the Arctic Circle

THINK OF IT AS A NOAH'S ARK FOR THE world's plants. Or, as TIME's Bryan Walsh called it when the Svalbard Global Seed Vault opened in 2008, "the planet's ultimate back-up plan." Svalbard is a repository for samples from national seed banks across the globe, whose purpose is to preserve and protect native plant varieties. If climate conditions change or a disease threatens crops currently in use, plant breeders can dip into these national repositories to try to grow new crops.

The seed diversity preserved in these banks can mean the difference between feast and famine. But the banks that contain our most diverse and important collections of seeds tend to be located in developing countries, where budgets are tight and conditions are less than stable. One disaster, and seeds can be lost forever, often before scientists even know what they have to offer. "That's like burning books before we open them," explained Cary Fowler, executive director of the Global Crop Diversity Trust, which operates the Svalbard vault along with Norway's government and the Nordic Genetic Resource Center in Sweden.

The vault was built on the far northern Norwegian island of Spitsbergen, where the Arctic cold helps keep the seeds viable. It is also far from tectonic fault lines, and thus well suited to its task of rebooting global agriculture after a catastrophe. The $9 million vault's entrance, below, opens into a huge storage space 400 ft. (122 m) inside a mountain, where some 200 million individual seeds representing almost 500,000 distinct plants are stored. In case of emergency, break glass.

75.
McMurdo Station

Yes, it can get cold, and the nights are long—six months long. But who needs heat and light, anyway?

THE DIRECTIONS TO REACH IT ARE SIMPLE: Head south. And when you arrive at the unique U.S. scientific facility based at McMurdo Station on Ross Island in Antarctica, you will be standing in one of the world's most remote outposts, where conditions are reminiscent of a science-fiction movie set on an alien, frozen planet. The skies here are sunny for six months straight during the Antarctic summer, then grow dark for the six months of winter, during which residents will brave 100-m.p.h. winds and temperatures that have been known to drop to 127.3°F. below zero. Small wonder, the station's population follows

the sun: some 1.000 people live here in summer, but the number can fall to 150 in winter.

The U.S. opened its first station here in 1956, and McMurdo has come a long way from its pioneer days. "Mac-Town," as residents call it, has become a thriving community that boasts about 85 buildings and is served by a harbor, a heliport and three airfields, two of them seasonal. Most of the station's goods arrive by water, thanks to an annual "sealift" of cargo ships following lanes opened by icebreakers. Residents get around the base courtesy of a Terra Bus, a huge vehicle that sports six big wheels and can carry 56 passengers.

Interested? German director Werner Herzog created a fascinating portrait of the base and its residents in his 2007 documentary *Encounters at the End of the World*.

Research studies at McMurdo are managed by the National Science Foundation's U.S. Antarctic Program. Special areas of interest include astronomy, atmospheric science and, of course, climate change and glaciology. It's also the jumping-off point for those hardy souls who may find McMurdo a bit too crowded: the road to the even more remote U.S. Amundsen-Scott South Pole Station, located at the Geographic South Pole, starts here.

CHAPTER EIGHT
WHERE THE FUTURE WAS FORGED

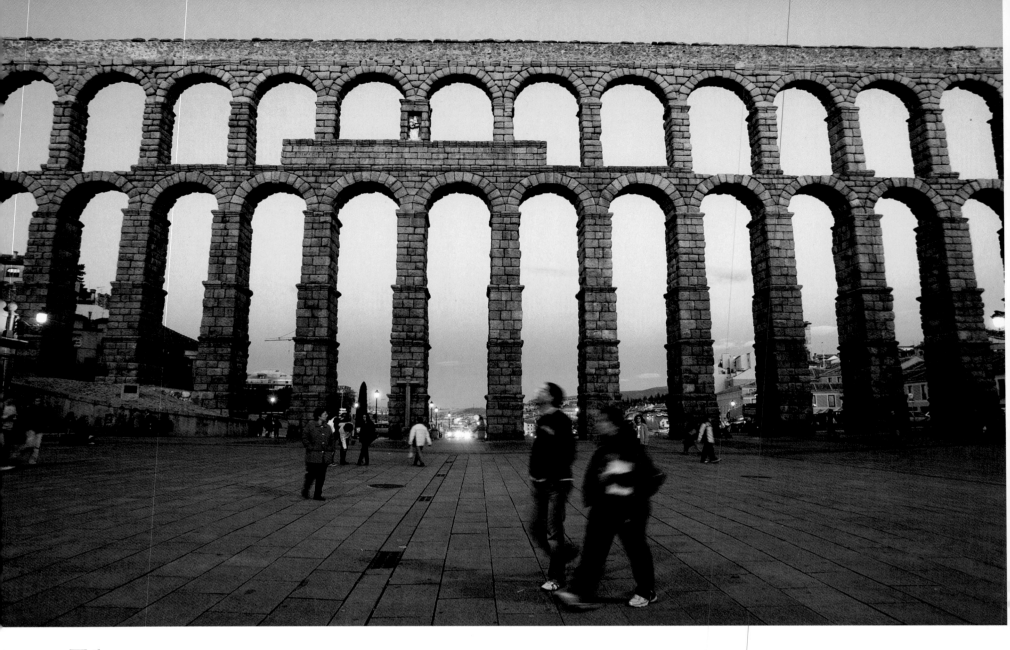

76.
Segovia Aqueduct

Functional and graceful, this Roman structure is now about 2,000 years old—and counting

ROME WASN'T BUILT IN A DAY, NOR WAS IT built to last for a day. Two full millenniums after the great imperial city presided over the Mediterranean world, its physical remains—roads and aqueducts, colosseums and basilicas—are found wherever imperial soldiers preserved the Pax Romana. One such monumental structure is the great aqueduct at Segovia in Spain, whose two graceful levels of curving arches effortlessly bridge a deep gap in the hilly city, above.

The structure, both functional and beautiful, has become so significant to Segovia's sense of identity that it is featured on the city's coat of arms. Historians believe the original structure dates to 50-100 A.D. Much of it is the authentic work of the Romans, but significant portions were reconstructed, with great care taken to copy the original, during the reign of Queen Isabella and King Ferdinand in the late 15th century. The aqueduct is notable not only for its craft but also for the outsized ambition it embodies: it carries water some 11 miles (18 km) from the mountains outside Segovia to the city—a project whose audacity reveals the confidence and engineering know-how that kept the empire thriving. At its height, it reaches 93 ft. (28 m), supported by foundations that are 20 ft. (6 m) deep.

The method of constructing curved arches, whose shape allows them to bear great weight, survived the fall of the empire. Similar arches in this Romanesque style can be found at two different ends of the empire that are shown elsewhere in this volume: at the Grand Mosque in Córdoba, begun in 784 A.D., and at the Palatine Chapel at Aachen Cathedral, which also dates to the 8th century A.D.

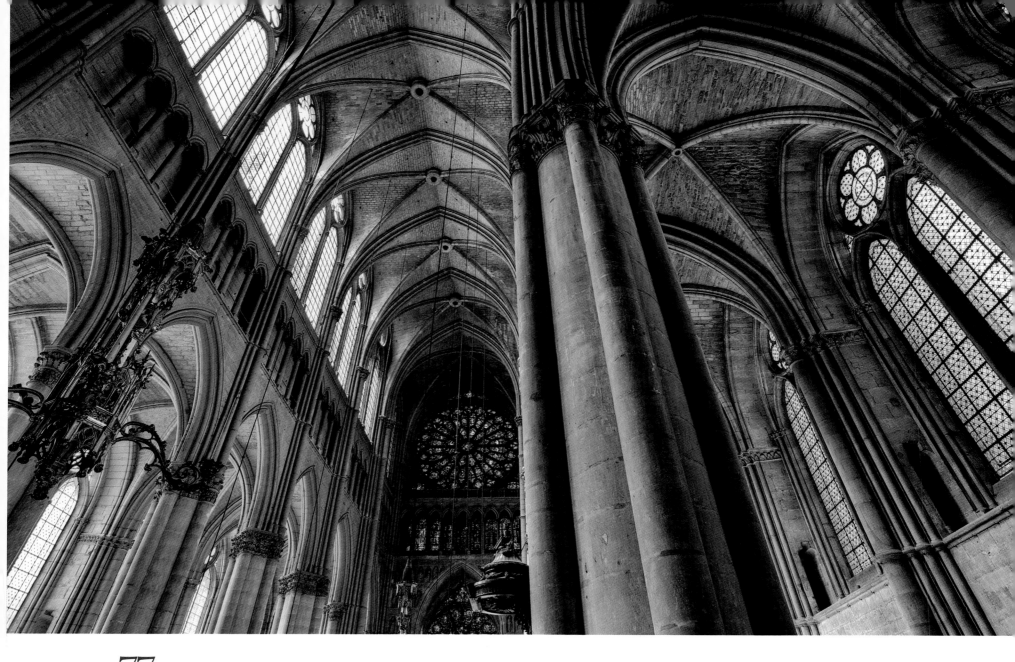

77.
Reims Cathedral

This monument to the faith and knowledge of its builders also reflects their rising station in society

THE SOARING CATHEDRAL OF REIMS IN France, where generations of French kings were crowned, does not represent a stepping stone in the evolution of the Gothic style. Rather, it shows that style, whose characteristic pointed arches are a clear evolution from the rounded arches of the Romanesque style, at its high point. That's because the cathedral replaced its predecessor, which burned to the ground in A.D. 1211, and the new version that arose reflected the latest advances in building construction and ornamention.

The cathedral is a showcase of the strengths of the High Gothic style: the thrilling nave reaches some 125 ft. (38 m) from floor to ceiling, illuminated by radiant light that pours through tall stained-glass windows. Outside, the weight of the nave's walls is borne in part by flying buttresses, while more than 2,000 richly carved sculptures adorn all its façades, including a row of the kings of France atop the main entrance doors. The cathedral was badly damaged by German shelling in the early days of World War I but has largely been restored.

If the structure captures the evolution of architecture in the Middle Ages, it also reflects the growing status of those who built these magnificent edifices. These architects and engineers, who called themselves masons, formed trade guilds that gradually began to demand an equal place on the social ladder with the clerics and nobles who commissioned and paid for such buildings. A tomb slab in the cathedral honors the architect Hugues Libergier, who died in 1268. He is shown holding a model of an abbey he designed, an honor formerly reserved for noble patrons. In the Gothic age, a new social order was ascendant.

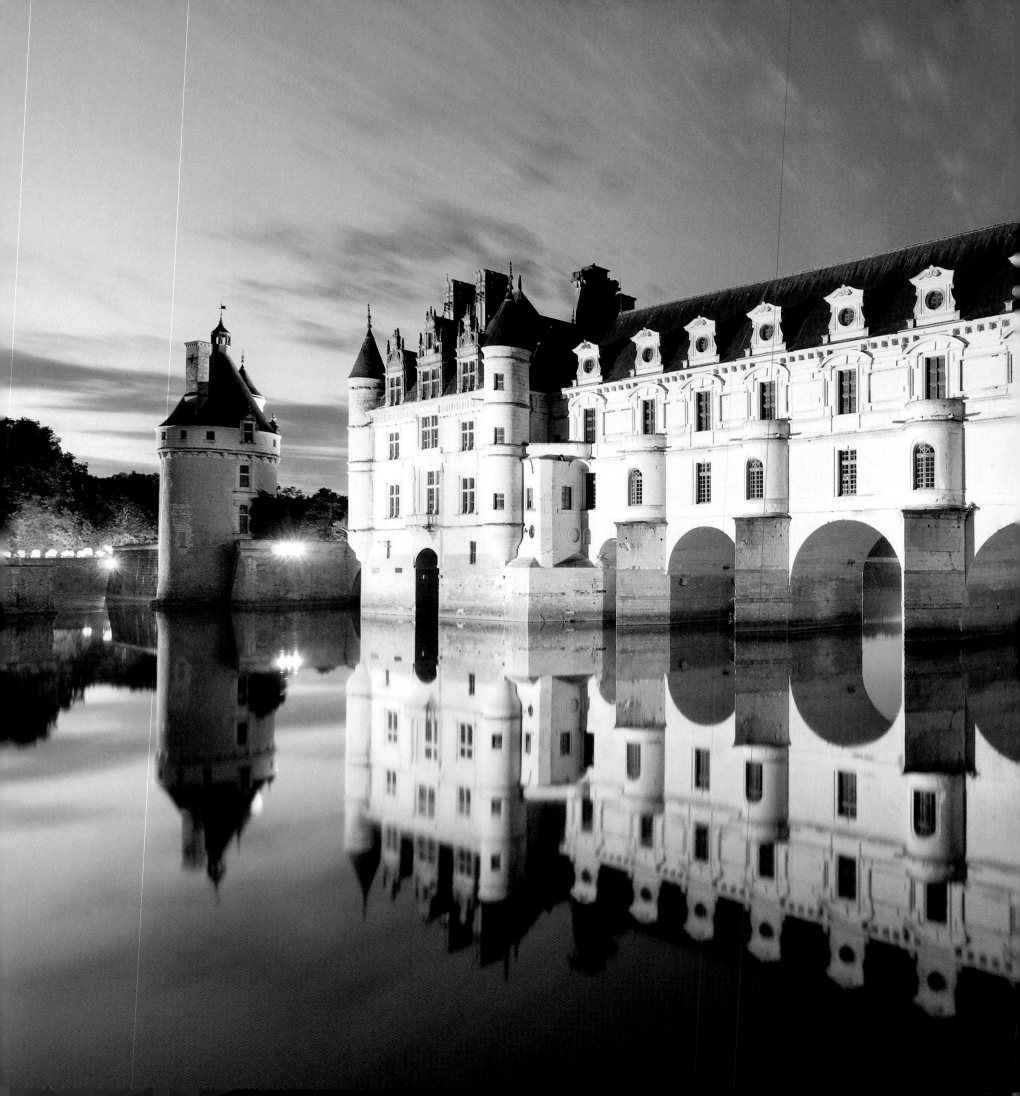

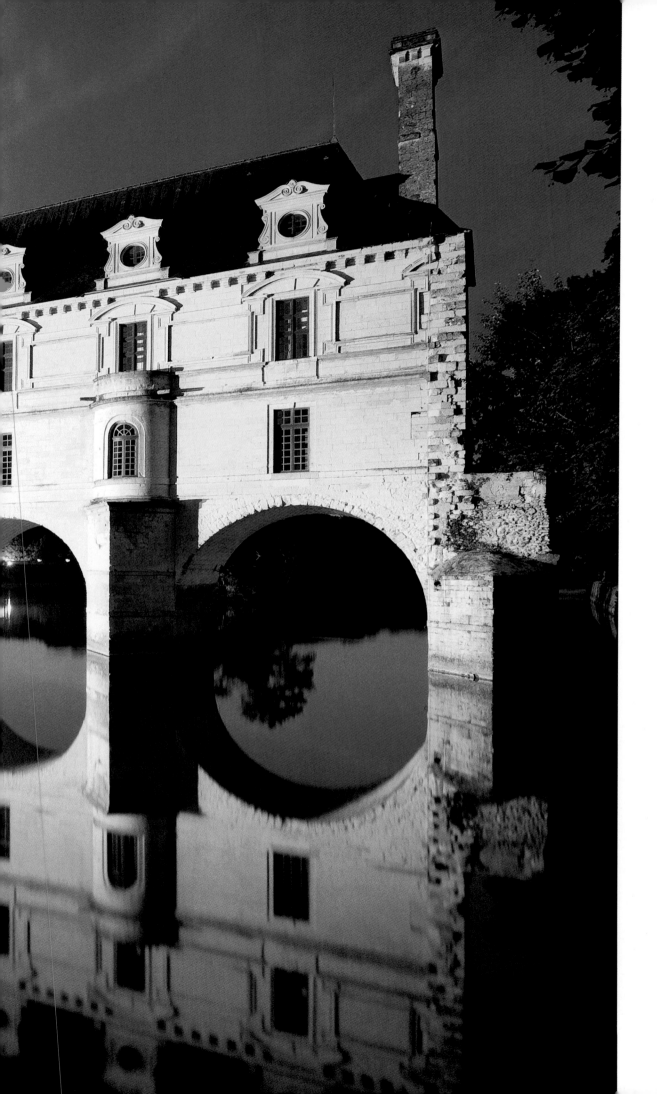

78.
Château de Chenonceau

It spans a river—and also
France's turbulent history

WITH ITS ROMANESQUE ARCHES GRACEFULLY
fording the River Cher about 16 miles (26 km)
outside the French city of Tours, Château de
Chenonceau looks very pleased with itself—
and why not? A ménage à trois of location,
aspiration and inspiration, it is one of the
architectural treasures of France. The
audacious concept—a residence built across
running water—was inspired by a mill that
once occupied a bank of the river. Eventually
a castle was built, replacing the mill, and then,
in the early days of the French Renaissance,
the castle became the property of the crown.
King Henry II's longtime mistress, Diane de
Poitiers, is the presiding spirit of the château;
this Renaissance woman, highly educated and
a great patron of the arts, created the elegant,
river-spanning home we see today during
the mid-16th century, working with architect
Philibert de l'Orme.

The history of the building after Diane's
death mirrors the social evolution of France.
The château remained a favorite haunt of
French royals until it was sold to a local squire;
during the Enlightenment, it welcomed such
free-thinking visitors as Voltaire and Rous-
seau. The symbol of luxury was spared de-
struction during the revolution because it was
the only span across the Cher. But its greatest
patroness was not so fortunate: during the
Reign of Terror, the tomb of Diane de Poitiers
was opened and her body was removed by
sans-culottes, who threw it into a common
grave. More than 200 years later, in 2010,
her remains were disinterred again and were
given a proper burial at one of her former
residences outside Paris, the Château d'Anet.

79.
Imperial Vienna

Overflowing with Baroque grandeur, Vienna became a citadel of Europe's Old Order

THE IMPERIAL LIBRARY OF AUSTRIA, SHOWN below, is housed in the Hofburg Palace complex in Vienna, where a long line of Hapsburg emperors reigned over a succession of political entities that controlled a large swath of central Europe, from the Holy Roman Empire of the 12th through the early 19th centuries until the defeat and division of the Austro-Hungarian Empire in World War I.

The Hofburg Palace itself is an enormous complex that traces the evolution of the Austrian monarchy as well as the history of architectural style. The splendid main hall of the Imperial Library, completed in 1735, exhibits a swooping, flowing Baroque style that can also be found in the music of such contemporary masters as J.S. Bach.

But more than fugues were orchestrated in imperial Vienna. In this palace, following the downfall of Napoleon Bonaparte, the leaders of Europe gathered in 1815 at the Congress of Vienna to redraw the boundaries of political power across the Continent. Here, in the wake of the French Revolution and the Napoleonic Wars, was an opportunity for leaders to exercise real innovation in politics and the social order. But the chance was lost. The agreement that was reached helped Europe remain relatively stable for almost a century, until World War I broke out in 1914. But, spooked by France's revolution, the aristocrats ignored the poverty and hopelessness of society's lower orders. Their new political order may have kept nations from war, but in allowing Europe's conservatives to retain their grip on power, it laid the groundwork for future revolutions.

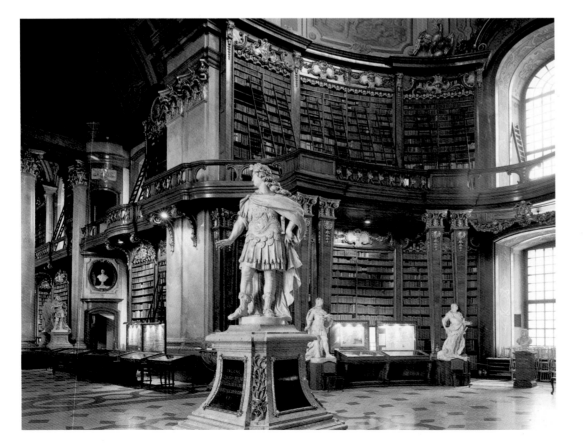

80.
Grand Place

The sublime plaza at the heart of Brussels charts a historic shift in social power

THE MIGHTY SPIRE ATOP THE MAISON DE VILLE, OR CITY HALL, IN Grand Place in the heart of Brussels, suggests both the ambitions of its builders and the social revolution they championed. For centuries, European cities had been oriented around huge cathedrals. But this large commercial gathering place reflects the rise of a new order in society: merchants and guildsmen. Grand Place took shape gradually on the site where three large 13th century markets stood, covered with roofs for use during winter. Its magnificent centerpiece, City Hall, was built in a High Gothic style between 1401 and 1449, when its great tower, which rises 315 ft. (96 m) above the plaza below, was completed.

Other guild halls soon joined City Hall around Grand Place, status symbols of a class on the upswing. Indeed, the newfound clout of such commoners, albeit wealthy commoners, was so threatening to the area's leading nobleman, the Duke of Brabant, that he built a competing edifice across the way as a show of noble power, even as City Hall was rising. He called his lavish building the Maison du Roi, or King's House—although to date, no monarch has ever lived there.

While it would be pleasant to report that Europeans resolved all their disputes through such creative building competitions, the history of Grand Place is more standard: Brussels was bombarded by a French army in 1695, and many of its great buildings were destroyed. The good news: both City Hall and the King's House were still standing.

81.
Jefferson's Virginia

The polymath's life was a tangle of contradictions. But his buildings are classically simple

THOMAS JEFFERSON EMBODIED MANY OF THE ideals of the Age of Enlightenment, including the French Encyclopédistes' compulsion to study, classify and master every branch of knowledge. From the home he built on a hilltop in Virginia, he cultivated a network of contacts who kept him up to date on the latest news of French viniculture, English novels, German philosophers and Gaelic poetry. He followed agricultural innovations closely and was a casual inventor, concocting revolving bookstands, fancy clocks, a nifty dumbwaiter. Yet when it came to architecture, a discipline he deeply enjoyed, he clung to ancient models. His home, Monticello, follows the Palladian lines of classical buildings, complete with multiple pediments and stately columns, crowned with a splendid octagonal dome.

If Jefferson's love of simplicity is on display in his buildings, his politics and private life were deeply complex. He yearned to create a tidy nation presided over by gentleman farmers like himself, yet in acquiring vast Western lands in the Louisiana Purchase, he guaranteed America's continental destiny. In his ardent early support of the French Revolution, he found himself calling for the ouster of the landed gentry—a group that included himself. His most powerful political statement was a clarion call that embodied America's radical premise that all men are created equal. Yet it was directly contradicted by the people who erected Monticello: the slaves Jefferson owned. He took special care to keep the mingy cabins they occupied offstage in the idyllic view at right that greeted visitors to his domain.

82.
Mountain Railways Of India

A new technology knits together India's widely separated regions

IT'S NOT SURPRISING TO FIND THAT THE Taj Mahal and Acropolis are included on UNESCO's list of World Heritage Sites. But when the U.N. cultural body designated three of the five famed Mountain Railways of India to its list of humanity's milestones, its officials showed both insight and imagination.

The designation was a reminder of the extent to which societies around the globe were reshaped by the Industrial Revolution. The engine of this dynamic period of progress was steam power; the backbone was iron. And when you put the two together, a powerful new force in human affairs emerged: the railroad. Introduced in the late 1820s and '30s, this technology was so adept at hauling great loads of weight and large numbers of people

that railroad tracks quickly swept the world.

In India, railroads helped weave the country's most geographically isolated regions into the national fabric. Each narrow-gauge line is a triumph of human engineering over a challenging landscape. The Darjeeling Himalayan Railway, in the north, chuffs uphill for 55 miles (88 km) to connect Siliguri to the lofty tea-growing fields of Darjeeling. The Nilgiri Mountain Railway in the south, above, connects the town of Mettupalayam with the hill station of Udagamandalam, via 208 curves, 16 tunnels and 250 bridges. The Kalka-Shimla Railway in the Himalayan foothills tops that with 864 bridges, many of which would look familiar to Roman builders: their stone arches mirror those of the Segovia Aqueduct.

83.
Iron Bridge

This graceful span is one of the most revolutionary structures in history

WHAT'S SO SPECIAL ABOUT AN IRON BRIDGE? Well, the span below is significant for a good reason: it is *the* Iron Bridge, the very first bridge made of cast iron in the world. It was built to carry traffic across the River Severn between the towns of Coalbrookdale and Broseley in the British Midlands, replacing a technology long overdue for a makeover: a ferryboat. Answering the demand of local manufacturers for speedier ways to move their goods, it is both a product and a propagator of the Industrial Revolution.

The bridge was designed by Thomas F. Pritchard, championed by local "ironmaster" John Wilkinson and built by foundry owner Abraham Darby III. Each of its 482 metal components is made of iron cast in specially designed molds. Since no one had ever envisioned using cast iron to create a truss to support heavy loads before, the Iron Bridge is far from perfect. It contains much more iron (384 tons) than it needs. And because ironworking was in its infancy, its connecting elements are simply jumbo, iron versions of joints long familiar to carpenters: mortices and tendons, even dovetailed joints.

It may have been overdesigned, but the Iron Bridge did its job. After it opened in 1781, it became a magnet for visitors—and so it remains, if slightly updated to ensure its ongoing survival. Its builder, Darby, was so enamored of his creation that he was said to have acquired "iron madness." He was buried in an iron coffin under an obelisk of iron.

84.
Skyscrapers Of Chicago

There's a reason why things—and people—are always looking up in the Windy City

THE 19TH CENTURY WAS THE GREAT AGE OF iron and its refined form, steel, as steel tracks carried steel trains across steel bridges. But aside from a locomotive's ability to chug up a hill, the empire of steel was a horizontal kingdom—until Chicago builders made the sturdy metal take a 90° turn, and began using it to raise structures high up in the sky, higher than anyone had ever imagined they could rise.

A bevy of architects and engineers was involved in this great breakthrough, but there's no question that the first real skyscraper was Chicago's Home Insurance Building, completed in 1885. It was designed, fittingly

enough, by an engineer, William LeBaron Jenney. Its 10 stories stood 138 ft. (42 m) high, and the weight of its walls—the tricky part— was entirely supported by its steel frame. When harnessed to another new technology, the elevator, patented in 1861 by inventor Elisha Otis, this new sort of lofty building put cities firmly on the vertical trajectory that still defines the modern urban landscape.

Chicago, roaring with energy as the crossroads of America's agricultural and manufacturing heartland, remained in the forefront of skyscraper design at the turn of the 20th century. And as the buildings shown below amply demonstrate, it remains in the vanguard. To visit Chicago is to take a tour through the history of skyscraper design. But don't bother looking for one historic landmark. The Home Insurance Building met a fate all too typical of skyscrapers: it was torn down in 1931 to make way for a taller building.

85.
Panama Canal

The Central American waterway is a triumph of geo-engineering, the human shaping of the planet

A MAN, A PLAN, A CANAL: IF ONLY IT WERE that simple. But the construction of a waterway across Central America required $375 million ($8 billion in today's terms), major advances in construction techniques, innovations in medicine and hygiene (malaria and yellow fever claimed the lives of tens of thousands of workers) and an outright U.S. land grab that gave birth to a new nation.

Humans have built artificial waterways to carry goods and people cheaply and efficiently as early as the days of Mohenjo-Daro in the Indus Valley, around 2500 B.C. China's Grand Canal, still the world's lengthiest at 1,115 miles (1,794 km), was completed in 609 A.D. Entire cities—Venice, Amsterdam, Bangkok—have been based around canals. The notion of the Panama Canal was sparked by the enormous success of two predecessors, the Erie Canal in upstate New York (1825) and the Suez Canal in Egypt (1869), which links the Mediterranean and Red seas. A French attempt to build a canal across Central America was halted in 1889, after some 20,000 workers succumbed to tropical diseases. The U.S. took over the project in 1904, after President Theodore Roosevelt helped pro-canal supporters in the region create the new nation of Panama out of land wrested from Colombia.

Construction of the 48-mi. (77 km) -long canal took 10 years. When it opened in 1914, it more than halved the sailing time from New York City to San Francisco. That year, some 1,000 ships passed through its locks; today the number tops 14,000 each year. Under the terms of a 1977 treaty, Panama has exercised control of the waterway since Dec. 31, 1999.

86.
Brooklyn Bridge

Spanning a great city with stone, steel and grace, it gave us a new kind of beauty

THE U.S. BOASTS MANY GREAT BRIDGES, FROM San Francisco's famed Golden Gate Bridge to Michigan's Mackinac Bridge. And that invites a question: Why has the Brooklyn Bridge become *the* bridge of the American imagination?

A real estate agent might explain it in three words: location, location and—well, you know the rest. After all, a walk across the big span over New York City's East River offers an unmatched view of lower Manhattan and Brooklyn. A poet—say, Hart Crane—might sing the praises of its taut geometries: "How could mere toil align thy choiring strings!"

But it's engineers who love the bridge the most. They admire the Gothic arches of its supporting piers, anachronistic but sublime. They know the difficulty of sinking its

foundations, as sandhogs toiling in caissons beneath the river risked "the bends" to build its pilings: 20-30 of them died. And they recall the story of the trio who raised it up. Its designer, the noted builder John Roebling, died of tetanus sustained in an accident on the building site. He was succeeded by his son Washington, who, after himself suffering "the bends," enlisted his wife Emily to supervise the project. Thanks to her diligent efforts, when the bridge opened in 1883, it was hailed as a marvel. It spans 6,016 ft. (1.8 km), including approaches, and its twin towers, rising to 135 ft. (41 m) above the water below, achieve the goal John Roebling set for them: "to be ranked as national monuments. As great works of art." Mission accomplished.

87.
Hoover Dam

A masterpiece of New Deal
know-how faces a problem
no one anticipated: drought

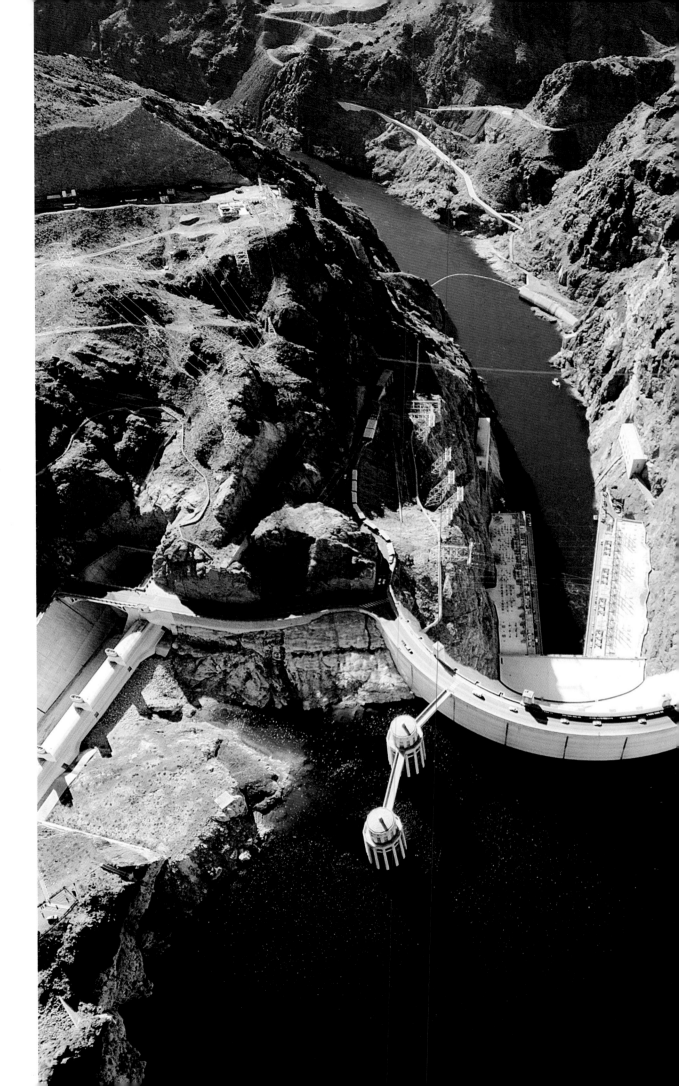

VISITORS TO THE MONUMENTAL HOOVER
Dam on the Arizona-Nevada border, which
bestrides the Colorado River to create Lake
Mead, can be forgiven if they at first are struck
only by the structure's sheer monumental-
ity. From top to bottom, the main wall of
the dam stands more than 70 stories high,
at 726 ft. (221 m). That's a lot of concrete, but
as a U.S. Department of the Interior website
notes, "Hoover Dam is concrete; and without
concrete, this dam could not have been built."
Engineers and cement-mixer buffs find much
to admire here. The dam, built over a five-year
period between 1931 and '36, has been rated
by the American Society of Civil Engineers as
one of America's Seven Modern Civil Engi-
neering Wonders.

But there's more to be seen here than
concrete: as writer Julian Rhinehart observed
in 1995, "The dam is not only an engineering
wonder. It also is a work of art." Rhinehart
noted that architect Gordon B. Kaufmann
simplified the design of the complex's exterior
elements, replacing ornamentation with the
flowing lines of Modernism and Art Deco.

The dam cannot be viewed today, however,
without an eye to its impact on the environ-
ment. As TIME's Bryan Walsh pointed out in
2010, Lake Mead is a keystone in the complex
irrigation system that keeps the parched
states of the American Southwest wet with
the waters of the Colorado River. As nearby
Las Vegas pulls more and more water from the
lake, and a drought continues to plague the
region, a crisis is looming that all the concrete
in the world cannot solve.

88.
Bauhaus School

A small institution in a tiny German town was the laboratory for a style that swept the world

ITS NAME MEANS "HOUSE FOR BUILDING," and though the design school run by architect Walter Gropius in Weimar, Germany, existed for only 14 years (1919-33), it indeed built the dominant design shape of the 20th century: the rigorously geometric, stripped-down style that came to be known as Modernism. In its first years, the school stressed crafts: woodworking, ceramics, metalworking, printmaking and weaving. But in a 1923 exhibition titled "Art and Technology—A New Unity," the institution found its direction.

According to TIME critic Richard Lacayo, "Now came much more of the work we think of as quintessentially Bauhaus: spare, sharplined products like Marianne Brandt's geometric tea-and-coffee sets and Josef Albers' austere little stacking tables. Marcel Breuer devised tubular steel chairs with bands of stretched black canvas, a skeletal combination of lines and taut planes that looked like an X ray of a chair." The advent of the Nazi regime sent many of Germany's best architects into exile and spread the Modernist aesthetic around the globe. Today, from Chicago to Tel Aviv to New York City and beyond, it's a Bauhaus world—we only live in it.

89.
City of Arts And Sciences

A native son, architect Santiago Calatrava, thrusts Valencia, Spain, into the future

VISITING THE FUTURE IS EASIER THAN YOU might think: it appears to have touched down in Valencia, where the City of Arts and Sciences looks as if it just dropped in from 2112. This large development isn't unique: in recent decades, cities around the world have vied to bring new energy to their central cores with arts complexes, aquariums and other tourist magnets. Not all have succeeded. Valencia's effort stands out because its five main components, located in a dried-up bed of the River Turia, are the work of two architects with a common vision, native son Santiago Calatrava and the late Félix Candela, born in Madrid.

Candela designed the city's lovely Oceanographic building, but the complex is considered the magnum opus of Calatrava, 60 in 2011, who in recent decades has become one of the world's most celebrated and influential architects. His work reflects his unusual approach: the architect is also an engineer, and he is an artist as well, who begins his design process by creating sculptures he evolves into buildings. He first came to fame in Europe as the designer of bridges that were both innovative in design and artistic in form. Soon he began designing larger structures whose gleaming white surfaces, swooping curves, exposed structural elements and enormous moving sections have been compared to birds in flight and the bones of dinosaurs.

At left is the Queen Sofía Palace of the Arts, Calatrava's opera house that opened in 2005. The futuristic building has 14 stories aboveground and three below: its main auditorium seats 1,400 visitors from the early 21st century.

90.
CCTV Headquarters

China's roaring economy and soaring ambitions make it a global leader in new design

THE FIRST DECADE OF THE 21ST CENTURY served notice that the world order that followed World War II, when the global economy was led by the U.S., Europe and Japan, was obsolete. No nation better exemplified the rise of new players than China, which had spent the 20th century mired in foreign invasions, civil wars and socialist stagnation. But after the nation's communist leaders unshackled the force of private enterprise, China's growth was remarkable. The capital, Beijing, was a city transformed. "[Its] sinews and shape had been constant for hundreds of years," TIME Beijing correspondent Simon Elegant reported, but now it was "a place that aims to rival New York or London as an iconic world city of the new century."

The extent of China's ambitions was best exemplified by Beijing's China Central Television (CCTV) Headquarters, designed by Rem Koolhaas, the Dutch architectural gadfly who previously had gained fame more for his critiques of contemporary urban design than for his own buildings. When the CCTV Tower opened in 2009, its unique shape, which resembled the sort of mind-bending spatial puzzles drawn by Dutch artist M.C. Escher, put Beijing in the forefront of world design. The building was not a traditional upright shaft but rather a loop of six horizontal and vertical sections enclosing an open center. TIME architecture critic Richard Lacayo called it "a prodigious twist on the idea of an office tower, a kind of backflip in glass and steel."

Koolhaas, said Lacayo, doesn't think architecture should change the world so much as the world should change architecture. When Seattle asked for a new central public library, Koolhaas' firm, the Office for Metropolitan Architecture, delivered in 2004 the last word in rare volumes—an irregular stack of cantilevered spaces wrapped in angular glass walls and a honeycomb of steel. According to Lacayo, "[Koolhaas] may not be a man who wants to impose his vision on the world, but somehow the world is looking more and more like he wants it to."

91.
Burj Khalifa

Dubai captures the lead in the vertical space race—thanks to a last-minute bail-out

CALL IT THE URGE TO SURGE: SINCE THE DAWN OF THE SKYSCRAPER age, titans of industry and cities around the world have vied for the honor of erecting the world's tallest building. In the late 1920s, as a stock-market crash was ushering in economic depression, three buildings in New York City battled to be the world's tallest; the Empire State Building won the title. In the 1970s, the twin towers of Manhattan's World Trade Center wore the crown for a few years, until Chicago, the skyscraper's birthplace, recaptured the honors with the Sears Tower. Malaysia and Taipei later joined in, each sharing the title for a spell.

Skyscrapers, in short, follow the money. So it wasn't a surprise when the tiny, wealthy financial capital of Dubai on the Arabian Peninsula announced in 2003 that it would become the new home of the world's tallest building, the Burj Dubai (Dubai Tower), a 160-floor monster that would top out at 2,717 ft. (828 m). But before it was completed, Dubai's go-go economy stalled out. Sheik Khalifa bin Zayed el-Nahyan, the oil-rich ruler of neighboring Abu Dhabi, stepped in with $10 billion to stave off an embarrassing default, and the tower—hastily renamed the Burj Khalifa—opened in January 2010. As of 2011, nine of the world's 10 tallest buildings are located in Asia or the Middle East.

92.
Renaissance Florence

This relatively small city in Italy helped light the spark of a revolution in fine art

CLOAKED IN SIMMERING HUES OF OCHER AND umber, Florence seems to be glowing in this photograph. It's an appropriate palette for the city in Tuscany, for this was the crucible of the Italian Renaissance, the flowering of art and scholarship that ran, roughly, from A.D. 1400 to 1600. Of course the great artists who walked these streets—Ghiberti, Botticelli, Fra Filippo Lippi, Michelangelo and more—did not regard themselves as Renaissance men; the term became popular after it was used in an 1860 book by Swiss historian Jacob Burckhardt.

Modern scholars have attacked the very notion of the Renaissance as overly simplified, and it is. But general audiences understand the term as referring to the liberating awakening of humanistic thought and the creation of glorious art that flowed from such events as the Black Death of 1348 and the fall of Constantinople to Ottoman Turks in 1453.

The Renaissance took place in different nations at different times, but Florence was its epicenter, thanks in part to the wealthy noble family, the Medici, who became patrons of its artists. Thanks to the enduring love affair between the city and its artists, many of the masterpieces of the period can still be seen here: Michelangelo's statue *David;* Botticelli's *La Primavera* in the Uffizi Gallery; Ghiberti's bronze doors of St. John's Baptistery. And then there's the cathedral itself, Il Duomo, its tower completed by Brunelleschi in 1436. Its graceful dome, right, still towers over the skyline, much as Florence remains pre-eminent among the world's repositories of artistic genius.

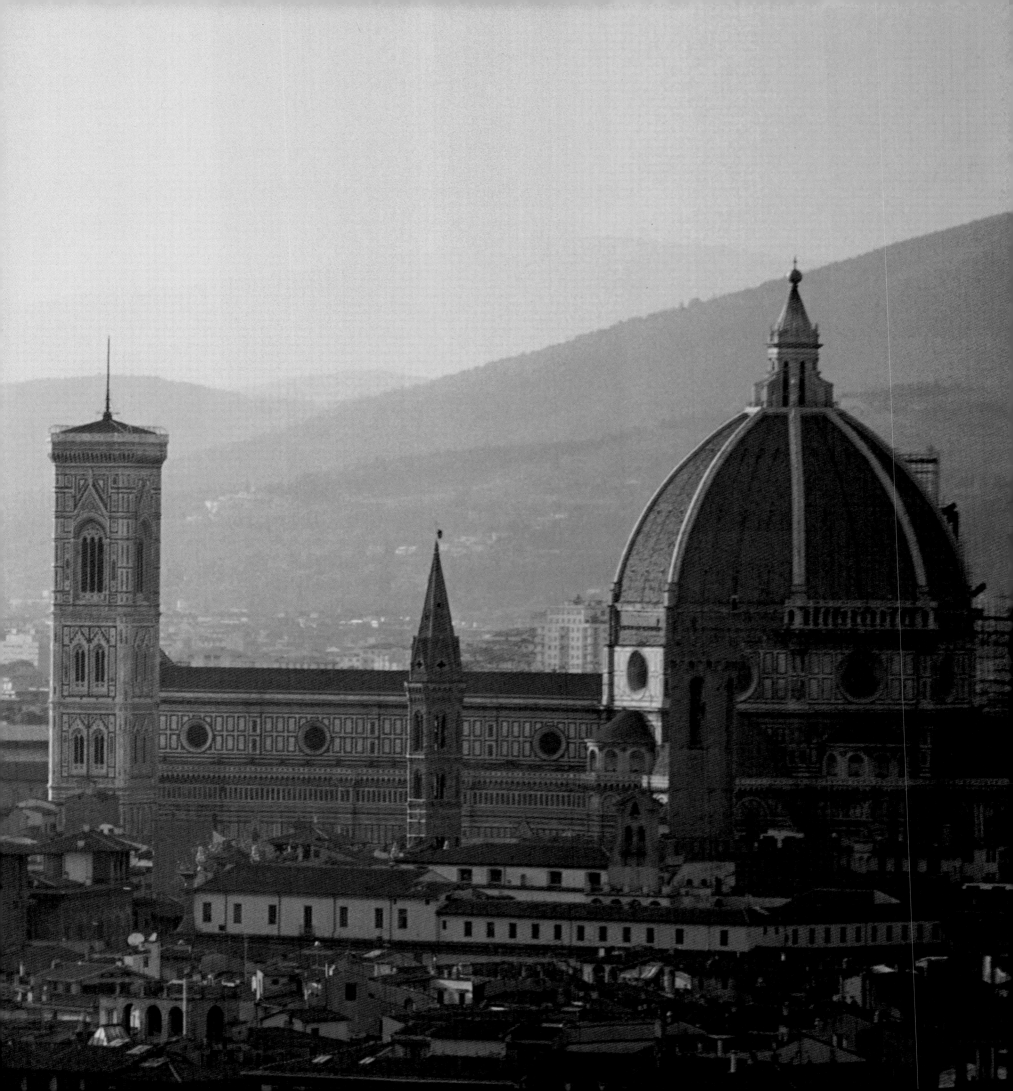

93.
Mozart's Salzburg

The Alpine city retains its magic, as do the works of its favorite native son

HE WAS PERHAPS HISTORY'S MOST FAMOUS child prodigy: beginning at age 6, Wolfgang Amadeus Mozart was carted around Europe by his musician father and trotted out to display his formidable gifts at the piano before swooning aristocrats. But the child who found fame all too quickly met death all too soon. Mozart died, penniless, in 1791, at age 35, leaving admirers to wonder what great works of music he might have created had he lived for another 40 years.

Mozart is fondly remembered in his hometown of Salzburg in Austria, whose well-preserved historic center, the Old Town shown at right, was named a World Heritage Site by UNESCO in 1996. Nestled amid the Alps, the city's Baroque churches and the sprawling Hohensalzburg Castle that looms over them take on a fairy-tale grandeur worthy of the composer of *Eine kleine Nachtmusik* and *Die Zauberflöte*. Mozart's birthplace, on the third floor of a center-city apartment house, is now a museum where his harpsichord, violin and other memorabilia may be viewed.

If the town's most famous son died amid tragic circumstances, Salzburg's auditoriums still resound with his melodies. For five weeks each summer the renowned Salzburg Festival draws music lovers from around the world to enjoy the works of Mozart and other composers amid breathtaking mountain scenery. Chances are you're familiar with those views, even if you've never visited Austria: they were featured in the memorable opening scene of the 1965 film *The Sound of Music*.

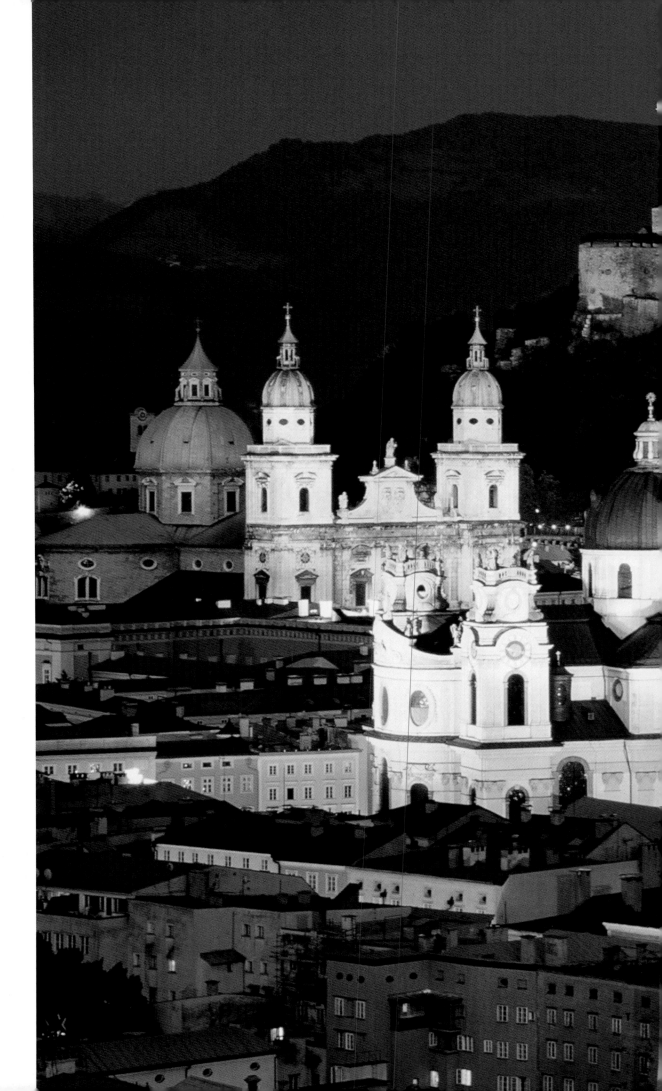

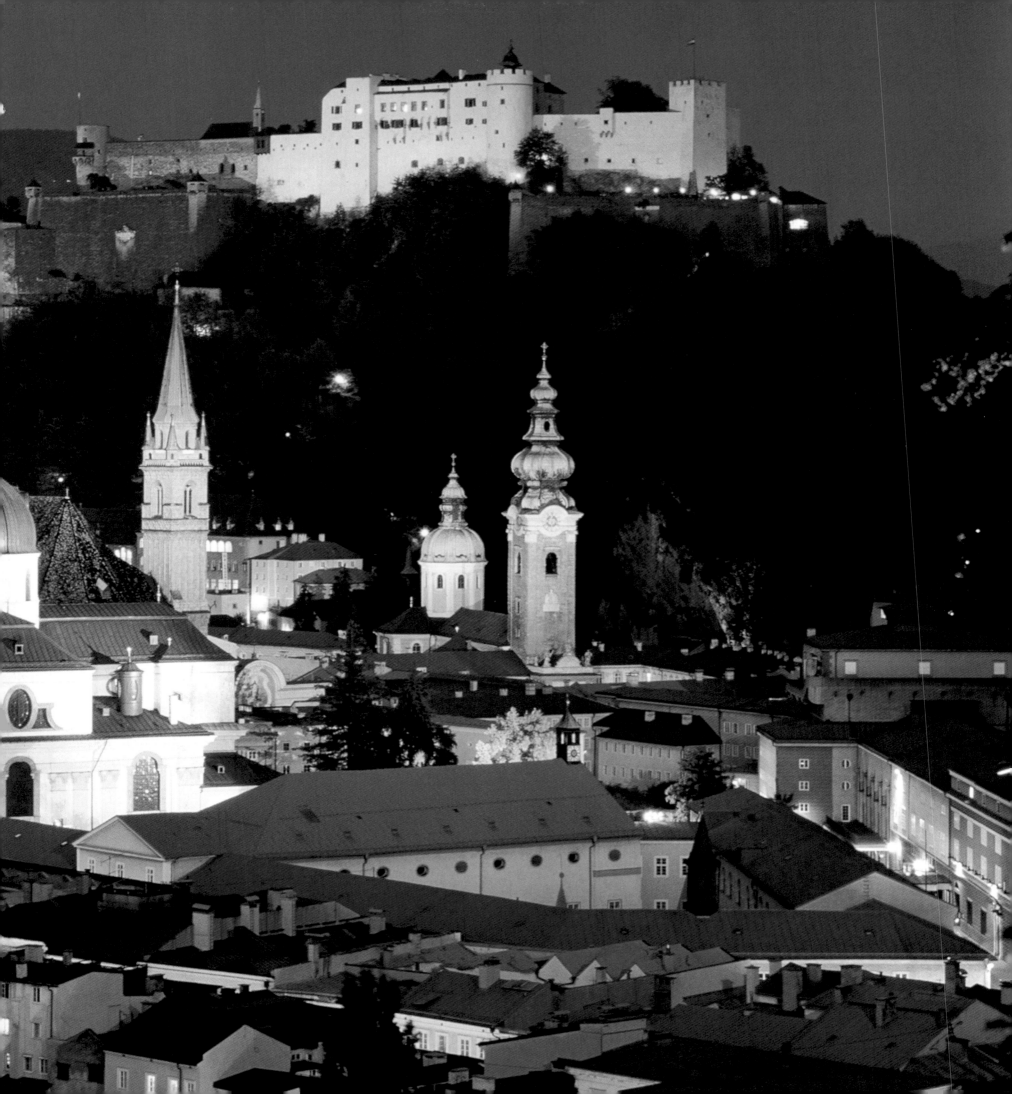

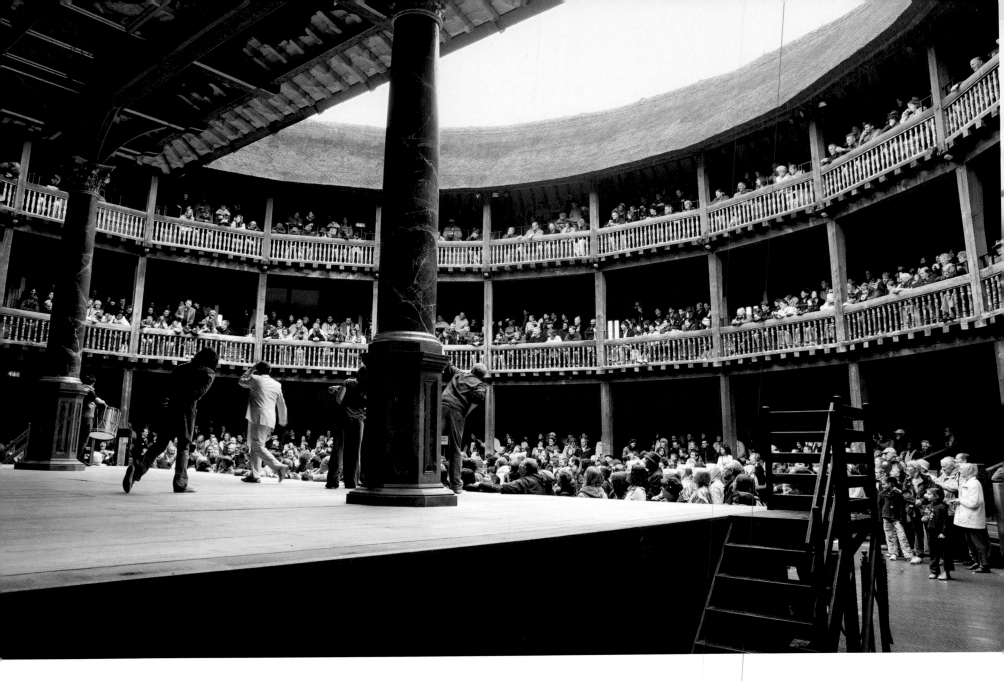

94.
Shakespeare's Globe

A modern playhouse seeks to replicate the production styles of Elizabethan England

THE PLAY'S THE THING THAT FILLS THE house at an afternoon performance in the replica of the Globe Theatre on the south bank of London's River Thames, above. And don't forget the playwright: almost 400 years after his death in 1616, William Shakespeare is still putting fannies in the seats—except for those of the "groundlings" who, like their Elizabethan predecessors, stand beneath stage level in "the pit." The structure is based on modern scholars' knowledge of the original "Wooden O," where Shakespeare's troupe, the Lord Chamberlain's Men, performed. It was consumed by fire in 1613 when a cannon misfired during a staging of *Henry VIII,* igniting the thatched roof over the galleries.

The modern theater, called Shakespeare's Globe, opened its doors in 1997 with a staging of *Henry V,* chosen for the references Shakespeare made to the theater and to the audience itself in the prologue to each act of the play. It is located about 750 ft. (230 m) from the site of the original Globe.

In recent years urban archaeologists have unearthed the vestiges of other Elizabethan playhouses. In 1989, they found remnants of the Rose Theatre, where some of Shakespeare's early works were performed. In 2008 the foundations of the city's first playhouse, the Theatre, were located. Sadly, little remains of the larger London where Shakespeare lived and wrote: the buildings of the Elizabethan age went up in flames in the Great Fire that devoured London in 1666.

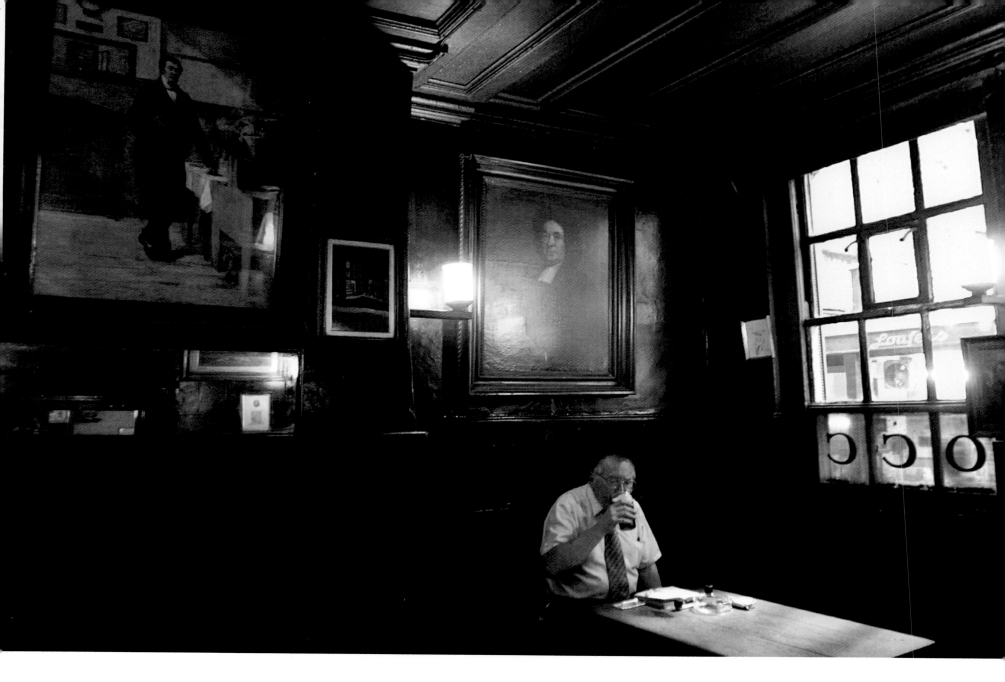

95.
Dickens' London

Trained as a reporter, the novelist chronicled life in England's capital city

CHARLES DICKENS WAS A MASTER OF THE imagination: the characters he made up—Scrooge and Pickwick, Pip and Oliver Twist—seem to have always existed. But Dickens was also a great realist, whose novels are firmly rooted, street by street, in the physical actuality of London. As a young man determined to better himself, he had served as a parliamentary reporter, chronicling the day-to-day speeches and doings of its members. His first success came as a journalist, when, under the pseudonym Boz, he began contributing sketches of London life to local papers. It was at this time that he began his lifelong habit of taking long, energetic walks around the city. When he turned to fiction, those perambulations helped him gather the meticulous details of London life that fill his novels with the sounds and smells of the great metropolis.

The London Dickens knew before his death in 1870 has not entirely vanished. Its great landmarks are still there, of course: Parliament and Whitehall, Westminster Abbey and the Strand. More surprisingly, a few establishments he frequented, like Ye Olde Cheshire Cheese pub on Fleet Street, above, are still open for business. The house the writer and his wife moved into in the Holborn neighborhood when Dickens was only 25 is now a museum. Though the prolific author lived there only two years, he completed his first great success, *The Pickwick Papers,* there, as well as writing all of *Oliver Twist* and *Nicholas Nickleby*—while fitting in his daily constitutional.

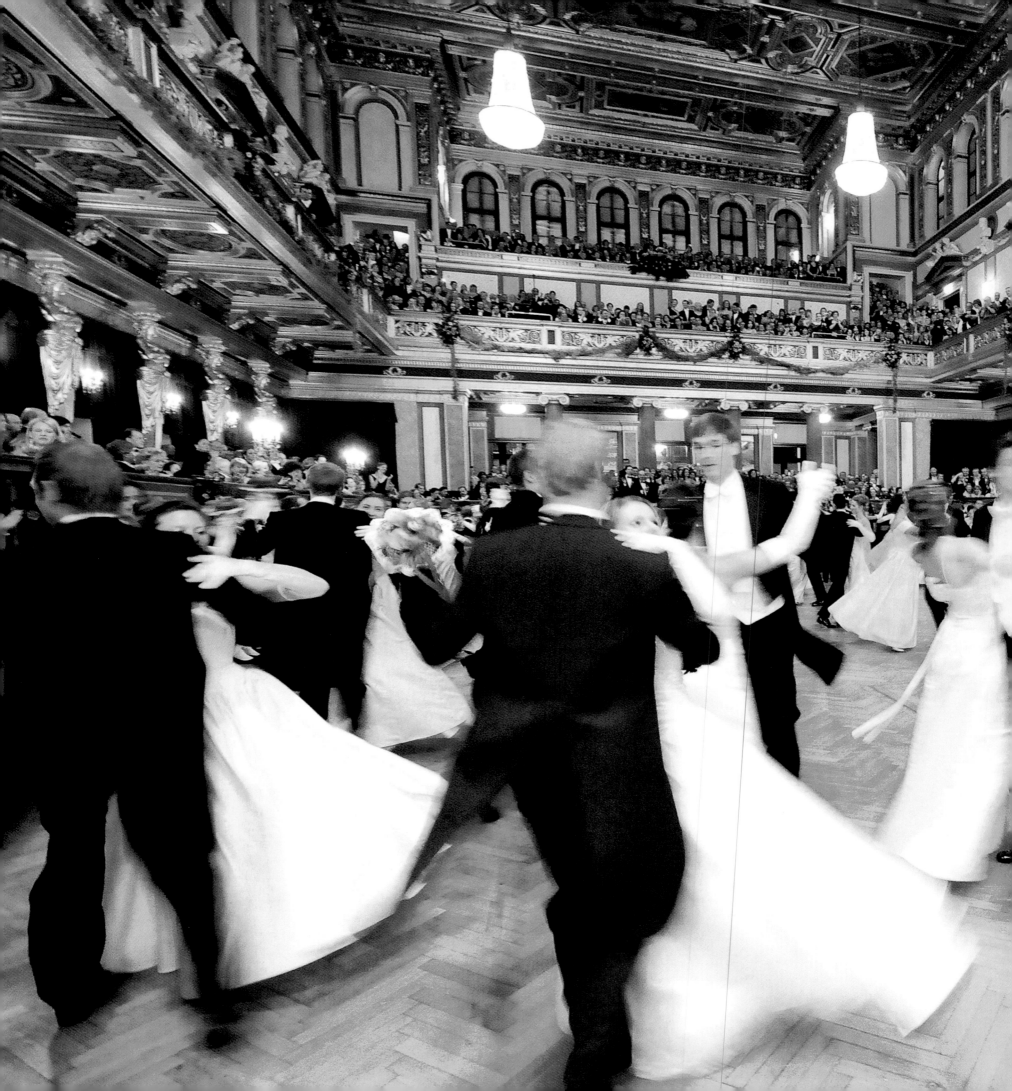

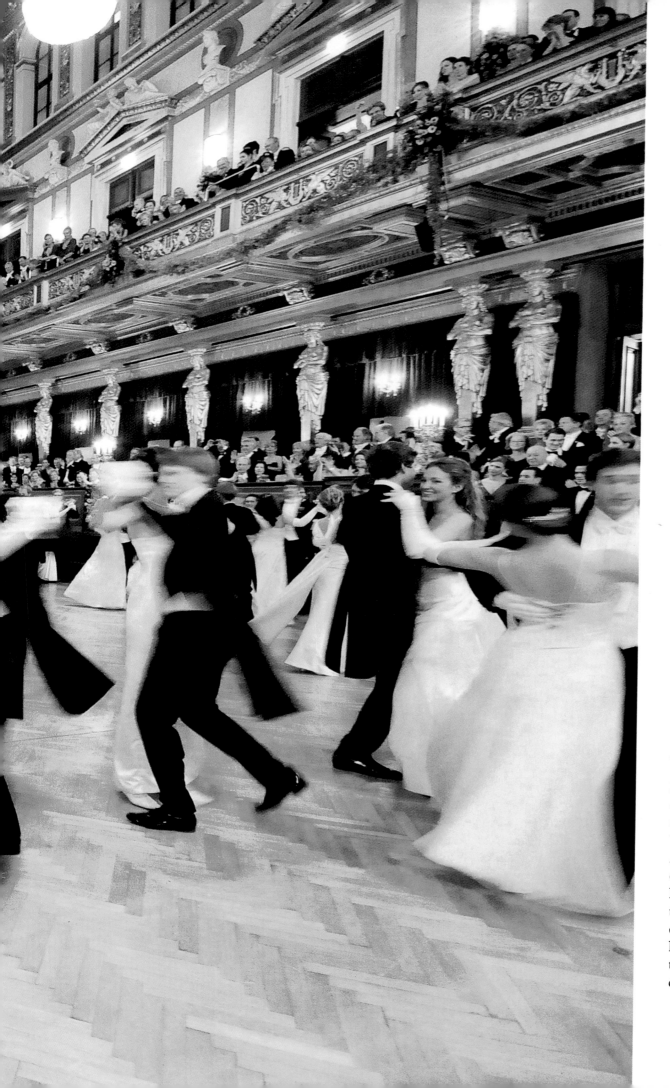

96.
The Strausses' Vienna

By the blue Danube, a family
of musical geniuses clashed

JOHANN STRAUSS WON FAME ACROSS EUROPE
in the 1830s and '40s as a gifted composer of
marches, polkas, waltzes and similar Sacher
tortes of the musical repertoire. This was
music made for dancing, and Strauss toured
Europe extensively for years, conducting his
handpicked orchestras in lavish dance halls.
At home, Strauss was a domestic tyrant who
ordered his six children not to take up music,
for reasons unresolved; he may have hoped
they would avoid his life of constant touring
—or he may have feared competition.

Strauss had every reason to envy the talents
of his eldest son and namesake, Johann
Strauss II. Though his father beat him
severely one day when he found him practic-
ing the violin, he could not keep his son from
becoming a musician—and, indeed, from
eventually eclipsing his father in popularity.
Their conflict was also generational: Johann II
supported the 1848 revolutions across Europe
that sought to effect social change, while
Johann I fiercely supported the status quo.

Happily, this family rivalry (Johann I's sons
Eduard and Josef also became notable compos-
ers) resulted in music that continues to move
audiences, with the works of Johann II, "the
Waltz King," remaining the most popular.
And the beautiful Baroque stage where this
duel was fought—19th century Vienna—is also
largely intact. Millions of listeners worldwide
tune in each year to the New Year's Concert
of the Vienna Philharmonic from its
historic home, the Musikverein, left. And
the program? Hey, there's a reason they
call this auditorium the House of Strauss.

147

97.
Wagner's Bayreuth

The ambitious composer of epic operas imposed his vision on every aspect of his productions

IN RECENT YEARS THE ENGLISH LANGUAGE has given us a term that perfectly sums up the German composer Richard Wagner, albeit 150 years after the fact: he was a control freak. Unlike most opera composers, Wagner preferred to write his own librettos, based on his own stories, rooted in his own intense love affair with Teutonic lore and legend. Wagner used the term *Gesamtkunstwerk* ("comprehensive artwork") to sum up his desire to make his operas not only powerful works of music but also intense dramas, dazzling spectacles and ritualist evocations of cultural memory.

Wagner's works resonated deeply with King Ludwig II of Bavaria, the eccentric ruler who built the magnificent stage-set palace Neuschwanstein as a tribute to German greatness. As Wagner's patron, he helped fund the completion of an opera house designed specifically for his works. Two architects worked on the project, incorporating plans for an opera house in Munich that was never built. But its chief visionary was Wagner himself.

The result, the Bayreuth Festspielhaus, was revolutionary. Eschewing vertical galleries, Wagner arranged its 1,925 seats in a wide horizontal semicircle with no aisles, covered the orchestra pit and used two prosceniums in order to enhance the "mystical gulf" he sought between performers and viewer. Here his great works were first presented, and here they are still presented—above is a 2007 production of *Tannhäuser*—in the Bavarian mountain town that is now a Mecca for his admirers.

98.
Yasnaya Polyana

Tolstoy wrote his greatest novels here, then chose to renounce them

LEO TOLSTOY LIVED SO LONG AND ACHIEVED so much in so many realms that his life eludes synopsis. Few dispute that his novels *War and Peace* and *Anna Karenina* are among the world's fictional masterpieces. But sometimes forgotten today is the extent to which Tolstoy commanded the world stage as thinker and polemicist in the last years of the 19th century and first years of the 20th. The Russian nobleman who had moved the world with his art now tried to change it through social activism. He publicly renounced—and even denounced—fiction in his later years, becoming an outspoken advocate for social justice, a peace activist and a radical Christian. In his last decades, Tolstoy was more prophet than artist: he commanded a worldwide following of admirers, even as many branded him as no more than an idealistic, eccentric crank.

All the disparate strands of Tolstoy's life can still be felt at the family estate he moved into in 1856, at age 28. At Yasnaya Polyana's 4,000 acres outside Tula, some 123 miles (198 km) south of Moscow, Tolstoy wrote his great works, harvested grain with the peasants, ran relief efforts for famine victims and entertained Anton Chekhov and Ivan Turgenev. Wife Sophia, his great love (and frequent adversary), gave birth to 13 children here, while hand-copying her husband's new writings each night. After Tolstoy's death at 82 in 1910, the home was taken over by the state. Today, it remains a magnet for admirers of a great artist, albeit one who turned against his craft.

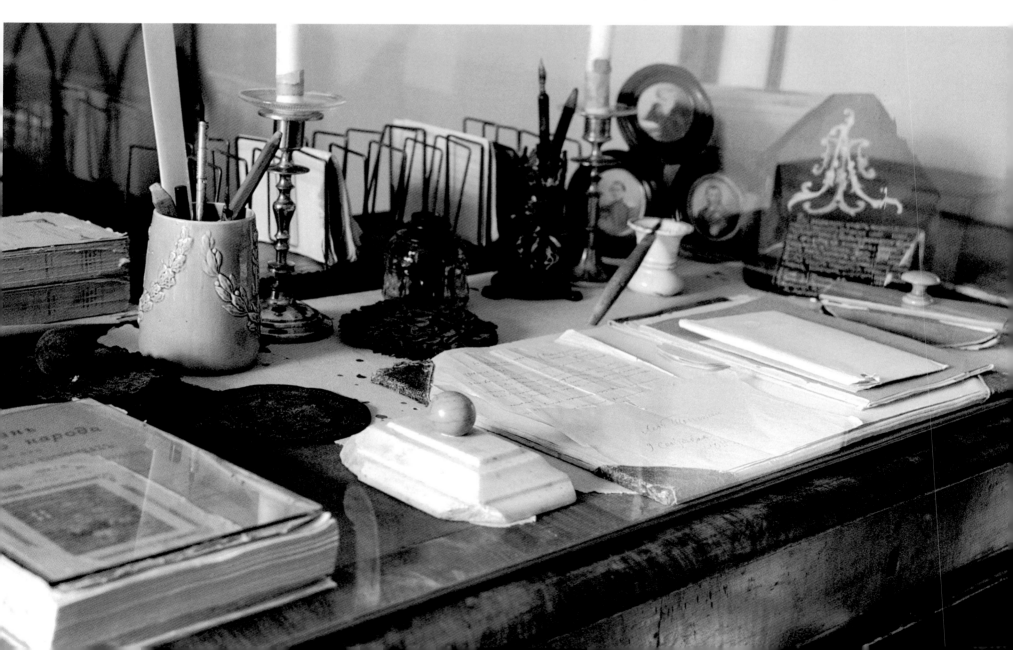

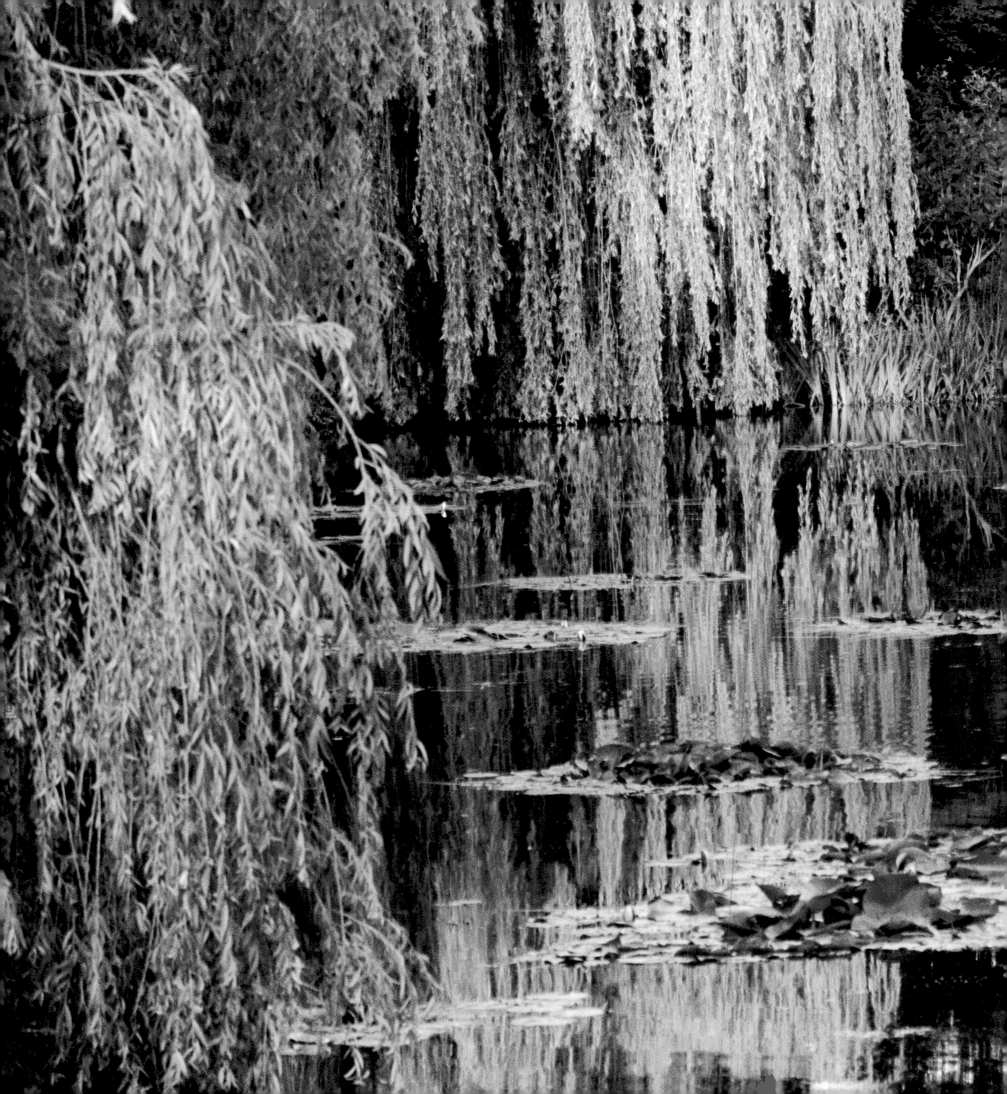

99.
Monet's Garden

In Giverny, the great painter planted the seeds of his inspiration

THE FIRST ISSUE OF *TIME* MAGAZINE, PUB-lished on March 3, 1923, carried good news for art lovers. "Claude Monet, blind French painter and last of the great Impressionists, recovered his eyesight after a surgical opera-tion at which his oldest friend, Georges Clem-enceau, stood at his side to cheer him. Monet, 83, has been blind for several years," the new publication reported, going on to explain that "Monet was working, when his eyesight failed, on the last of his great series, the so-called *Nymphéas,* 300 separate paintings of a single lily pond in his garden."

That garden, a two-part paradise of green-ery, water and flowers, is located in Giverny, France, which lies on the River Seine some 50 miles (80 km) northwest of Paris. The painter first noticed the village from a train window as he passed through in 1883, four years after the death of his first wife, and vowed he would move there. He personally planned and planted the garden, the rare artist who controlled the source of his inspiration. A monumental succession of paintings flowed from this magical setting over the next decades, in the plein air Impressionist style that Monet had helped create and popularize. After his death in 1926, the garden languished until it was restored to its original condition over a 10-year period. Opened to the public in 1980, it is visited by 500,000 people each year.

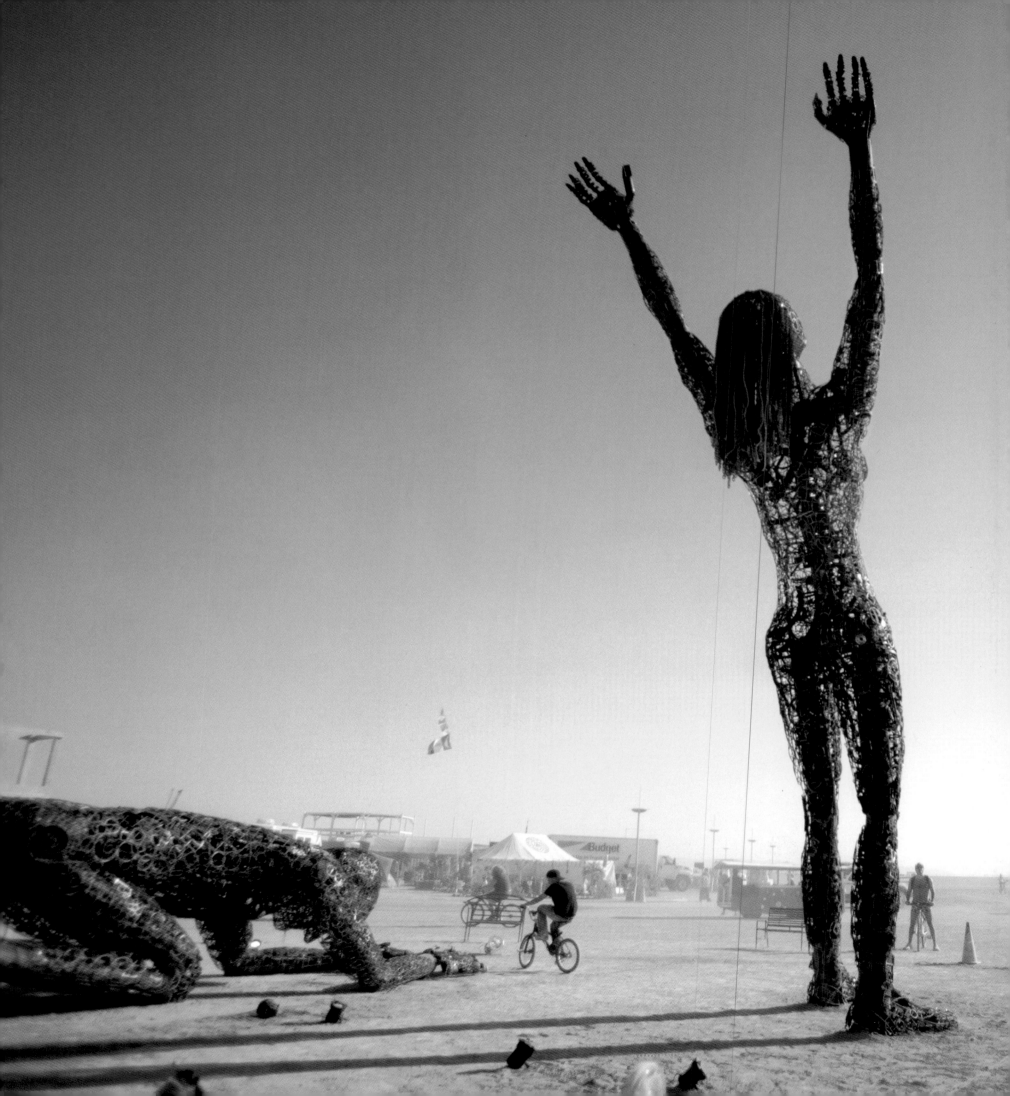

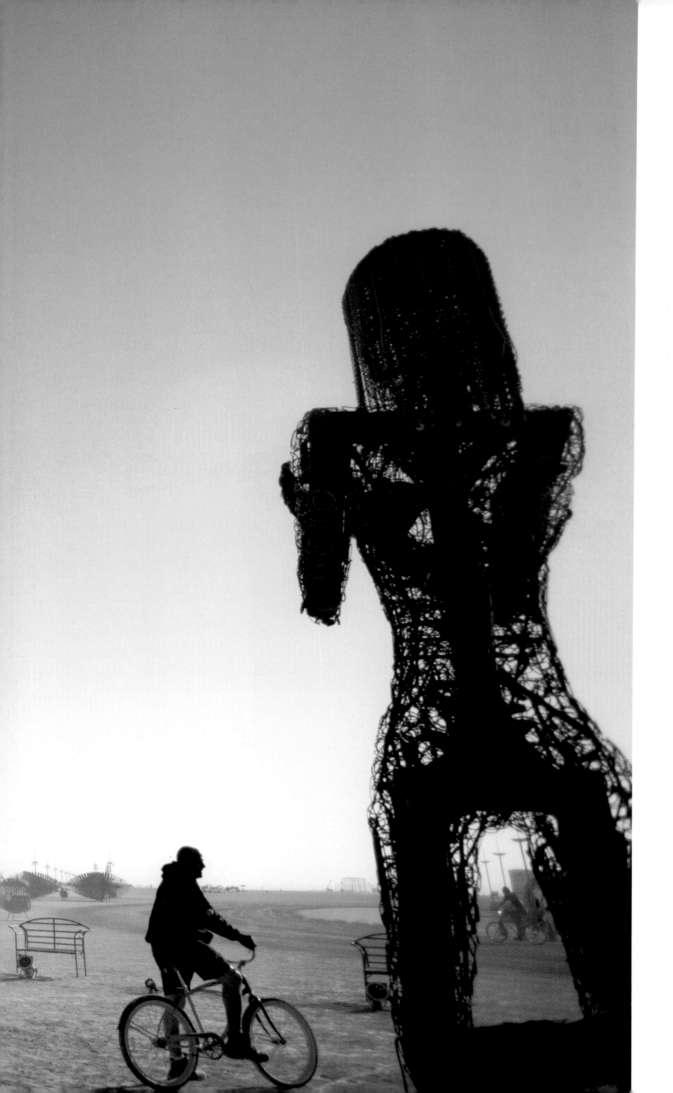

100.
Burning Man

It's a good bet that the future of art is on view today—in the middle of the Nevada desert

A GREAT DEAL OF ART IS CREATED, DISPLAYED and performed at the annual festival called Burning Man, much of it so avant-garde as to defy conventional labels. We do know this: the gathering takes place each year in Nevada's Black Rock Desert, and it is in the business of defying convention. It can't be summed up— that's integral to its appeal—and if you asked the more than 50,000 people who attended the week-long event in 2010 to describe it, you'd hear 50,000 different answers. Suffice it to say that the big to-do, which concludes with the ritual burning of a 40-ft. (12 m) sculpture of a man, is a crazy quilt of counterculture, New Age, punk and digital-era influences.

Burning Man's principals declare, "To truly understand this event, one must participate." They call it "a city in the desert, dedicated to radical self-reliance, radical self-expression and art ... [where] innovative sculpture, installations, performance, theme camps, art cars and costumes all flower." In short, it's a head trip, where startling and wonderful works of art can be experienced, and nudity and recreational drug use are widespread—but cars, dogs and timid spirits are not welcome.

The festival began as a lark among a few friends in San Francisco in the 1980s, then moved to Nevada in the '90s and grew, gradually, to its present size. Success and publicity have led some critics to accuse its organizers of being perhaps a bit too organized. Maybe so, but as TIME tech correspondent Douglas Wolk reminds us, "It's an insanely interesting art festival, with tiny and huge and awful and magnificent work sprawling all over an enormous patch of desert." What's not to like?

FRONT COVER *(top to bottom, left to right)* PictureNet—Corbis; Guido Cozzi—Atlantide Phototravel—Corbis; Claro Cortes IV—Reuters—Corbis; Ruggero Vanni—Corbis; Travelpix Ltd—Getty Images; Adam Jones—Corbis; Stephen Exley—Getty Images; Sean Caffrey—Lonely Planet Images—Getty Images; Marc Chapeaux TIPS—Aurora Photos; Pawel Wysocki—Hemis—Corbis; Bob Krist—Corbis; Reza—National Geographic Images—Getty Images; Burning Man installation by Dan Das Man, 2006, Photograph by Heidi Schumann—Polaris; Stefano Amantini—Atlantide Phototravel—Corbis; Martin Puddy—Corbis; Per-Andre Hoffmann—Aurora Photos; Kevin Fleming—Corbis; Benoit Doppagne—AFP—Getty Images; Andreas Pessenlehner—EPA; Stefano Spaziani—Polaris; Gavin Hellier—JAI—Corbis.

BACK COVER Michael Melford—National Geographic Images—Getty Images.

HALF-TITLE *(top to bottom, left to right)* Massimo Ripani—Grand Tour—Corbis; Reza—National Geographic—Getty Images; Ira Block—National Geographic Stock; Harald Sund—Getty Images; Martin Puddy—Corbis; Tui De Roy—Minden Pictures; Gavin Hellier—JAI—Aurora Photos; *Big Rig Jig* by Mike Ross, Photograph by Ryan Jesena.

INTRODUCTION ii Gavin Hellier—JAI—Corbis.

CHAPTER ONE 1 Massimo Ripani—Grand Tour—Corbis. 3 Stephen Studd—Getty Images. 4 Kevin R. Morris—Corbis. 5 *(from top)* Reuters—Corbis; Keren Su—China Span—Getty Images. 6 Gianni Dagli Orti—Corbis. 7 Ocean—Corbis. 8 David Noton Photography—Alamy. 9 Buena Vista Images—Getty Images. 11 Marco Cristofori—Corbis. 12 James L. Amos—Corbis. 13 Shaul Schwarz—Getty Images. 15 Philippe Renault—Hemis.fr—Aurora Photos. 16 Ted Spiegel—National Geographic Images. 17 Christopher Herwig—Aurora Photos. 18 Ocean—Corbis. 19 PictureNet—Corbis. 21 Nadia Isakova—JWL—Aurora Photos.

CHAPTER TWO 23 Reza—National Geographic Images—Getty Images. 25 Philippe Lissac—Godong—Corbis. 26 *(from top)* Jon Hicks—Corbis; Jim Hollander—EPA. 27 Blue Images—Corbis.

29 Kazuyoshi Nomachi—Corbis. 30 Michele Falzone—JAI—Corbis. 31 *(from top)* Michele Burgess—Corbis; Michel Setboun—Corbis. 33 Bob Krist—Corbis. 34 Thomas R. Anderson—Getty Images. 35 Blaine Harrington III—Corbis. 36 Yi Lu—Corbis. 37 David Frank—Polaris. 38 Antonello Nusca—Polaris. 39 X. Rey—EPA 40 Christopher Brown—Polaris. 41 David Lefranc—Polaris.

CHAPTER THREE 43 Ira Block—National Geographic Stock. 44 Tibor Bognar—Alamy. 45 *(clockwise from top)* James L. Stanfield—National Geographic Stock; The Art Archive—Alamy; Robert Harding—Robert Harding World Imagery—Corbis; Corbis. 46 Kenneth Garrett—National Geographic Stock. 47 Adam Woolfitt—Corbis. 49 Manor Photography—Alamy. 50 *(clockwise from left)* Roger Wood—Corbis; Erich Lessing—Art Resource, NY; Erich Lessing—Art Resource, NY. 51 Bridgeman Art Library International. 52 Michael Nicholson—Corbis. 53 A. Dagli Orti—DeAgostini—Getty Images. 54 Ira Block—National Geographic Stock. 55 Michael Yamashita—Corbis.

CHAPTER FOUR 57 Harald Sund—Getty Images. 59 Stephen Shaver—Polaris. 60 Diego Lezama Orezzoli—Corbis. 61 Domingo Leiva—Getty Images. 63 Stephen Exley—Getty Images. 64 Stefano Torrione—Hemis—Corbis. 65 Richard Wagner—Getty Images. 66 Gavin Hellier—Robert Harding World Imagery—Corbis. 67 Richard Cummins—Corbis. 69 Visions of Our Land—Getty Images. 70 Werner Forman—Corbis. 71 *(from top)* Anthony Allen—Gallo Images—Getty Images; Dave Hogan—Getty Images.

CHAPTER FIVE 73 Martin Puddy—Corbis. 75 Adam Wookfitt—Robert Harding World Imagery—Getty Images. 76 Uwe Gerig—DPA—Corbis. 77 Ezequiel Scagnetti—Invision Images—Aurora Photos. 78 *(from left)* Imagno—Hulton Archive—Getty Images; Christian Kober—JWL—Aurora Photos. 79 *(from left)* Stephane Godin—Getty Images; Glen Allison—Getty Images. 81 View Stock—Stock Connection—Aurora Photos. 82 Skyscan—Corbis. 83 *(from top)* Frederic Soltan—Sygma—Corbis; C. Sappa—DeAgostini—Getty Images. 85 Russ Heinl—All Canada Photos—Corbis. 86 Stefano Amantini—Atlantide Phototravel—Corbis. 87 Walter Bibikow—Aurora Photos.

CHAPTER SIX 89 Maurice Savage—Alamy. 91 Michael Melford—National Geographic Images—Getty Images. 92 Russ Heinl—All Canada Photos—Corbis. 93 Kevin Fleming—Corbis. 95 Greg Dale—National Geographic Images—Getty Images. 97 Martin Norris Travel Photography 2—Alamy. 98 Corbis. 99 Bertrand Desprez—Agence Vu—Aurora Photos. 100 Torin Boyd—Polaris 101 Alex Masi—Corbis.

CHAPTER SEVEN 103 Tui De Roy—Minden Pictures. 104 Kelly Cheng Travel Photography—Getty Images. 105 Christophe Boisvieux—Corbis. 107 Ayse Topbas—Getty Images. 108 *(from top)* Nik Wheeler—Corbis; Ian Walde—Getty Images. 109 Chris Andrews—Oxford Picture Library—Alamy. 111 Danita Delimont—Getty Images. 112 Tony Hallas—Science Faction—Getty Images. 113 Mari Tefre—Global Crop Diversity Trust. 115 Chad Carpenter—Lightroom Photos—Hollandse Hoogte—Redux.

CHAPTER EIGHT 117 Gavin Hellier—JAI—Aurora Photos. 118 Scott Warren—Aurora. 119 Sylvain Sonnet—Corbis. 121 Luca da Ros—Grand Tour—Corbis. 122 Massimo Listri—Corbis. 123 Massimo Borchi—Atlantide Phototravel—Corbis. 125 Tetra Images—Aurora Photos. 126 TRV—Imagerover.com—Alamy. 127 David Paterson—WildCountry—Corbis. 129 Panoramic Images—Getty Images. 130 Frans Lanting—Corbis. 131 Bernd Auers—Getty Images. 132 Lindsay Hebberd—Corbis. 133 Arcaid—Corbis. 135 Topic Photo Agency—Corbis. 136 Astock—Corbis. 137 Jose Fuste Raga—Corbis.

CHAPTER NINE 139 *Big Rig Jig* by Mike Ross, 2007, 18-Wheeler Tanker Trucks, Steel, 42' x 29' x 11', Photograph by Ryan Jesena. 141 Glen Allison—Getty Images. 143 John Lawrence—Getty Images. 144 Travelshots.com—Alamy. 145 Alan Weller—Bloomberg—Getty Images. 147 Andreas Pessenlehner—EPA. 148 Jochen Quast—EPA. 149 RIA Novosti—Alamy. 151 Farrell Grehan—National Geographic—Getty Images. 153 Burning Man installation by Dan Das Man, Photograph by Heidi Schumann—Polaris.